Victorian Artists

Victorian Artists

Quentin Bell

ACADEMY EDITIONS • LONDON

This first paperback edition, completely redesigned
and with additional colour plates, published in
1975 by Academy Editions 7 Holland Street London W8

SBN 85670 151 3

Printed and bound in Great Britain
by Burgess & Son (Abingdon) Ltd. Abingdon Oxfordshire.

Contents

Property of Jan Popper

Preface

This book has been made out of eight lectures delivered at Oxford during the spring of 1965. My indulgent and responsive audience probably did not expect and certainly did not receive the fruits of a profound research. What I attempted to do was to offer some general considerations concerning the Victorian period and a partial adumbration of its historical shape. In rewriting my lectures for publication I have not attempted to go beyond my original purpose. I have used published material and the works of art themselves to support my arguments; the lectures have become not monographs, but essays. In a book of this size dealing with a period so large and so little studied by art historians this method appears both prudent and appropriate.

I should perhaps add that I have devoted my attention almost entirely to the art of painting in England and, even within those limits, I have taken an essayist's liberty and have omitted much that would have to be included in a complete history of the period.

I should like to thank a great many people who have helped me, and in particular the courteous, patient and helpful officials of many public galleries. I hope I may be forgiven if I content myself with the mention of five names: Dr. Alan Bowness, who allowed me to read an unpublished lecture, Dr. D. M. White of the University of Leeds who solved a problem of attribution for me, Mrs. Alistair Stead, who gave valuable help and advice with my second chapter, Mrs. Phyllis Winning, and my wife, who saved me from innumerable errors.

Q.B.

I
The Age of Fragmentation

The period with which I am concerned, that is to say the years 1837–1910, may, roughly speaking, be called the Victorian Age. Constable and William IV died in 1837; 1910 saw the first Post-Impressionist Exhibition and the end of an epoch in British painting.

It was a time when the French produced some of their greatest men of genius; in fact I suppose it might be generally agreed today that the nineteenth century is the great century of French painting. In this country, on the other hand, we produced only two men of unquestionable stature: Turner, who died in 1851, and Sickert whose greatest manner ends with the close of our epoch. For the rest we have to consider men of some talent, of a little talent, and of no talent at all. Many people would consider this to be the gloomiest and most unrewarding period in the history of British painting. Why then do I choose to examine it?

The question contains an assumption that ought to be considered at once: the assumption that the historian must be an apologist. I am not an apologist. I shall not try to 'sell' you Victorian painting, I am not joining in that revivalist movement, which, for a generation, has been teaching us to reconsider our too hasty judgments of Victorian architecture. Useful and illuminating though a revaluation of Victorian painting might be, it would at best be incidental to my purpose. And although I shall, I hope, bring to your notice some artists who have been almost forgotten and who I think deserve to be remembered, I shall also ask you to look at detestable paintings which I shall not attempt to defend.

I shall do this because the first duty of the historian in this field is to exhibit the evidence. Unlike Victorian architecture, Victorian painting is barely visible; much of it lies concealed in the basements of our galleries where, owing to the size and weight of Victorian frames, it remains more or less immovable. Much of it has never been photographed. To a surprisingly large extent it belongs to an unknown chapter in the history of art.

The Pre-Raphaelite movement has been partially explored, but, for the rest, the period has attracted the attention of few art historians and this, very largely, because it is thought to be unworthy of examination. It is felt to be aesthetically and therefore historically negligible and because it is the kind of history that we don't find interesting, we feel it to be the kind of history that can be disregarded. Let me offer an example of what I mean.

A great American scholar has recently published a history of art from the earliest times to the present day. In so far as I can judge, I should say that up to the middle of the nineteenth century the record is admirably compiled. Nothing, I am sure, is said that should have been left unsaid, nothing omitted that ought to have been mentioned. But the past one hundred years are treated in a very different fashion. The author traces the successive revolutionary movements of French painting from Courbet to Picasso but he never tells us against what the revolutionaries were revolting. As for British art, after Turner it appears not to exist, the Pre-Raphaelites are not even mentioned and, in a history which devotes some attention to Thomas Eakins, Morris and Burne Jones are passed over in silence.

Compare this account with that of Mrs. Arthur Bell in *Representative Painters of the 19th Century*, published in London in 1899. This lady mentions Whistler, Manet, Monet and Degas as well as Rossetti, Holman Hunt, J. F. Millet, Burne Jones, Landseer and Leighton. But she also mentions artists of whom we know

far less: Abbot Henderson, Thayer, Rosa Bonheur, Troyon, Cazin, Regnault, L'Hermitte, Dagnan-Bouveret, Makart, Mesdag and others whose names are to-day almost forgotten. She says nothing of Daumier, Renoir, Pissarro, Seurat, Cézanne or the Post-Impressionists.

Nevertheless this seems to me the better history of the two. The authoress gives as complete a picture as she can. She can hardly be blamed for not mentioning Cézanne because in all probability she had never heard of him. In 1899 very few people had. Whereas we certainly have heard of Landseer and know that he was considered by the great majority of his contemporaries to be a man of high genius. If we omit him we omit him on a principle of taste.

Consider what would happen to other departments of history if this art historical method of selection were employed. What for instance would become of a chronicle of the past thirty years if all regrettable persons and incidents were omitted? How strange such a history would be, and how short.

However much we may wish to do so we cannot possibly omit Judas Iscariot from the story of the twelve apostles. It appears to be less easy to understand that you cannot omit Bouguereau and the *Salon de M. Bouguereau* from the history of Impressionism and that, if you do, you do less than justice to the courage and originality of men like Pissarro and Seurat. In the nineteenth century the art of the Salon and of the Academy provides a necessary background (a very dark one if you like) without which the highlights appear at less than their true value.

The greatest painters were, in fact, singularly unrepresentative of their age. They were either unknown or thought to be frivolous eccentrics. In looking at them alone we are looking at exceptional and uncharacteristic figures who may furnish an agreeable anthology; but such an anthology is not history.

History is, or should be, something wider than a treatise on gifted non-conformists. In fact bad art is of greater evidential value than is good art. Bad art 'dates'; it belongs, unmistakably, to its period. Good art is, as they say, 'not for an age but for all time' which, of course, makes it decidedly unhistorical.

Therefore Mrs. Arthur Bell, in that she deals not only with good but with bad artists, has produced a document of considerable evidential value, deficient only in this, that it dwells with too much particularity upon painters who seem to us only to need a brief mention, while failing to look deeply enough into those areas of art history which were to be of paramount importance in the development of painting in our own time.

But is she any more at fault here than we? My American historian carries his survey up to very recent times and in so doing makes selections which I, for one, find unacceptable. In truth, neither he nor I can claim to know what, in living art, is likely to appear important fifty years hence. There are plenty of historical precedents for thinking that the historians of the twenty-first century may stand amazed at our stupidity.

There may even now be some quiet maiden lady drawing arum lilies with a very hard pencil in the suburbs of Luton who holds the entire future of British painting for the next hundred years in her industrious but still unknown hand, and—to our shame—we do not even know her name. Fifty years hence I fancy that I shall have outgrown the youthful habit of blushing, but the faces of some of my readers may be red.

To some extent we are obliged continually to re-write the history of art. It

was possible, in 1889, for Sir Frederick Leighton, as he then was, to give an extremely learned and comprehensive discourse on Spanish Art and yet never once to mention El Greco.[1] El Greco had to be rediscovered *via* Cézanne. But although we amend and extend our history of the older masters, questions of aesthetic preference do not become matters of capital importance until the nineteenth century, and it is only at this point that a twentieth-century taste in painting may lead to a complete misunderstanding of the facts. We are, after all, pretty much in agreement in thinking that Vasari was a less important artist than Michelangelo and Rubens a more important painter than Jordaens, and our judgment concerning these artists comes quite close to the judgments of contemporary critics. The development of painting is changed by Michelangelo and Rubens, they formed their successors and, even though we may think more highly of the Mannerists and less highly of van Dyck than did our grandparents, still the change in valuations does not greatly upset our notion of the historical process, so that art history, in many large areas, does conform to a pattern of aesthetic preferences.

It is this which makes it so easy to fall into error when we come to the history of painting in the nineteenth century and continue to apply the same rules.

Now this brings me to the first of the things that I want to say about this book. I am going to try, in a very superficial way no doubt, to follow some aspects of the development of Victorian painting and of some Victorian ideas about painting. At the outset I attempted to do this without reference to modern standards of taste. The effort proved too great, but I hope that I can at least avoid the error of dismissing that which I do not like on the pretext that it has no importance. I shall, and this will no doubt seem very perverse, omit some of the things on which you might expect me to dwell—as for instance the later English watercolourists and Turner's final period—because I am trying to adumbrate, not a history of the epoch, but a history of various tendencies in painting which were to have an important effect upon the development of art in this century.

To this end I must begin by trying to make some generalizations about the social context, without which the English contribution can hardly be understood.

However little one may actually know about it one must begin by mentioning the Industrial Revolution. It changed the look of things. Large areas of the countryside became more domestic, more highly patterned, more cultivated and, in the north, great expanses of barren moorland were rapidly covered by cities. Perhaps it would be better to speak of 'great towns', for the word 'city' suggests the *piazza*, the avenue, the forum, some kind of civilian discipline, a coherent pattern endorsed by, and radiating from, the seats of temporal and ecclesiastical power. These urban agglomerations grew haphazard in vegetable profusion, drawing their life from the pit head, the quarry or the engine house, clinging in luxuriant abundance to the railway or the canal, overshadowing and engulfing whole villages and towns in their impetuous, untidy embrace.

The inhabitants, like the streets, sprawled towards the light in blind, unruly force; the strong crushing and suffocating the weak, each competing *entrepreneur* driving his own bargains, building his own mills, sidings, back-to-back workers' dwellings and warehouses without deference to authority or care for his neighbour. Only the weak and the unfortunate co-operated with each other

[1] Leighton, *Lectures on Art*, n.d. 'Spanish Art', *passim*.

and their co-operation was accounted a crime by the strong; for these were taught, not only that self-reliance is virtuous, but that through the operation of continual commercial warfare the happiness of man will best be secured.

Such teaching did not appear ridiculous; men might decay but wealth accumulated. And while the system could hardly be expected to engender social or aesthetic harmony, it did, in its fashion, deliver the goods. It did foster a kind of valuable idiosyncrasy which will not be found in more co-operative types of society and it engendered a passionate, unappeasable longing for beauty.

Capitalism produced dividends. There was a striking increase in the number of people who could afford to live in Islington and a consequential increase in the size of Islington itself. Great fortunes were amassed by industrialists in Liverpool and Manchester and Leeds—a few of whom were ready to buy Pre-Raphaelite pictures, and by men in Boston, Chicago and Pittsburgh, a few of whom bought Impressionists. There were also the lesser incomes of rentiers or men in a smaller way of business—men with names like Millais, Bazille, Sisley, Cézanne, Degas, Gachet, Durand Ruel.

It was perhaps the nineteenth century spirit of individualism which moved the independent painters, but it was the diffusion of unearned income which made their revolt a practical possibility.

Whether the nineteenth-century love of art was serviceable to these eccentric men of genius may be doubted. In fact there may be some of my readers who, remembering the howls of disgust with which nearly all the great painters were received, may doubt whether the century can properly be described as art loving. They forget that love is blind; the Victorians cherished some odd passions but they were not the less passionate for that.

It was, after all, a century which, practically speaking, invented the national and the municipal art gallery; it created, or at least it transformed, art criticism, schools of art and art dealing. From its steam-presses poured forth a prodigious torrent of keepsakes, steel engravings, illustrated periodicals, art journals, art annuals and art books. In its architecture it was by no means content with the austerities of our own time or those of the eighteenth century. It left no stone uncarved, no surface unadorned; regardless of expense it piled crockets on pinnacles, urns on balustrades; it was prodigal with encaustic tiles, stained glass and iron work. The exterior of the buildings staggers under the weight of art and within, even if we look into comparatively humble dwellings where each object of virtue represents a material sacrifice, the portraits mounted on velvet and framed in gold, the flocked wall paper, the ornately carved chairs, the settee, the rubber plant, the antlered hat rack, the commode, the whatnot, represent a whole-hearted love of beauty which has never been surpassed. The Victorian gentleman was *not* exuberantly aesthetic in his appearance but this deficiency was more than remedied by the costliness, the elaboration, the structural audacity, the sheer volume of the Victorian lady. In everything that they made, in their nut-crackers, their lamp posts, their cutlery, their beer pumps, their advertisements, even their agricultural machinery, the Victorians have left striking evidence of their passion for art.

The effort, the expenditure in time, energy and ingenuity was enormous: and yet, so deeply sensitive were they to the claims of beauty, that the Victorians themselves were the first to criticize the results and to find that, for all their efforts, they had not done enough.

To them and to some modern critics it would seem that the machine itself—amoral in its operation, immoral in its social effects—was the chief agent of a decay of taste which was already being noticed and deplored in the 1830s.[2] In many industries however, the substitution of steam power for man power or water power did not, in itself, produce substantial aesthetic alterations. A factory like that of Chelsea, Worcester or Spode did not, I suspect, undergo a very radical transformation between 1750 and 1850; the division of labour between fussers, jollyers, slip-house workers, furnace men and decorators would not have been substantially altered. More work would have been mechanically performed, coal might have replaced wood, the tendency to employ artists from London would have increased, but the position of the craftsman in the factory was not I believe greatly affected. In the 1840s Wedgwood employed Redgrave just as a former Wedgwood had once employed Flaxman and if the results were different it was not, I think, because in the 1840s the firm had more power-driven appliances than it had at its disposal in the 1780s.

The change had I think occurred elsewhere with the creation of a new aesthetic atmosphere. This resulted from the predominance of a new class which, of course, owed its ascendancy to the machine, but I think it will be found that in painting, at least, many nineteenth-century characteristics were already to be found in the Netherlands where a rather similar society attained a pre-eminent position without the assistance of modern industrial techniques.

The co-existence of many different genres, often of a highly specialized nature, the relative indifference to mythology, the corresponding love of landscape and seascape, the interest in domestic scenes, in mild anecdotic pleasantries, in still life, in very highly finished surfaces and very minute naturalism, the emphasis on people rather than on ideas, on psychological and moral problems rather than on theoretical programmes, the great areas of flat mediocrity, the fantastic summits of individual genius—these, broadly speaking, are qualities common to the art of seventeenth-century Holland and to that of nineteenth-century Europe and I do not think that they have very much to do with industrial systems.

But the specifically nineteenth-century condition of the plastic arts, a condition which *may* be connected with the industrial system and certainly derives from the condition of society, has only a very faint connection with Dutch painting or with anything that had previously occurred in the history of art.

It was an age of aesthetic fragmentation. There was schism between groups of artists so that we find two or more completely alien aesthetic principles at work within a society and these of so violently antagonistic a nature that, as I have already pointed out, the most assured judgment of one age can be entirely reversed by its successor; i.e. a situation in which good art is good in a different way to that in which bad art is bad. Thus in the seventeenth century a bad French artist would have been an inferior Poussin, in the nineteenth century a bad French artist was *not* an inferior Cézanne. As a necessary consequence of this, there was a complete divorce between the kind of art that we value today and all those institutions which, traditionally, have been associated with the genius of an age—the church, the monarchy, the municipalities and the aristocracy.

There was a radical division between social and individual enterprise in the

[2] Quentin Bell, *The Schools of Design*, 1963, pp. 51–60 *et passim*.

arts so that the history of architecture and the applied arts is but tenuously and locally connected with that of painting.

There was an unprecedented diversity of aims between artists working in the same arts, and an extraordinary tendency amongst artists to disassociate themselves from their own environment.

I believe that all these alienations can be traced back to the nature of the society in which the artist worked. It is not my present purpose to attempt such an analysis; but I think that it may be helpful to look for a moment at the social history of the artist himself.

If we go far enough back in history we come to a time when the artist was a craftsman, bound by such restrictive practices that he neither attempted nor achieved individual pre-eminence. The Renaissance, which altered that state of affairs, could not entirely end it and the social position of the painter remains largely undefined until the nineteenth century. The Academy was to be a professional association and a school, more reputable socially, than the Guild which was a union of tradesmen. It failed because a professional association must have professional standards and the very movement which had made the Academy possible had created a situation in which the assessment of standards became impossible.

Under the Guild it seemed, and indeed it was, as easy to distinguish a substandard picture as it was to distinguish a substandard shoe, but in a world capable of producing a Michelangelo these strictly commercial criteria were not so easy to apply. The Academy assumed a more difficult and dangerous role, it became the guardian of aesthetic purity; but what is aesthetic purity when you are torn between the genius of Poussin and that of Rubens and how do you maintain your authority when faced by the rank insubordination of a Blake or a David?

The aesthetic insurgents of the late eighteenth century shook the Academies. The romantics of a later generation destroyed and transformed them. The Academy became either a target for abusive scorn, or a useful market place—a highly profitable market place—controlled by a committee of the most successful producers. It was surrounded by a jealous company of independents who—unless they were prudently admitted to the inner circle—called loudly for a policy of free trade in art. Despite the efforts of the academies the status of the artist under the old régime had been equivocal; but the fluid class relationships of the nineteenth century offered him a new start. Now he was on the same footing as anyone else, he could sink or swim. Consider two typical success stories.

Born in a middle-class family, showing an early promise in his drawings but in little else, unhappy at school and becoming an art student against the wishes of his parents, who want him to be a solicitor, he goes nevertheless to an academy of art. He scandalizes his teachers, he is expelled, his work is ridiculed. He leads a dissolute life in Paris, he meets a few like-minded rebels at the Café Guerbois or the Nouvelle Athènes. His pictures are refused by the Salon, the critics deride him, he is considered mad, subversive, obscene; he lives in debt and despair; he dies of drink and disappointment. Then, at a retrospective exhibition, a few canvases are sold, a few critics 'discover' him, the Luxembourg buys a landscape, an American buys another, within twenty years of his death he is famous; and today Greek shipping magnates offer staggering sums for crude forgeries of his art.

We are all familiar with this kind of biography; we have seen it in techni-

colour. We do not so often see that other kind of success story which is in truth more typical of the period.

It begins in much the same way, although the abilities of the young artist may be more easily recognized by his teachers. Nevertheless there is almost always a struggle, the critics and the Academy are unkind, customers are few and prices are low. The young man must pinch and save and at times he almost despairs; if it were not for his wife—he is always a happily married man—who, to quote from the official biography, 'never faltered in her unfailing devotion and sympathy', he might have taken to drink or emigrated to the colonies. Instead of which he perseveres and eventually his perseverance is rewarded. *Cavaliers taking refuge in Bilsborough Manor after the Battle of Marston Moor* is hung on the line and sold; he follows it up with *Oliver Cromwell in the Lion Tavern on the Day before Naseby*; he is elected A.R.A. He paints the Duke of Connaught; he becomes a full Academician; the critics are now fulsome; a railing and then a policeman have to be set before his masterpieces to hold back the crowds; his life is a model of respectable and virtuous opulence; he is made a baronet, perhaps even a peer; he is President of the Academy; he is buried in St. Paul's—and today his name is forgotten.

Now these two artistic types, which seem to us so different and so completely opposed, have nevertheless certain common qualities; they are both what David Riesman calls 'self-directed', they both choose their destiny in a way that would have seemed quite strange to the great majority of artists in the seventeenth or eighteenth centuries. For them there is no universally accepted style developing from a national or international tradition and extending into every department of art and architecture: they belong to an age of individualism in which the notion of personal endeavour, of originality, of genius, is widely accepted, in which new fortunes are being made every day in new ways.

Usually, the painter while he is still completing his training is looking for a line which will sell; he may attempt the highest branch of the profession (which is history painting) or the most lucrative (which is portraiture), but his business is to find his market, the line which he can encompass. His object is self-help and he helps himself by becoming perfectly attuned to a section of the public which will buy what he has to offer. In his earlier career, before he has found his *clientèle*, and while he is still, of necessity, working not for others but for himself, he may produce pictures which please *us* today; but later when he has learnt how to please *his* public there is, almost inevitably, a loss of sincerity in that his art represents a bargain between him and them. Thus, again and again, particularly in British painting of the period, we find what seems like brilliant early promise sinking into mediocrity. To the painter himself this represents success, for it means that he has found and accommodated himself to the market place that his goods require.

In exceptional cases a painter might assert himself in a different way, painting not for a market but for himself. Such independence was invariably penalized and the artist might starve as a result of it, or, in some cases, end by imposing his own views upon the public and so eventually creating a market by the very force of his personality. Thus it was with Monet and with Degas.

The aesthetic anarchy of the period, which showed itself in a multitude of different manners upon the walls of the Salon and the Royal Academy, showed itself equally in a great variety of revolutionary movements. There is, in fact,

practically no common quality between artists such as Sisley, Toulouse-Lautrec, Odilon Redon, Whistler and Cézanne, save that they claimed the right to work as they pleased, and of all the vague terms in art history none is so vague as the term Impressionist.

To put the thing in another way: the artist of previous epochs knew fairly well what was expected of him, the taste of the market was homogeneous and he worked within a recognized stylistic system. Because it was his own taste he was seldom faced by the necessity of making compromises, of choosing between his sentiments and those of his client. Moreover, this homogeneous style embodied everything from the meanest to the grandest of artefacts, from wallpapers to palaces. But from the middle of the eighteenth century onwards, style became a matter of choice. In a sense there is no *one* style at any one moment in the mid-nineteenth century, all is flux, all is variety and the artist must find his own solutions to every problem. The achievements and the disasters of the nineteenth-century painting stem, I think, from this glorious but hazardous artistic freedom.

There is therefore, nothing to which the artist *must* conform and in the same way there is a divorce between painting on the one hand and architecture and the applied arts on the other—a state of disassociation such as had never before existed in the history of art. Imagine the difficulty of trying to find a connexion between Garnier's *Opéra* and Monet's landscapes or between the portraits of Whistler and the churches of Giles Gilbert Scott. Indeed, painting could not, in the nature of things, achieve a harmonious relationship with architecture for architecture was not in a harmonious relationship to itself.

Listen to Ruskin talking to the citizens of Bradford: 'I notice that among all the new buildings which cover your once wild hills, churches and schools are mixed in due, that is to say, in large proportion, with your mills and mansions; and I notice also that the churches and schools are almost always Gothic, and the mansions and mills are never Gothic. May I ask the meaning of this? For, remember, it is a peculiarly modern phenomenon. When Gothic was invented, houses were Gothic as well as churches; and when the Italian style superseded the Gothic, churches were Italian as well as houses. . . .'[3]

But Ruskin understates his case; the mid-nineteenth century had not two styles, it had many. If he had cared to glance at the neighbouring city of Leeds he might have seen not only the late Gothic tracery of St. Peter's, completed in 1859, and the Baroque tower of Brodrick's Town Hall, finished a year earlier, but the Venetian Gothic of the Westminster Bank, the Moorish arches and minarets of Sir John Barran's warehouse, and, most astonishing of all, Bonomi's Egyptian flax warehouse with its lotus-leaved columns and its roof on which sheep once grazed.

Superficially at all events, there is no truly nineteenth-century style, not at any rate in the middle of the century, and conversely, there is a multitude of historicist styles: nineteenth-century Sheraton, nineteenth-century François I, nineteenth-century Gothic and so on. Only in the art of costume does the century arrive at forms which are distinctly and unmistakably its own.

The clothes of men during this epoch are completely unlike those of any previous century and, within a broad area of time, we can situate a picture with

3 Ruskin, *Collected Works*, ed. E. T. Cook and A. Wedderburn, 1903–12, Vol. XVIII, p. 440.

confidence on the evidence of masculine clothes. Feminine costume, even though it sometimes imitates other periods, is even more precisely identifiable as nineteenth century. It provides the one universal, international, and clearly defined style of the age. And whereas it would be absurd to talk of the age of Impressionism if we mean that in the 1870s we shall find Impressionist paintings in Dublin, Impressionist furniture in Cincinatti or Impressionist architecture in Sweden, it is not at all absurd to talk of the age of the crinoline, the bustle or the tailor-made. For these modes were in fact copied as closely as possible, each minor variation of style being faithfully imitated wherever European culture prevailed.

It should be noticed that whereas we regard these nineteenth-century fashions with a certain nostalgic favour, the artists and critics of the time did not. In fact they considered the fashions of their own age perfectly hideous.[4] Nor was it only fashions in dress which seemed to them detestable. They hated nearly all contemporary products from the button hooks to the iron bridge. The railway age was, for them, an age of abysmal ugliness. For although an industrial town built during the nineteenth century has something of the character of an architectural museum, it *has*, nevertheless, a style of its own, the style of the suspension bridge and the bottle oven, the pithead and the marshalling yard.

But whereas the railway age leaves its mark upon architecture, the painters avoid it. Their purpose was moral, and these things belong to a world in which morality has been replaced by expediency. Like the architects, the painters seek or imagine a better aesthetic *milieu* in foreign countries or distant ages.

In the 'forties they turn for inspiration to Scott and Byron, to Cervantes, *Gil Blas*, and the *Vicar of Wakefield*. A later generation finds refuge in the Arthurian legends, in classical antiquity and in the picturesque antagonisms of Cavaliers and Parliamentarians. Even in this century the walls of the Academy were still covered with dragons in search of medieval but highly edible maidens and with mild domestic dramas which recalled the costumes, but not the acerbities, of Mansfield Park.

It is astonishing how reluctant even such an accomplished observer as Frith was to look at the life of his own century, how frequently he tries to return to the world of his grandfathers. Even so uncompromising a realist as Holman Hunt finds a refuge in which he can make his observations without being obliged to look steadfastly at modern life, by retiring to the banks of the Dead Sea.

Historicism of this kind is dead. I shall try to show the beginnings of its decline in this country during the years between 1870 and 1910. At the same time we see the beginnings of a reassociation of the visual arts at all levels. The process is not complete even today, but it is manifest. The establishment in Piccadilly is not quite the same as that which may be found in the neighbourhood of Bond Street, but what we still call 'modern' art is no longer in any true sense non-conformist; the way to prosperity for a young painter may be found in either direction. Above all we have rediscovered a style which is evident in architecture, the applied arts, the performing arts and painting.

The beginnings of that style and of the reunion of the arts were already

[4] My grandmother, who as a young woman lived very much amongst artists and art lovers, was proud of the fact that she never wore a crinoline. G. F. Watts, 'On Taste in Dress', M. S. Watts, *George Frederic Watts,* Vol. 3, 1912.

The Age of Fragmentation

evident by the end of the nineteenth century, and whereas England played practically no part in the development of Impressionism, which was of course eminently a symptom of the age of fragmentation, she did play a peculiar and not unimportant role in the development of that style which makes possible the reunification of the arts. Her history in the nineteenth century is therefore of capital importance to an understanding of the origins of twentieth-century art, and it is the slow gestation of modern art which forms the connecting thread and the main purpose of the following essays.

I JAMES COLLINSON:
The Empty Purse. Tate
Gallery

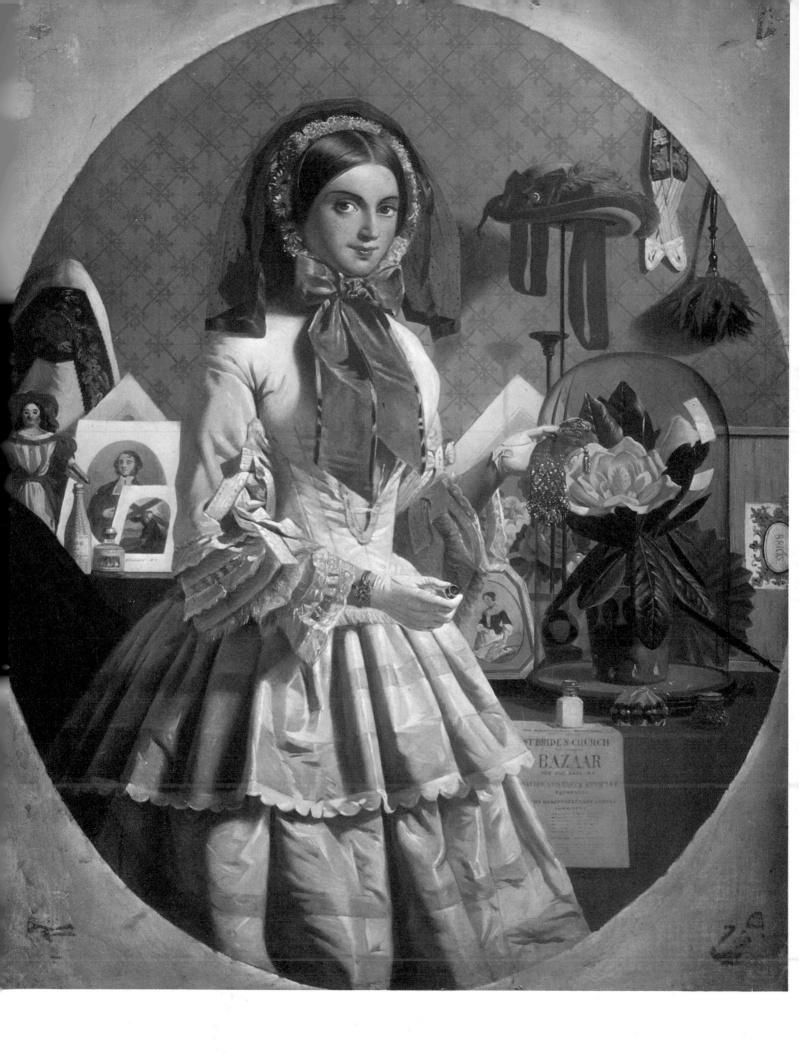

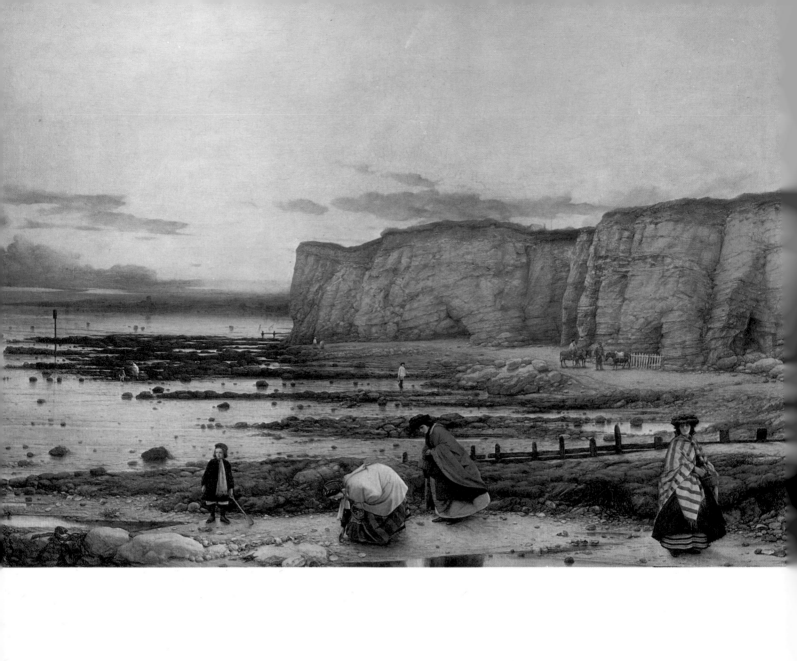

2
The Teutonic Influence

I want to begin with a description of an imaginary building. The building belongs to Eustace Lyle, the scion of an ancient cavalier and catholic family. The Lyles have pulled down their old house and built a new one. Disraeli describes it thus in *Coningsby*:

'In a valley, not far from the margin of a beautiful river, raised on a lofty and artificial terrace at the base of a range of wooded heights, was a pile of modern building in the finest style of Christian Architecture.'

Look inside and Dizzy will show you exactly what you would expect to find:

a long gallery rich in ancestral portraits, specimens of art and costume from Holbein to Lawrence . . . rich saloons . . . [and] the chapel, in which art had exhausted all its invention, and wealth offered all its resources. The walls and vaulted roofs painted entirely in encaustic by the first artists of Germany, and representing the principal events of the second Testament, the splendour of the mosaic pavement, the richness of the painted windows, the sumptuousness of the altar, crowned by a master piece of Carlo Dolce and surrounded by a silver rail, the tone of rich and solemn light that pervaded all, and blended all the various sources of beauty into one absorbing and harmonious whole; all combined to produce an effect which stilled them [the visitors] into a silence that lasted for some minutes, until the ladies breathed their feelings in an almost inarticulate murmur of reverence and admiration; while a tear stole to the eye of the enthusiastic Henry Sydney.[1]

Disraeli lays it on pretty thick, and a bit carelessly. I doubt whether Carlo Dolci was really smart in 1844, but Gothic piles, though hardly a novelty even when termed 'modern buildings in the finest style of Christian architecture'— the phrase is borrowed from Pugin—were very much *comme il faut*, while the 'first artists of Germany' is beautifully topical. German art, like German philosophy and German literature, was then admired in England in a way that it had never been admired before. The Germans are 'assuredly the great artists of Europe', declared the *Art Journal* in 1839, 'perhaps owing to that earnest attention, natural to the German mind . . . which labours so long and so diligently at an object. In art . . . the intense nationality of the German finds a refuge and a consolation'.[2]

British attention was particularly directed towards Bavaria, 'now the classic country of the Arts' according to a Select Committee's report of 1836.[3] Here Munich had found her Medici in the eccentric Ludwig I who provided her with a Loggia dei Lanzi, an Arc de Triomphe, a neo-classical Valhalla, a Pitti Palace, an Aegina Temple, all copied with patient enthusiasm from the originals.

But the more cultivated patrons looked not so much to Germany herself as to the Nazarenes, a colony of German artists settled in Rome since the beginning of the century, who set a particularly fair example of earnest endeavour and Christian piety and who were following an aesthetic course which was both novel and exciting. Sir Thomas Lawrence had I think been their first English patron, Mr. Beresford Hope of the Ecclesiological Society was another, Lord Lindsay, the author of *Sketches of the History of Christian Art* (1847), was an ardent

[1] Disraeli, *Coningsby*, 'Beaconsfield' Edition, Vol. I, p. 130.
[2] *Art Union Journal* (later *Art Journal*), 1839, p. 136.
[3] *Select Committee on Arts and Manufacturers*, 1835–36, *Report*, p. iv.

admirer and so was Pugin. From 1839 onwards there is hardly a number of the *Art Journal* that does not carry some account of the life and works of these painters. Overbeck was described as 'a truly great man whose works have elevated his country'. Cornelius had pupils scattered throughout Europe and 'we continually see, even in our own country artists even unconsciously pursuing the various phases of manner which have marked the different periods of his career'.[4]

Who then were these painters and why did they attract so much attention at a time when Ingres and Delacroix, Géricault, Corot and Daumier were so little regarded by Englishmen?

The first part of this question is now fairly easily answered for the Roman Nazarenes have been discussed with lucidity and learning by Mr. Keith Andrews in a book recently published.[5] Peter Cornelius, Joseph Führich, Friedrich Overbeck, Franz Pforr, Schnorr von Carolsfeld may therefore be names familiar to a large public. They came from Germany and from Austria at the beginning of the nineteenth century; they established themselves in the deserted monastery of S. Isidoro on the Pincian and there, living in Christian amity, attempted to revive Christian art. They condemned 'the lack of religious feeling and sense of mysticism in contemporary painting'. They adapted a programme very close to that advocated by the philosopher Schlegel:

> Stern and serious figures, sharply outlined and standing out from the canvass; no contrast or effects produced by blending chiaroscuro and murky gloom and cast shadows, but pure proportions and masses of colour in distinct intervals. Draperies and contours which appear to belong to the figures and are as simple and unsophisticated as they.[6]

The programme was in a large measure fulfilled; they did at times produce a kind of painting which really did have a pre-Raphaelite look, far more truly pre-Raphaelite in the sense of being archaistic than anything ever produced in this country. Nevertheless it would be wrong to suggest that the movement was simply antiquarian, for although it looks back to the quattrocento, and is very inclined to imitate the pretty simplicities of northern and Flemish art, it is also very much in love with Raphael himself and also with Italy. Of all the Italianizing Germans who have crossed the Alps none were ever more wholeheartedly Italianizing, more enthusiastic in their love of Italy, than these.

But the Italy that they loved was an Italy devoid of that robust and noisy carnality which is so evident in the later Venetians and of which we may detect a trace even in the most delicate essays of Botticelli and Fra Angelico. The Italy of the Nazarenes is wholly pious, antiseptically pure and not, one would have thought, wildly exciting. (Plates 1 and 2)

And yet it did excite the British public in the 1840s. That public was, for the most part, instructed through prints. It will be remembered that the Pre-Raphaelites were inspired by Lasinio's engraved copies of the frescoes in the Campo Santo and also by the work of Professor Führich. Here then I reproduce engravings made from drawings by this artist. (Plate 4)

[4] *Art Journal*, 1844, pp. 13 and 62.
[5] Keith Andrews, *The Nazarenes*, Oxford, 1964.
[6] Quoted by Keith Andrews, *op cit.*, p. 17.

Of these designs one owes something to Guido Reni, the other is more purely German, but in both there is a stern moral lesson. The dangers of progress (political progress I think) hardly need to be pointed out. Observe the reprehensible liberties that are being taken under the cloak of Emancipation; clearly these liberals, communists perhaps, libertines at all events, are being driven by the devil to destruction, and one of the devils you may notice has something on his head which looks very like a jet of steam from the funnel of a locomotive. But the action of the other picture is less easily understood. It teaches another lesson. The young man in the boat has fallen asleep, he is so fast asleep that he has not noticed the very large number of fiends of both sexes who have come on board; one of these is cutting the painter that moors his punt to the solid ground of religion, another breaks his oar, a third is, I think, daintily binding him with floral chains, a fourth is about to pluck from his bosom the sacred text with which the foolish fellow had thought he could preserve himself from harm.

If I insist upon the moral qualities of German art it is because it was precisely these which had so profound an effect upon British opinion in the 'thirties and 'forties, and it was this that made German art so refreshingly different from most French painting, and indeed, from our own.

That element in society which can vaguely, but conveniently, and I think sufficiently accurately, be labelled 'Young England' could not be satisfied with the kind of painting which was to be found in the Royal Academy in the 1830s and 1840s. It needed something with a strong religious purpose, expressed in a strong religious manner. It needed a kind of art which could satisfy not only its spiritual but its social aspirations. Pugin sees in the destruction of the fifteenth-century city and its replacement by the anarchic squalor of his own days, not only an aesthetic and a religious disaster but a social problem. He points to the destruction of charity by the engines of the class struggle. The almshouse is replaced by the workhouse, the guild by the 'Socialist Hall of Science'. A spectre is haunting Europe, the spectre of Communism.

The serious and wholehearted gothic of Pugin and the Ecclesiological Society seemed to offer a kind of cure for the evils of the times. It proclaimed a belief in the pure uncontaminated faith, the benevolent autocracy of a more beautiful, more Christian and I suppose largely imaginary medieval society. It was, as Disraeli and Pugin put it, 'Christian Architecture'.

But where was the Christian Painting that would be its natural complement?

What Young England needed was a style of painting that would be at once heroic, chaste, and devout. In the year 1837 it was hard to see what British painter could meet these requirements. The neo-classical artists had certainly devoted themselves to heroism and they were still represented by Benjamin Robert Haydon, but Haydon had outlived his talent and his popularity; his most notable pupil, Sir Charles Eastlake, was a solid and honourable rather than an inspiring figure and both were nearer to paganism than to Christianity. The leading British exponent of the academic theme was William Etty and although his paintings might inspire enthusiasm of a kind it was an enthusiasm which had little to do with religion. The lesser men of his school, the confectioners of 'fancy portraits', of nymphs and *banditti*, of well-formed, prettily dressed *contadine*, gracefully posed against alps, vines and ruins, were totally lacking in moral purpose.

There was greater hope of redemption amongst the genre painters, the followers of Wilkie, who had himself turned from Netherlandish anecdotes to more elevated themes and died on his way back from the Holy Land. Richard Redgrave was painting domestic scenes which embodied valuable moral lessons; from them the public might learn that wives should be faithful, parents kind, that even governesses have feelings of their own. But Wilkie and Redgrave were not typical of their kind. Mulready was a man of high ability as a painter but not as a preacher, his schoolboys are comic rather than pathetic; Frith, Horsley, Webster and the great majority of their brethren were frankly anecdotic, they painted to amuse and to please, not to move or to instruct.

Young England could hardly expect that the great school of English portrait painting, now coming to an end—not altogether disgracefully—with Sir Francis Grant, could supply what it lacked. Landseer might perhaps have done so; certainly he was heroic and, in a sense, chaste; but piety can hardly flourish in the gun room or the stables. (Plates 3, 5, 7)

It was not until 1843 that England learnt that she had been entertaining an angel unawares at 47 Queen Anne Street, and that the still, small voice of God was to be heard amidst the raging cataracts of the St. Gothard or the tempests of the German Ocean. But Turner was already an old man and Ruskin could not claim that he had any worthy successor. Moreover, by then Pugin had already found the saviour of modern art in

> the great Overbeck, that prince of Christian painters [who] has raised up a school of mystical and religious artists who are fast putting to utter shame the natural and sensual school of art in which the modern followers of paganism have so long degraded the representation of sacred personages and events. . . .'[7]

Naturally enough this new and regenerative movement in art found imitators in this country. There was much to favour the establishment of an English Nazarene school. And yet it can hardly be said that such a thing ever fully came into existence. The Teutonic influence is there and it makes itself felt in the painting of the 'forties and in the book illustrations of the 1850s and 'sixties, but it never really flourishes and although there is talk of German influence it is not always easy to discern.

The example of the Nazarenes was not easy to follow. There was a good and important reason for this. The Gothic revival in architecture starts as a decorative fashion, a superficial adornment which can be applied to a building, the essential plan and structure of which is completely adapted to the habits of a later age. Even when, with a more thorough-going acceptance of Gothic ideas, the plan of the building is, as far as possible, based upon ancient examples, the building itself, although it may be rendered somewhat inconvenient, will still be reasonably efficient—it will stand and it can be used or lived in. For the nineteenth-century architect the question of style was therefore largely a matter of fashion, his building might be clad with Palladian formality or he might dress it in pointed arches and flying buttresses but, so long as the structure could function, so long as it was, in a utilitarian sense, efficient, no one would doubt his competence.

But in painting there was no question of functional efficiency; the efficiency

[7] Keith Andrews, *op cit.*, p. 78.

of the painter was of another kind; his first, though by no means his only duty was to capture an image of the visible world—to make things like—that is to say to render optical truth in the manner which had been customary in Europe since the High Renaissance.

Judged from this standpoint, the painters of the era before Raphael, unlike the architects, were inefficient. Howsoever great their moral and religious excellence there was no denying their 'incompetence'.

> We must not [says an apologist for the Quattrocento] look for artistic perfection in the productions of Fra Angelico. The limbs are defective in most of his pictures . . . they resemble pieces of wood stuck to the body. But cold were the critic who could dwell on these defects.[8]

The danger of returning to an ancient style of painting lay therefore in the possibility that the artist who sought to emulate the piety of his forebears would succeed only in imitating their awkwardness. Hostile critics were not slow to make the point. Haydon writing in 1842 declared that the Nazarenes exhibited:

> Albert Dürer's hardness, Spranger's exaggeration, Cimabue's Gothicism, and the gilt ground inanity of the Middle Age. All the vast comprehensiveness of Velasquez, Rubens and Titian are to be set aside and we are not to go on where they left off, but to begin where their predecessors began 300 years before.[9]

That this view was fairly common would appear from Plate 6, which is taken from *Punch* (1846). The caricatures, entitled 'The German School of Drawing' stand above a legend which seems worth transcribing.

> The alarming spread of the German School in Art has created considerable astonishment; but the phenomenon has at length been accounted for, by it having been discovered that the Committee of the Art Union[10] cannot understand, and will not patronize any other class of drawing. Every competitor for the Art Union Prizes is consequently driven, in self-defence, to adopt the serpent-like hair for the countenance, inflamed gooseberries for the eyes and tufts of tow for the moustaches, which are the principal features of the German School of drawing.
>
> We have furnished three striking specimens of this extraordinary class of composition:
> No. 1. Is supposed to represent that state of pathos into which a lawyer's clerk is liable to fall after office hours, when giving himself up to BULWER and melancholy, by reading a novel of that author, and fancying himself the hero thereof.
> No. 2. Is a victim to strong emotions, and to that excessive length of hair which implies an inability to pay the perruquier's small demand.
> No. 3. Is a warrior with that peculiar turn of the head which is not exactly to

8 *Art Union Journal*, 1839, p. 168.
9 Haydon, *The Diary of Robert Benjamin Haydon*, ed. Willard B. Pope, Harvard, 1960. Vol. V, p. 79. See also: *Correspondance and Table Talk of Benjamin Robert Haydon, with a Memoir by his Son*, 1876, Vol. II, p. 408.
10 The Art Union was a body founded in 1837 which distributed works of art by means of a lottery.

be found in nature, but could no doubt be accomplished if Nature had only thought of supplying the human neck with a sort of double swivel, allowing the head to be turned completely round, so that the warrior's nose would be where his occiput ought to be.[11]

Here then is the problem as the early Victorians saw it: the painters of the age before Raphael were superior, morally, to the modern; but the moderns were technically superior to them. To imitate inferior techniques was clearly absurd. And here is Pugin's answer:

. . . no reasonable man would think of altering the proportions of the human frame so beautifully and wisely ordained by the Creator; but it is by the disposition and draping of the figure that the Christian artist obtains his effect. The sublime repose of the ancient statues, and the majestic simplicity of the folds of their drapery are the true characteristics of the old sculptors, and not any affected quaintness of outline. By draping a lay figure of natural proportions in stuff and vestments which were in use during the middle ages, the identical forms and folds are produced in reality which we see represented in greater or less degree of perfection in the ancient works. *The finest productions of Christian Art are the closest approximations to nature, and when they failed in proportion and anatomy, it was not a defect of principle but of execution.*[12]

There is something rather touching and rather splendid in the simplicity of Pugin's argument. Here, at least, he shares the optimism of his century. To him and his contemporaries it did not seem an absurd idea that an artist might adopt the properties, the poses, the programme of Medieval art and then repeat its performances—but ever so much better—armed as he would be with all the improved techniques of later centuries. Such a man might combine the innocence of Cimabue with the wisdom of Michelangelo and achieve unimaginable masterpieces. It was an infinitely seductive idea; one of the great formative ideas of nineteenth-century painting.

It is interesting, and perhaps significant, that both the English and the German schools of Pre-Raphaelism were anxious to refute the charge of wilful archaism and each accuses the other of this failing. Holman Hunt declares that the Brotherhood did not share Ford Madox Brown's admiration for 'the new school of Overbeck and others, who set themselves to imitate all the childlike immaturities and limitations of the German and Italian Quattrocentists'.[13]

On the other hand Beavington Atkinson, an apologist of the Nazarenes, considered that, whereas the Pre-Raphaelites 'dealt with the life model crudely and inartistically . . . Overbeck and his adherents declared they sought nothing else than the truth.'[14]

In fact neither party entirely avoids a certain imitation of fifteenth century

[11] *Punch*, 1846, Vol. X, p. 145.

[12] Augustus Welby Pugin in *The Builder*, 2 August, 1845.

[13] Holman Hunt, *Pre-Raphaelitism and the Pre-Raphaelite Brotherhood*, 1905, 1906, Vol. I, p. 120; see also pp. 226 and 440. In the work of the Nazarenes technical and moral problems could nearly be equated. Ford Madox Brown noticed that, in the cartoons of Overbeck 'where any naked flesh was shown it looked exactly like wooden dolls or lay figures. I heard him explain that he never drew those parts from nature, on the principle of avoiding the sensuous in art.' Ford Madox Hueffer, *Ford Madox Brown*, 1905, p. 44.

[14] Beavington Atkinson, *Overbeck*, 1882, p. 37.

manner; Frans Pforr in his *Sulamith und Maria* (Plate 1) comes very near to a pastiche of the Quattrocento while the Pre-Raphaelites cultivate a certain wooden angularity of form which surely derives from ancient models.

But it is equally true that both the Pre-Raphaelites and the Nazarenes were shy of carrying the matter to its logical end. A belief in the need to respect that kind of optical truth which had been explored by the masters of the High Renaissance acted as an effective brake and prevented nineteenth-century painting from following the same path as nineteenth-century architecture.

Daniel Maclise came near enough to the Teutonic style to make Haydon shudder at his 'pernicious popularity' and to declare that he was the 'sort of genius that the Academy should have controlled.'[15] In retrospect he does not look very uncontrollable; he does indeed rejoice in hard, sharp, bright details, his forms are bold and precise, but he seems a very long way from the brethren of the Pincio. John Rogers Herbert came nearer to the real thing; unfortunately he imitates the faults rather than the virtues of the Germans, catching their empty, insipid cheerless piety with some exactitude (Plate 8). But undoubtedly the most purely Nazarene and most gifted of the painters who felt this influence was William Dyce.

He came near to being a great painter but his genius was marred by a certain irresolution; one has the impression of a great talent dispersed in so many rivulets that it could never carve out for itself a deep and effective style. He visited Rome twice and on the second occasion he saw a great deal of the Nazarenes, who obviously had the highest opinion of him. He, for his part, was deeply affected by them although this did not prevent him, when he returned to Scotland, from painting portraits in the manner of Raeburn. But his visit to Rome had not been a purely aesthetic one. He went also, as far as I can find out, with a religious purpose. In this journey, however, he found it better to travel hopefully than to arrive. He became a very high Anglican, a friend and collaborator in artistic—as also in musical—matters with men such as Beresford Hope and Gladstone. He decorated the walls of All Saints, Margaret Street, and became in fact a kind of Puseyite Pugin, the chief advisor in things artistic to the ecclesiologists and Young Oxford.

Dyce's great triumph and the beginning of his success as a painter was a very Nazarene picture, *Joash shooting the arrow of deliverance* (Plate 10), which was exhibited in 1844 at the Academy. Nevertheless, according to Dyce himself this and other works produced at this time were by no means well received; the arrival of a cultivated German prince in London must have been very welcome. Albert purchased what has always seemed to me the best of Dyce's Nazarene pictures—*The Madonna and Child* (Plate 9)—a work which combines the clarity, serenity and probity of Cornelius with a grace, sensibility and authority of drawing which I do not often find in the work of the German Nazarenes. Albert also commissioned an ambitious, perhaps too ambitious work, *Neptune giving the Empire of the Sea to Britannia* which probably seemed the more important acquisition in that it was executed in fresco at Osborne.

There was something particularly praiseworthy and pious about fresco, it was so very Quattrocentrist. It was a craft which the Brethren at S. Isidoro had

[15] *Correspondance and Table Talk of Benjamin Robert Haydon with a Memoir by his Son* (Frederick Wordsworth Haydon), 1876, Vol. II, p. 408.

rescued from those few surviving Italian workmen who still held the secret of
the business as transmitted from the earliest ages of Christian art. They had used
the knowledge in two of their most important undertakings, the decorations of
the Casa Bartholdy and of the Casino Massimo. Fresco took one away naturally,
almost it seemed inevitably, from the spurious sophistications of modern art,
from the *sfumato* and *sprezzatura*, the scumblings and glazings, of post-renaissance
impiety.

In 1834 the Houses of Parliament had been destroyed by fire. A great many
people were delighted and none more so than Benjamin Robert Haydon, who
for many years had been urging the government to find some place in which to
give British artists a chance to produce large historical paintings. 1832 had seen
the return to power of the Whigs and with them of the philosophic radicals, who
were inclined to believe that a nation could be made artistically great by an Act
of Parliament. Provide the appropriate demand—the great bare walls of the new
Parliament House, and the challenging opportunity for an exercise of pictorial
idealism in the service of national glory—and the supply would follow naturally.
It was altogether in the spirit of liberalism that a Select Committee of the House
of Commons was appointed in 1841 'to take into consideration the promotion
of the Fine Arts of this country in connexion with the rebuilding of Parliament',
and later that the selection of artists was entrusted to a commission which pro-
ceeded by way of open competition.

But from the beginning the whole matter had come into the hands of the
Prince Consort who strongly favoured Germanic ideas. It was decided that the
decorations should be executed in fresco and it appears that the Prince, carrying
the notions of free trade rather farther than most of his wife's subjects would
have wished to see them taken, was prepared to offer the commission to Herr
Cornelius who, however, replied with characteristic good nature: 'What need
have you of Cornelius to come over and paint your walls when you have got
Mr. Dyce?'[16]

The story may not be true, but it certainly is true that Dyce won the first of
the competitions and was the first artist selected actually to paint a fresco, *The
Baptism of Ethelbert*.

The victory of Dyce and of the new style was accompanied by the defeat of
Haydon and the old. Haydon, who had agitated for so long in favour of this
enterprise that he had come to think of it as his own, was rejected without
qualification. A contemporary writer tells how he saw a man in an eating house
with his head buried in his hands, and then perceived that it was Haydon—
Haydon who was usually so ebullient and so self-confident; the tears were
slowly trickling down his cheeks, he had that day learnt of his failure.[17] For him
indeed, it was not a defeat but a disaster; he was at an age when discouragement
hurts most deeply and he had involved himself in debts which he could not now
repay.

His life had been one of continual hardship. He had known dazzling success;
his genius had been acclaimed by Wordsworth, Keats, Leigh Hunt, and he him-
self had believed in it. Now he made one last effort. He exhibited his *Banishment
of Aristides* and London flocked to see—not his picture but the celebrated

[16] Holman Hunt, *op cit*, Vol. I, p. 50; Ford Madox Hueffer, *op cit*, p. 36.
[17] Eric George, *The Life and Death of Benjamin Robert Haydon*, Oxford, 1948, p. 267.

American dwarf, General Tom Thumb, who was being exhibited next door. The mortification was too great. The unhappy man tried to blow out his brains, failed, and cut his throat with a razor.

The death of Haydon marked the death of academic art in England. As a theorist Haydon is the natural successor of Reynolds and brings to the *Discourses* emendations which are in some respect subtler than those of his teacher. As a painter his best work was done in a genre that he despised, his great historical machines gain steadily in absurdity and incompetence, but it was not so much his faults that destroyed him as the evolution of public taste which first had established Wilkie, his friend and rival, as a successful competitor in what Haydon felt to be a low genre, and then brought forward this new and troubling phenomenon—the German School. It is odd that the young Pre-Raphaelites, who had so little in common with him, should have placed him amongst the list of the immortals, along with Homer, Byron and Cavalier Pugliesi. Perhaps they sympathized with the rebel, the man against authority, rather than with the painter.

The celebrated Westminster cartoon competition was the death of Haydon. But it was not altogether a fortunate transaction for Dyce. The Parliamentary Committee moved slowly; he was impatient, and there were difficulties about money. The architects, as is sometimes the case with architects, planned their building without regard to the painters. There were far worse difficulties also, connected with the technique of fresco. The medium was unfamiliar, it was impossible to correct and, when things went wrong, the plaster had to be cut away and a fresh layer relayed. All the painters suffered, two of the plasterers went mad. Careful investigations had been made into the chemistry of an art which had not been practised in England for centuries. But perhaps the enquiries were not careful enough, perhaps the effects of London fog and the exhalations from the Thames had been underestimated. Within a few years the frescoed pictures darkened, sweated, bubbled, blackened and decayed.[18]

Despite all miseries, Dyce and the other artists worked on. Dyce completed *The Baptism of Ethelbert*. When he embarked upon his second great commission, the decoration of the Queen's robing room, he proposed to take as his assistant young Mr. Holman Hunt.

> I expressed [said Holman Hunt] my sense of the joy it must be to him to have the opportunity of exercising his powers on the State building where he was employed, and on so large a scale. I shall ever remember the sadness with which he said: 'but I begin with my hair already grey'.[19]

Herbert, Maclise, Cope, all experienced similar difficulties. When the Prince Consort died in 1861 the whole scheme ground to a standstill; it had lost its original impetus and far from encouraging history painting, as Haydon and the other promoters had originally intended, it was felt to be an impediment to its development.

The works of Herbert, Maclise, Ward, Dyce [said a contemporary critic in

[18] See T. S. R. Boase, 'The Decorations of the New Palace of Westminster 1841–1883' in *Journal of the Warburg Institute*, Vol. 17, 1954, p. 319. I have also used: *The Frescoes in the Houses of Parliament, 1841–1863*, a dissertation submitted by Miss Jennifer Haigh (Mrs. Alistair Stead) for the degree of M.A. in the University of Leeds, 1962.
[19] Holman Hunt, *op cit.*, Vol. I, p. 229.

1859] remain unseen. . . . We are told to search the Houses of Parliament. We do, and find their essays hidden in Lobbies, Chambers and Corridors— sacrificed to the inexorable architecture and uncompromising stained glass. . . .[20]

For many years Dyce laboured to complete the Queen's robing room. Then one day in 1864 he collapsed at his work and was taken home to die.

It is tempting to round off that sentence by saying that the Nazarene movement in England died with him, but it would not be accurate. For Dyce was no longer a Nazarene; at least ten years before his death he had become a Pre-Raphaelite.

Dyce provided the aesthetic climate from which Pre-Raphaelism sprang. Already, and for a long time, there had been a spirit of insurrection in the Academy Schools in which Dyce was a teacher and his influence cannot but have had a profound effect upon the young Holman Hunt. With Ford Madox Brown, who had made the pilgrimage to Rome and undoubtedly exercised a considerable influence on the young Pre-Raphaelites, the ideas of Germany were conveyed to artists who were entirely to transform them. Dyce did everything he could to assist the young men and it was he who enlisted Ruskin and made him write his celebrated letters to *The Times*. With the development of the school, Dyce himself developed. His style becomes less archaic and more scientific and three of his finest works, *George Herbert at Bemerton, Titian's First Essay in Colour*, and his best known picture, *Pegwell Bay*, date from this late period (Plate 11, Colour Plate II).

I do not think that I can do better in concluding this chapter than by quoting the comments of MacColl, a late nineteenth-century critic, on *Pegwell Bay*. They form the best kind of epitaph for Dyce.

> One thinks of him as dwelling on the shores of chalk that he has painted in a desperate pallid gleam of imagination . . . The blue waves, and the goddess-bearing dolphins do not come: only nicely dressed ladies pick their insect steps across the seaweed, and the portent of a comet hangs above this truest of Dyce's histories. It is as if a man had come to the ugly end of the world, and felt bound to tell.[21]

[20] *Art Journal*, 1856, p. 73.
[21] D. S. MacColl, *Nineteenth Century Art*, Glasgow, 1902, p. 115.

3
Hard-edge
Pre-Raphaelism

Slosh or Splosh. I want to define the term; for if I can I think I may be able to come near to determining the aims of the Pre-Raphaelite Brotherhood. *The Shorter Oxford English Dictionary* gives

> SLOSH, sb. 1814. **1.** Slush, sludge. **2.** Watery, weak, or unappetizing drink 1819. Hence **Sloshy** *a.* slushy. Also SLOSH *v.* 1844. **1.** To splash about in mud or wet. [This is more like the meaning I want.] **2.** U.S. To move aimlessly; to loaf about 1854. **3.** To make a splashing sound 1888.

But the dictionary says nothing about the Pre-Raphaelites. And yet Slosh or Splosh was a part of Pre-Raphaelite slang like the word 'stunner' and it was used as a term of condemnation.

Slosh, as far as I can gather, was *malerisch* gone mouldy; it was a method of painting and also, I think, a state of mind. Slosh was liberty degenerating into licence, the bravura that serves to conceal feebleness—Raeburn and Etty at their most meretricious. More specifically it was the method of painters like W. E. Frost, painters who worked with a big thick brush loaded with bitumen, bitumen which would glow with a splendid dark warmth when new, 'like the tone of an old brown violin', but which would, presently, darken and crack.[1] Slosh was the brilliant splash dashed into the dark wet ground to simulate the light in an eye or the sparkle of a wave. Splosh was the attitude of the painter who displays well-formed nudes in a wholly artificial light before a wholly contrived penumbra. It is all manner and no matter, all parade and no feeling, all skill and no direction. It was a term of abuse that could, rightly, be applied to the work of a great many careless and flashy painters, but it could also be used to denigrate the free and vivacious handling of some very great artists. It is said that the first president of the Royal Academy was sometimes referred to by young Pre-Raphaelites as 'Sir Sploshua'.[2]

The Nazarenes and their British followers were of course innocent of splosh; they may even be described as 'anti-sloshy'. But the reaction against what was felt to be a meretricious and an uncraftsmanlike manner extended beyond the Teutonic school; we find it in J. F. Lewis's minutely painted, brightly coloured studies of Islamic life and, to a lesser extent, in the work of Richard Redgrave.

Redgrave points out that already, in his youth, there was a feeling of unrest, a dissatisfaction with academic 'rule-mongering' in the Academy Schools. We may fairly suppose that this had not vanished by the mid-1840s, when the Pre-Raphaelites were students.

Amongst these young men the most brilliant was certainly John Everett Millais. He was an infant prodigy, who at the age of seven could produce completely perceptual drawings. He seemed able to do pretty nearly anything for which he had a mind. What he did do, at the age of sixteen, was to produce a completely and splendidly academic picture, *Pizarro Seizing the Inca of Peru* (Plate 12), which is in fact more than a little sloshy. For my part I can well imagine that he would have spent the rest of his life producing equally unexceptionable works, more accomplished but hardly less banal, if he had never met Holman Hunt.

Holman Hunt was a formidable character, no doubt he was a formidable student—a self-directed man if ever there was one. Unlike Millais, to whom

[1] *See* Plate 13 also Plate 7, which is an even better example of slosh.
[2] F. E. Benson, *As we Were*, 1930, p. 270.

painting came easily, he lacked facility; working against parental opposition he worked also against the opposition of the examiners of the Academy who twice rejected him as a student. But he overcame all obstacles. Painfully, meticulously, perhaps one should say conscientiously, for there is no element of timidity in his work, he forced his pencil to describe that which he was determined to express. His aims were at once simple and outrageous. He wanted to be wholly moral and entirely true to life. He wanted to get down on canvas everything that he could see, or rather, everything that he could after minute observation discover in nature.

A part of his trouble was that he saw altogether too much. Standing on the hills above Jerusalem he could perceive the satellites of Jupiter without using a telescope.[3] No man ever had a more starkly naked eye than he, and this eye, this implacable visual conscience, had to be assuaged. Somehow, by Heaven knows what stubborn diligence, the thing was done. The facts were all stated and the result is, in its way, magnificent.

But Holman Hunt did not think of himself as a realist, nor was he. His intensely earnest morality filled him with the belief that facts are sacred, but it was not content with facts alone. This, I think, was his undoing.

If we look only at his detail, or at those few paintings in which the picture carried no moral lesson, it is possible, despite the facts that he paints without grace, without affection and with nothing that can be termed 'breadth', to respond to the impeccable honesty of his method. But, when he attempts higher flights the powerful descriptive engine that he forged explodes in his hand.

Look, for instance, at *The Triumph of the Innocents*. (Plate 19) In itself it must have been hard for a Victorian to face that cheerless passage in the New Testament with all its horrid implications. Holman Hunt's determination to reconcile us to the gruesome theme by using all his powers of sentimental invention does nothing to mitigate its horror. He does not show us Herod's soldiers carrying out their orders and yet his presentation of the story is far more dismal than that of painters such as Raphael and Poussin who seem to spare us nothing. The Holy Family flees, leaving behind it scenes which, to us alas, are of imaginable horror. Everything is faithfully, historically described; we are shown the actual landscape, the historically accurate harness on the right kind of ass. All this is tolerable; but when the painter, relying upon his imagination, represents the ghosts of the freshly butchered infants, each enclosed in a shiny new plastic space-bubble, he creates a work which is disgusting and inept precisely because he is so completely devoid of imagination.

This is not a religious painting but a would-be religious painting; the century abounds in work of this kind in which emotion is falsified by doubt, but here the very sincerity of Holman Hunt's desire to believe and the ruthlessness with which he does in fact observe, makes the failure more painful and more obvious.

It is legitimate to discuss Holman Hunt's mature work when we are considering his nonage, for his style is so extraordinarily consistent. He it was who really gave the Brotherhood its character, it was he who first enlisted the young Millais and washed his brain clean of all the teachings of the academic school and it was he who, for a short time, brought the wayward genius of Rossetti into a triumvirate which, in 1848, started the Brotherhood.

[3] Phythian, *Fifty Years of Modern Painting*, 1908, p. 22.

That Rossetti could be brought into harmony with the other two is, I think, only explicable if we realize that he was at this stage a very immature artist, a very lazy student who had been too impatient of tuition to gather much in the way of technique in the Academy Schools, and was sufficiently intelligent to know that he still had a great deal to learn. He asked Millais and Hunt to help him with some of his first pictures and went to Ford Madox Brown for lessons in the use of colour. On no other terms, under no other conditions could Rossetti have been anything but the leader of the movement; the moment that he began to feel strong enough to stand on his own legs he went his own way and the Brotherhood fell to pieces, for he was far more intelligent, far more sensitive and imaginative, in every way far more of an artist than either Millais or Holman Hunt.

It was then—as I see it—from an accidental and purely temporary situation that the Brotherhood resulted. Holman Hunt was the central figure, a Holman Hunt who was pretty certain of his own direction and could hold Millais as a disciple until that direction began to lead into perilous situations, and who could also very tenuously and very briefly make Rossetti his ally.

Of the other members of the Brotherhood little need be said. Woolner was a sculptor, whose brief association with the Brethren seems to have had but little effect upon his work. William Michael Rossetti was a civil servant, who became the editor and memorialist of his more remarkable brother and sister. There were two other young painters, James Collinson and F. G. Stephens. Collinson, a painter with a sweeter eye for colour than most of his brethren, was influenced by their techniques rather than by their aspirations; he dithered with slow lymphatic hesitation between Christina Rossetti and the Church of Rome and finally drifted out of the Brotherhood. F. G. Stephens soon turned from a rather wooden style of painting to art criticism (Plate 25, Colour Plate I).

William Rossetti, Woolner and Collinson were enlisted by Rossetti; he would, very likely, have brought in Ford Madox Brown as well, if Holman Hunt and Brown himself had not felt that an older man, and one so closely connected with the Nazarenes, would have been out of place.

Holman Hunt clearly found Dante Gabriel Rossetti trying and unpredictable from the start.

Rossetti, in fact, was not very serious about the business, for him it was all rather a lark and certainly he did not intend to pursue any formulated doctrine. The articles of belief ascribed to them[4] were vague enough and wide enough to have been accepted by any independent-minded young painter in England or in France. Millais was never a man for theory, his aims at this period have been well described as a desire to 'paint a lot of good pictures which would bring him fame and wealth'.[5] Holman Hunt was the only one who was in deadly earnest and

[4] Percy Bate records the following programme, which has the breadth and vagueness of a political platform:

a. To have genuine ideas to express.
b. To study nature attentively, so as to know how to express them.
c. To sympathize with what is direct and serious and heartfelt in previous art, to the exclusion of what is conventional and self parading, and learned by rote; and
d. most indispensable of all, to produce good pictures and statues.
Percy H. Bate, *The English Pre-Raphaelite Painters; their Associates and Successors,* 1899, p.8.
[5] Francis Bickley, *The Pre-Raphaelite Comedy,* 1932, p. 50.

this for the very good reason that, in a sense, he *was* the Brotherhood, he gave it its hard-edge style which Millais was for a time to magnify into something superb and which Rossetti played with briefly, which Stephens and Collinson all echoed in their work and which for a few years set the style of serious painting in England.

This hard-edge style is more easy to understand if we consider it as a way of painting rather than as an ill-formulated idea in the mind of Holman Hunt. It may be defined as 'anti-slosh'.

During the years when the Brotherhood was in existence, that is to say from about 1848 to about 1854, the Pre-Raphaelites were against slosh. They were all of them painting anti-slosh pictures and, in so far as we can speak of a Pre-Raphaelite style, that is it. Slosh was a moral and a technical problem and the cure for slosh was also both moral and technical; the Nazarenes found it in fresco, the Pre-Raphaelites in a technique, invented it would appear by Millais and Holman Hunt.

Here, at the risk of being tedious, I reproduce Holman Hunt's recipe for painting a Pre-Raphaelite picture.

> The process may be described thus. Select a prepared ground, originally for its brightness, and renovate it, if necessary, with fresh white when first it comes into the studio, white to be mixed with a very little amber or copal varnish. Let this last coat become of a thoroughly stone-like hardness. Upon this surface complete with exactness the outline of the part in hand. On the morning for the painting, with fresh white (from which all superfluous oil has been extracted by means of absorbent paper, and to which again a small drop of varnish has been added) spread a further coat very evenly with a palette knife over the part for the day's work, of such consistency that the drawing should faintly show through. In some cases the thickened white may be applied to the forms needing brilliancy with a brush, by the aid of rectified spirits. Over this wet ground, the colour (transparent and semi-transparent) should be laid with light sable brushes, and the touches must be made so tenderly that the ground below should not be worked up, yet so far enticed to blend with the superimposed tints as to correct the qualities of thinness and staininess, which over a dry ground transparent colours used would inevitably exhibit. Painting of this kind cannot be retouched except with an entire loss of luminosity.[6]

And Holman Hunt adds: 'Millais proposed that we should keep this as a precious secret to ourselves'. Needless to say they had to tell Rossetti and he, of course, told everyone else. But it was Millais, who it would seem, informed Ford Madox Brown, for Brown notes that the picture *Christ Washing Peter's Feet* was 'painted in four months, the flesh painted on *wet white* as Millais's lying instigation; Roberson's medium, which I think dangerous like Millais's advice.'[7]

Anyone who has attempted to follow Holman Hunt's instructions will understand Ford Madox Brown's exasperation. The business of working clearly and delicately into a soft pigment that can, by a slight variation of pressure, become hopelessly clouded is one of extreme difficulty. This is but the first of many

[6] Holman Hunt, *op cit.*, Vol. I, p. 276.
[7] Ford Madox Brown, *Journal*, 16 August, 1854; in *Pre-Raphaelite Diaries and Letters*, ed. W. M. Rossetti, 1900, p. 110.

trials. A careful examination, in a raking light, of the surface of a Holman Hunt (see Plates 16 and 17) will show that the picture is composed of a number of compartments, the boundaries of which are made by the drawing. The surface is, to use the language of another craft, *cloisonné*.

These compartments are a necessary consequence of the method that Holman Hunt describes, each represents the work of one day, or perhaps one should say one session, for wet white from which the oil has been expressed will not dry quickly. To make each area harmonize with its neighbours the artist must know exactly what he is going to do at each stage.

Now in making a large decorative work in which the design carries the weight of the picture and in which the artist is not looking for minute detail or effects of depth dependant upon slight variations of tonality—that is to say if you are an Italian painting a fresco—then, given an accurate cartoon and much practice, you may unroll your picture on the wall day after day, complete in every detail from beginning to end. But if you are painting a picture such as Holman Hunt's *Early Britons Sheltering a Missionary* (Plate 16), which abounds in minute detail and reflected lights, and depends for its effect upon sharp tonal differences between one area and another and on aerial perspective, then, however careful your final cartoon may have been, you will find that in order to bring one passage into agreement with another you must continually correct. This is something that most painters find in the everyday practice of their art and in oil colour one can usually rectify a statement by a modification of colour, tone or outline. It is in fact this business of adjustment that constitutes the major part of painting for many of us. But the Pre-Raphaelites could not adjust, to correct on the wet paint was extremely difficult, to correct on the dry paint would be to defeat the entire purpose of the exercise. In consequence it must have been necessary to erase the work of days, weeks or perhaps months, re-draw, recover and re-paint *ab initio*, and this might have to be done many times.

It is not surprising that, in the time of the Brotherhood, Millais, a facile and prodigiously skilful worker, was producing but two not very large pictures a year for the Academy exhibition, while Holman Hunt barely finished one. It is still less astonishing that Rossetti, much less experienced technically and much less stubborn in character, soon became impatient with the business and abandoned it altogether.

Hunt, I think, never abandoned the method; it was, I believe, used by some of the followers of the movement but not, I imagine, for very long. Millais gave it up in 1855[8] and I think it no accident that his best work ends with his abandonment of this technique.

It was a method of great technical virtue. Few nineteenth-century pictures have survived so well as those of the Pre-Raphaelites, few are so luminous or so clear. It lent itself to the most sincere and abiding passion of the Brethren, the pursuit of truth in detail. But it also magnified the corresponding weakness of the school—the inability to handle a large design. If one looks at Holman Hunt's picture of *The Finding of our Saviour in the Temple* (Plate 20) one finds many places where he has entered into parentheses which have nothing to do with his main text. The colour gets out of hand, recession becomes anarchic, one is left in the end with a series of detailed essays which fail to cohere. How could they?

[8] J. G. Millais, *The Life and Letters of Sir John Everett Millais*, 1899, Vol. I, p. 231.

Several of his pictures were sent in wet to the Academy. You cannot erase and repaint forever.

It is an almost impossibly difficult manner of painting but it was certainly a discipline, and on the whole a very healthy influence on several young painters, and something, I think, without which Millais, Brown and Rossetti become soft, indecisive and overblown.

I have said a good deal, and yet must say a little more about the technique of the Brotherhood. They held a theory of colour which, though imprecise, was important. Again it was a reaction from the academic practice of the 'forties. They rejected the so-called 'brown tree' formula, that is to say the harmonization of the painting through a unified colour system, which usually meant the adoption of a general pervasive golden tone.[9] They favoured strong, pure local colour, and they enjoyed sharply acid hues which seem to presage the aniline dyes of later years. Holman Hunt's method was well calculated to serve this purpose. The white background shines out through the thin overpaint to give the effect of a jewel or a stained glass window. Put a work of this kind between two pictures by Eastlake and, as has been said, it looks like an aperture in the wall, through which the sun streams in. In other words, they killed their neighbours in the Academy Exhibition. Is it surprising that they were unpopular?

Perhaps it is fruitless to ask why. Any sincere artistic expression in the nineteenth century was bound to offend a great many people. But I would like to point to one attack which presents a side of Pre-Raphaelism which I think has not been sufficiently considered. In the *Art Journal* for September 1850, Ralph Wornum, at that time a considerable figure in the art world, wrote an article entitled 'Modern Moves in Art: Christian Architecture: Young England'. Mr. Wornum begins by considering Gothic as a peculiarly Christian style of art and points out that the Byzantine and Romanesque forms had a better claim to this distinction. He then considers the revival of Gothic painting: 'The recurrence to an old and imperfect style . . . sometimes styled . . . "The Young England" and sometimes the Pre-Raphael School.' He finds its origins in Germany.

> The German painter Carstens was one of the first to deprecate the purely physical tendency of the Cinquecenti and subsequent schools. . . . Overbeck, another German settled in Rome, comprised the works of Michelangelo himself in the deprecation as the source of corruption: making it altogether a religious question, and transplanting the most morbid fanaticism of the cell to the hitherto glowing face of art. It is a purely ascetic movement, corresponding to that intolerable idea that sanctification consists in mortification of the body; and, in so far as it is a monastic resuscitation, in perfect harmony with its sister revival of the Ecclesiastical gothic. . . .[10]

Wornum is hitting hard and hitting well below the belt, for he writes this in 1850, the year of the encyclical 'from without the Flaminian Gate' the year of the so-called 'Papal Aggression' and the Ecclesiastical Titles Bill, at the moment when otherwise sane Englishmen believed that the faggots of Smithfield were smouldering anew, that the whole work of the Reformation was to be undone by a new Popish plot, and that Britain was being betrayed by Cardinal Wiseman and a band of sinister Italian clerics.

III FREDERIC LEIGHTON:
The Garden of the
Hesperides. By permission
of the Trustees of the Lady
Lever Art Gallery, Port
Sunlight

[9] Holman Hunt, *op cit.*, Vol. I, p. 25. [10] *Art Journal*, 1850, pp. 270–1.

In this climate of opinion, a band, a secret brotherhood, connected no doubt with the Popish brethren of the Pincian, a cryptic society of men with foreign-sounding names, attempting to revive a monkish form of art, could not fail to be considered subversive. Even Ruskin felt a chill of misgiving at the sight of the papistical bibelots on the table in Millais's *Mariana*, and had to be re-assured that the young men were not romanists.[11] The accusation could not stick—it was completely unfounded. Holman Hunt and Millais were very far from being Roman Catholics; for Rossetti religion was little more than a means to poetry, and Collinson, who did go off to black the Jesuits' boots at Stoney-hurst, resigned from the Brotherhood in order to do so. But I think that this line of criticism probably had considerable emotional impact at the time.

The charge of Popery is allied to the charge of archaism which I mentioned in the preceding chapter. And yet it is also to some extent involved in the accusation of naturalism. The word 'morbid' may perhaps be made to contain all three varieties of reproach. The Pre-Raphaelites were held to be morbid because they were thought to be monkish—which was nonsense; they were also accused of an unnatural quaintness and of an over-enthusiastic attention to the imperfections of nature—to its more distressing minutiae—and these accusations were in some part true.

It is possible to discover both realist and romantic elements in the early work of the Brethren. The romantic side may be thought to derive from Lasinio's engravings or perhaps rather from German drawings, which circulated widely at the time. This influence shows itself in a taste for feverishly emphatic gestures and expressions, a rather disquieting oddity of attitude, an angular, overcrowded kind of composition, something which can hardly be called archaistic but which does, I think, originate in archaic sources. This is the one characteristic of the hard-edge school which has a lasting effect upon Rossetti's work. And yet the Quattrocentist conception of space is misunderstood, or if understood, dis-regarded or adjusted in accordance with modern ideas.

We are back at Pugin's programme of medieval art corrected by modern knowledge. It was in fact a part of Pre-Raphaelite theory, or perhaps one should rather say of the galaxy of ideas to which the young men of the time were sus-ceptible, that art should have something of the exactitude of science.

> Why teach us to honour an Aristides or a Regulus and not one who pays an equitable, though to him ruinous tax without a railing accusation. . . . Why teach us to hate a Nero or an Appius, and not an underselling oppressor of workmen and a betrayer of women and children?[12]

Such teachings, if formulated and translated into practice, might have led the Pre-Raphaelite Brethren to a species of realism as thorough-going as anything that existed on the other side of the Channel and it was not unreasonable for Prosper Merimée, when he first came across the works of the new school in England, to conclude that this British realism, in that it was anti-academic, corresponded to the realism of Courbet.[13]

[11] Ruskin, *Collected Works*, Vol. XII, pp. 320, 327.
[12] John L. Tupper in *The Germ*, No. III.
[13] Prosper Merimée, *Oeuvres Complètes*, Paris, 1930, T.VIII, p. 161 (*Etudes Anglo-Americaines, Les Beaux Arts en Angleterre*, 1857).

IV PHILIP H. CALDERON:
Broken Vows. Tate Gallery

It was Millais's prosaic *Carpenter's Shop* (Plate 21), with his real carpenter, his muscles strained and deformed by the toil of his craft, his ageing tired old Mary, half broken by housework, which shocked *The Times* into passionate indignation.[14]

Holman Hunt approaches, but never attains, the same realism in his scene of shoddy and cheaply gilded vice—*The Awakened Conscience* (Plate 24)—and even Rossetti made one attempt at realism in *Found*. (Plate 18)

The two most determined essays in Pre-Raphaelite realism were not, however, produced by the Brethren themselves. William Bell Scott's *Newcastle Quayside in 1861* (Plate 33) is, I think, this artist's best work, certainly it stands out nobly amidst the historical nonsense with which he has adorned the other *stanze* at Wallington.

But the greatest and most social of these realists was Ford Madox Brown. *Work* (Plate 27) with its elaborate programme of social function is an obvious example. We find also in Brown a fine Impressionist disregard for poetic decorum, the determination to pay court to nature even at her most sluttish.

'Why did you choose such a very ugly subject for your last picture?' asked Ruskin. 'Because it lay out of my back window' was the painter's angry and contemptuous reply and it might have come from a Monet or a Sisley. Ford Madox Brown had something of that genius for extracting poetry from even the most unpromising material, which is the sovereign gift of the Impressionists. (Plate 30)

One may say that Pre-Raphaelism was above all anti-academic. Such at all events was the view of its opponents. A contemporary caricaturist shows us Ruskin, a frock-coated Paris, handing the apple of discord to a raddled hag and scorning the charms of a pretty girl and the Madonna of the Sposalizio; around him are gathered a gang of Pre-Raphaelite artists, one examines each individual brick in a wall with the aid of a pair of field glasses, another studies, with reverence, the monstrous carbuncular feet of an old woman.[15] The anti-academic programme is fully observed, the ideal rejected, minutiae preferred to generalization, and the artist chooses plebian rather than noble themes.

But the satire is not accurate. The nastier forms of realism made but a limited appeal to Holman Hunt and to Millais, while the caricaturist overlooks Rossetti. The phase of realism is short and never gave a clear direction to the movement. That which united the Brethren and their followers was a technique.

The Brotherhood itself petered out and may be thought of as moribund, if not dead, before 1855 and a second movement, which owed a great deal to Ruskin and to Rossetti and nothing to Holman Hunt, came into being, as I shall try to show in a later essay, in 1857. This second movement, which can only in a very loose sense be called 'Pre-Raphaelite' was neither 'hard-edge' nor realist.

Nevertheless Holman Hunt had set forces in motion which could not perish so easily or so quickly; his own paintings and, still more, the paintings that Millais produced under his influence, affected other artists very considerably. Painters such as Wallis, Arthur Hughes, Calderon, Windus and Deverell became,

[14] *The Times*, 9 May 1850.
[15] William E. Fredeman, 'Pre-Raphaelites in Caricature' in *The Burlington Magazine*, Vol. CII, December 1960.

Hard-edge Pre-Raphaelism

for a time at any rate, more Pre-Raphaelite than the Pre-Raphaelites (Plates 23, 31, 32, 50 and Colour Plate IV). It would, I believe, be possible to trace a continuing strain of careful and minute realism in British Art from the time of the Brotherhood up to the year 1910; indeed one might go further and find something of Holman Hunt's teachings still persisting in the work of Stanley Spencer and Mr. Lucien Freud.

4
Academy Notes

Ruskin enters the history of Pre-Raphaelism suddenly and dramatically in 1851 with his celebrated letters to *The Times*. These came in response to the critical onslaught by a reviewer who had accepted the current belief, a belief which was supported by the name that the Brethren had chosen for themselves, that the movement was archaistic, that it called for a return to medieval methods and what was thought to be medieval incompetence. This gave Ruskin a fair opening for one of his most convincing displays of scientific analysis. Ruskin was at his happiest and best, or at least at his most convincing, when he was discussing questions of verisimilitude, and there is something very conclusive in the way in which he convicts *The Times* critic of blindness, stupidity and malice.

No critic today could offer a group of young artists the advantages which, in 1851, were secured by the approbation of Ruskin. It would be quite easy to exaggerate the miseries of these young men; in fact, they sold their pictures and they sold them well; they had wealthy patrons and their sufferings never equalled those of the Impressionists. Nevertheless, they were deeply worried by a sense of insecurity, and they were extremely sensitive to public criticism. Ruskin gave them moral reassurance and the assurance of financial prosperity. For a time all the splendour of his language and all the force of his intellect was on their side. The letters to *The Times* were followed by further polemics[1] and in 1855, carrying war and havoc into the enemy's camp he issued the first number of *Academy Notes* which was sold beneath the portico of the National Gallery where the Academy held its summer exhibition. In that first issue he slaughtered Sir Charles Eastlake, wounded Augustus Egg, routed Thomas Faed, blew up J. R. Herbert and mutilated Daniel Maclise. His criticisms caused delight, fury and consternation. They were believed to be decisive in their practical effect. A work disparaged by him would remain unsold, he could make or break any artist by a stroke of his pen. There were, even, painters who set themselves to treat subjects that he had recommended in the hope of gaining a favourable word.[2]

As he continued, year by year, to pulverize their now thoroughly demoralized opponents, the Pre-Raphaelites seemed to ride in triumph upon the broad back of their war horse, carrying all before them. It is thus that they appeared to Frederick Sandys (Plate 34) and the image corresponds in a large measure to the truth.

Nevertheless one has to make a great many qualifications. The beast of burden could rear and trample his cavaliers. If it appeared to be his duty as a critic to turn vicious he had not the slightest compunction about doing so. Moreover, Ruskin's attitude to the theory or theories of hard-edge Pre-Raphaelism could not be one of uncritical enthusiasm.

His celebrated advice: 'go to nature in all singleness of heart, rejecting nothing, selecting nothing, scorning nothing'[3] was intended for students and he was of course delighted to find young painters who took his injunctions so much to heart. Holman Hunt had indeed read and been influenced by *Modern Painters* and it may be said that, in this sense, he remained a student of Ruskin all his life. But such prolonged apprenticeship was not what Ruskin wanted. In the sentence from which this quotation is taken he observed that, while young painters should

[1] Ruskin, 'Letters on Pre-Raphaelite Artists' in *Collected Works*, Vol. XII.
[2] Leon, *Ruskin, the Great Victorian*, Bk. IV, iv, 261.
[3] Ruskin, *Collected Works*, Vol. III, pp. 624, 625.

make the early works of Turner their example his *latest* works were to be their object of emulation. Realism was to be a means but not an end and the realism of the Brethren, though admirable, constituted no more than an auspicious beginning.

> Yet let me not be misunderstood. I have adduced them only as examples of the kind of study which I would desire to see substituted for that of our modern schools, and of singular success in certain characters, finish of detail, and brilliancy of colour. What faculties, higher than imitative, may be in these men, I do not yet venture to say; but I do say, that if they exist, such facilities will manifest themselves in due time all the more forcibly because they have received a training so severe.[4]

It is true that there are passages in *Modern Painters* which might lead one to suppose that Ruskin would welcome the realist and modernist side of the movement, and, as we shall see, he did have high praise for Millais's *Rescue* (Plate 40) and also for Holman Hunt's *Awakened Conscience* (Plate 24), but he had no sympathy for realism in its coarser aspects. He liked colour, he liked sweetness and light. He hated dullness, darkness, horror and gloom. When he saw Pre-Raphaelite work—which he could not but admire—he accepted it up to a point. Nevertheless, he became impatient with it and almost at once he found in Rossetti the Pre-Raphaelite whom he most esteemed and whom he came to think of as the leader of the Brethren. He never felt any sympathy for the realism of Ford Madox Brown. In his criticisms therefore, Ruskin is never 'a good party man' and in the end he ceased to produce *Academy Notes* simply because some of his friends expected him to be one. He did however *look* like the advocate of a faction in 1855 and I should like to decorate this page with a few sentences from his criticism of that year's Academy where he does, at times, write 'politically'.

Here he is then, passing judgment on *The Wrestling Scene from 'As You Like It'* by Daniel Maclise (Plate 36)

> Very bad pictures may be divided into two principal classes—those which are weakly and passively bad, and which are to be pitied and passed by; and those which are energetically or actively bad, and which demand severe reprobation, as wilful transgressions of the laws of all good art. The picture before us is of the last class. Mr. Maclise has keen sight, a steady hand, good anatomical knowledge of the human form, and good experience of the ways of the world. If he draws ill, or imagines ungracefully, it is because he is resolved to do so. He has seen enough of society to know how a Duke generally sits—how a young lady generally looks at a strange youth who interests her; and it is by vulgar choice, not vulgar ignorance, that he makes the enthroned Duke straddle like a village actor, and the young lady express her interest by a cool, unrestrained and steady state. . . .
>
> Next to pass from imagination of character to realization of detail. Mr. Maclise is supposed to draw well and realize minute features accurately. Now, the fact is, that this work has every fault usually attributed to the Pre-

[4] Ruskin, *Collected Works*, Vol. XII, p. 358.

Raphaelites, without one of their excellences. The details are all so sharp and hard that the patterns on the dresses force the eye away from the faces, and the leaves on the boughs call to us to count them. But not only are they all drawn distinctly, they are all drawn *wrong*.

Take a single instance in a simple thing. On the part of the hem of the Duke's robe which crosses his right leg are seven circular golden ornaments, and two halves, Mr. Maclise being evidently unable to draw them as *turning* away *round* the side of the dress. Now observe, wherever there is a depression or fold in the dress, those circles ought to contract into narrow upright ovals. There *is* such a depression at the first next the half one on the left, and that circle ought to have become narrowed. Instead of which it actually widens itself! The second is right. Then the third, reaching the turn to the shade, and all those beyond it, ought to have been in narrowed perspective—but they all remain full circles! And so throughout the ornament. Imagine the errors which a draughtsman who could make such a childish mistake as this must commit in matters that really need refined drawing, turns of leaves, and so on!

But to pass from drawing to light and shade. Observe, the light falls from the left, on all the figures but that of the two on the extreme left. These two, for the sake of effect, are in 'accidental shadow'. Good; but why then has Oliver, in the brown, a sharp light on the left side of his nose! and on his brown mantle? Reflected lights, says the apologist. From what? Not from the red Charles, who is five paces at least in advance of Oliver; and if from the golden dress of the courtier, how comes it that the nearer and brighter golden dress of the Duke casts *no reflected light* whatever on the yellow furs and red hose of the wrestler, infinitely more susceptible of such a reflex than the dress of Oliver?

It would be perfectly easy to analyse the whole picture in this manner: . . .[5]

The same number of *Academy Notes* carries a panegyric upon Millais's picture *The Rescue* which he calls 'the only *great* picture exhibited this year'. It is worth noting that in this remarkable work Millais was already abandoning his Pre-Raphaelite manner. Ruskin does not think less of him for that reason.

The execution of the picture is remarkably bold—in some respects imperfect. I have heard it was hastily finished; but, except in the face of the child kissing the mother, it could not be much bettered. For there is a true sympathy between the impetuousness of execution and the haste of the action.[6]

He notes also, with guarded approval, *Cimabue's Madonna carried in procession through the streets of Florence* (Plate 37) by a newcomer from the continent, young Mr. Frederick Leighton.

The *Academy Notes* for 1856 are more kindly than those for 1855. And this with good reason, for clearly the Pre-Raphaelite movement had arrived; 'the

[5] Ruskin, *Collected Works*, Vol. XIV, p. 9. Compare Dafforne on the same picture: 'No very great amount of observation is requisite to see that every prominent character introduced on the scene of action has been carefully and thoughtfully studied . . . the old Roman gladiator, the Duke's jester are inimitable impersonations . . . Rosalind and Celia noble looking maidens. Perfect balance is maintained throughout, James Dafforne, *Pictures by Daniel Maclise*, 1873, p. 43.

[6] Ruskin, *Collected Works*, Vol. XIV, p. 23.

battle is completely and confessedly won . . . animosity has changed into emulation, astonishment into sympathy . . . a true and consistent school of art is at last established in England'. Even Frith was feeling the Pre-Raphaelite influence.[7]

As for Millais—'Titian could hardly head him now'—and his picture *Autumn Leaves* (Plate 41) is 'much the most poetical work the painter has yet conceived; and also, as far as I know, the first instance of a perfectly painted twilight'. *Chatterton* (Plate 31) by Henry Wallis he describes as 'faultless and wonderful'.[8]

But there is one failure. Holman Hunt's *Scapegoat* (Plate 22). Ruskin is as gentle as he can be. It was courageous, he says of the young artist, to go to the Holy Land 'with the clouds of Eastern War gathered to the North of him',[9] to go to the shores of the Dead Sea to 'the poison of the marsh and the fever of the desert'. The subject is a noble one.

> we cannot, I think, esteem too highly, or receive too gratefully, the temper and the toil which have produced this picture for us. . . . [But Mr. Hunt] in his earnest desire to paint the Scapegoat, has forgotten to ask himself first, whether he could paint a goat at all.[10]

The year 1857 brings disaster. The fall of Millais. Ruskin finds himself confronted by the picture widely known as *Sir Isumbras at the Ford* (Plate 36) and exhibited as *A Dream of the Past*. Already he had noticed slovenliness and imperfection:

> . . . which I did not speak of, because I thought them accidental—consequent, probably, on too exulting a trial of his new powers, and likely to disappear as he became accustomed to them. But, as it is possible to stoop to victory, it is also possible to climb to defeat; and I see with consternation that it was not the Parnassian rock which Mr. Millais was ascending, but the Tarpeian. The change in his manner, from the years of *Ophelia* and *Mariana* to 1857, is not merely Fall—it is Catastrophe; not merely a loss of power, but a reversal of principle: his excellence has been effaced, 'as a man wipeth a dish—wiping it, and turning it upside down'. There may still be in him power of repentance, but I cannot tell: for those who have never known the right way, its narrow wicket-gate stands always on the latch; but for him who, having known it, has wandered thus insolently, the by-ways to the prison-house are short, and the voices of recall are few.[11]

The pamphlet this year is generous in its praise of Dyce (*Titian Preparing for his First Essay in Colour*) (Plate 11). But everything is overshadowed by Ruskin's sorrow at the fall of Millais. He could see that Millais, with Rossetti, was the great talent of the Pre-Raphaelite movement, and he foresaw, correctly, that there would be no recovery.

Perhaps it is still necessary, in discussing Ruskin's criticism of Millais, to exonerate Ruskin from the charge of personal animus against the painter. The

[7] So it appeared to Ruskin when he commended Frith's *Happy Returns of The Day* (Harrogate Library and Art Gallery); the artist himself, however, was indignant at such praise. See Ruskin, *Collected Works*, Vol. XIV, p. 53, n. 2.

[8] Ruskin, *Collected Works*, Vol. XIV, p. 60.

[9] i.e. The Crimean War.

[10] Ruskin, *Collected Works*, Vol. XIV, pp. 64–65.

[11] *ibid*, pp. 106–7.

awkward fact that Mrs. Ruskin had become Mrs. Millais did not affect Ruskin's criticisms at all. Mrs. Ruskin left her husband in 1854, and for three years Ruskin had nothing but praise and often the very highest praise for Millais. What is odd, to my mind, is that long after the criticism of *Sir Isumbras at the Ford*, people still regarded Ruskin as the apologist of Millais. Frederick Sandy's cartoon (a parody of Sir Isumbras) is one example. Du Maurier, writing in 1863, provides another.

> Happy Millais! fortunatus nimium sua si bona nôrit—who ran away with Ruskin's wife and became the ideal theme of Ruskin's pen. Some people say however that Ruskin has a sneaking gratitude—ayant l'honneur de connaître la dame en question, je m'abstiens de commentaires, but by jove, *I'd* run away with her to be praised by Millais.[12]

Ruskin was identified with the Pre-Raphaelite Brotherhood, even at a time when he was more and more drawn to the Italianate movement of Rossetti and Burne Jones, which I shall discuss in another chapter.

The notes for 1858 and 1859 are less interesting. Millais's *Vale of Rest* (Plate 38) is noticed, not without praise, but still with regret for a misused talent. Frith's *Derby Day* he accepts, but without enthusiasm. On the other hand, another work provokes him into one of those sudden schoolmasterish rages, to which he was sometimes prone, and in which he indulged once too often.

The victim on this occasion was W. L. Windus. In 1856 Rossetti had persuaded Ruskin to take a second look at this painter's *Burd Helen* and Ruskin had written a postscript to his *Notes* in which he expressed the view that it showed 'the grandest imaginable power'. But in 1859 at the sight of *Too Late* (Plate 50) he exclaimed:

> Something wrong here: either this painter has been ill; or his picture has been sent in to the Academy in a hurry; or he has sickened his temper and dimmed his sight by reading melancholy ballads. There is great grandeur in the work; but it cannot for a moment be compared with 'Burd Helen'. On the whole, young painters must remember this great fact, that painting, as a mere physical exertion, requires the utmost possible strength of constitution and of heart. A stout arm, a calm mind, a merry heart, and a bright eye are essential to a great painter. Without all these he can, in a great and immortal way, do nothing.
>
> Wherefore, all puling and pining over deserted ladies, and knights run through the body, is to the high artistic faculty, just so much poison. Frequent the company of right-minded and nobly-souled persons; learn all athletic exercises, and all delicate arts—music more especially; torment yourself neither with fine philosophy nor impatient philanthropy—but be kind and just to everybody; rise in the morning with the lark, and whistle in the evening with the blackbird; and in time you may be a painter. Not otherwise.[13]

Poor Windus was flattened. He stopped painting.

For a long time Ruskin gave up producing *Academy Notes*; he wrote no more of them until 1875.

In that space of sixteen years British art was undergoing transformation and

[12] *The Young George Du Maurier*, ed. Daphne Du Maurier, 1951, p. 216.
[13] Ruskin, *Collected Works*, Vol. XIV, pp. 233–4.

there was a drastic change in the moral and intellectual climate of the nation. Pre-Raphaelism was entirely transformed by Rossetti and Burne Jones. Whistler came to live in London. Ruskin lost his mother's faith in evangelical Christianity and his own belief in 'purist' art.

Each of these events marks a departure from the Germanic severity of the 'forties. We are moving away from Gothic conceptions of art towards something which could be described as 'Renaissance'—the word is during these years entering the vocabulary of British intellectuals.[14] The artists and critics are looking for something more decorative, more graceful, more agreeable and more sensual. 'A good, stout, self commanding, magnificent Animality.'[15]

This change of attitude is reflected in the work of the successful Academy painters who were making their name in the 'sixties, prospering greatly in the 'seventies and at the zenith of their fame and influence in the 'eighties. They too were producing a more sensual art, discarding their Nazarene and Pre-Raphaelite influences and finding their inspiration in Italy and Greece.

I have suggested that the revival of 'Gothic' painting was born of, as it certainly was born in, an age of religious enthusiasm and social anguish. (The Pre-Raphaelites were not the only ones to make a revolution in 1848.) The political tensions of that epoch were mitigated or changed by the re-establishment of order in Europe after 1851 and by a decrease in social unrest which was particularly noticeable in this country. The nostalgic vision of a benevolent medieval society would be less necessary to the imagination after Europe had seen its barricades flattened by artillery; it would be less attractive in an England which was rapidly and complacently advancing in prosperity, a prosperity which affected the artists themselves.[16]

At the same time the fierce sectarian differences which kept religious excitement and religious animosity at fever pitch during the second quarter of the century dwindles thereafter as the sects find themselves united against the growing menace of Darwinism. Quattrocentist art had been a kind of declaration of faith in a certain form of religious belief, but now the question was not so much: what *are* we to believe? as: what *can* we believe?

In this tepid aesthetic climate of material optimism and spiritual doubt, official art—the art of the Salon and of the Royal Academy—would not express a need to dwell upon political or religious themes. What the public—the prosperous picture-buying public—needed was some kind of inoffensive and intellectually unprovocative mythology. Mr. Geoffrey Grigson has pointed out[17] that Grant Allen's *Physiological Aesthetics* (published 1877) formulates a theory of Ideal Aesthetic pleasure—a conjuring up of pleasantly imagined situations—which provides in some sort a theoretical programme for the cosy ideal subject matter of much late Victorian art.

The perfect exemplar of such art is Lord Leighton. In his painting the big 'historical machine' of the second half of the century finds its perfect form. As President of the Academy he hastened a tendency, which was already noticeable when the Corporation moved from Trafalgar Square to Burlington House in

[14] J. R. Hale, *England and the Italian Renaissance*, 1954, pp. 145–8.
[15] Ruskin, *Collected Works*, Vol. VII, Introduction, p. xl.
[16] 'Altogether the artists had a famous time of it during the 'fifties and 'sixties.' Leslie, *The Inner Life of the Royal Academy*, 1914, p. 131.
[17] *Ten Decades of British Taste*, 1951, Introduction.

1869, to discourage 'subject pictures', that is to say, the kind of small, domestic, anecdotal works which were so much admired at the beginning of Victoria's reign. Now pictures became larger and subjects more ambitiously poetical. The Academy was becoming more Italian and less Dutch.

In 1878 when Sir Francis Grant died, Leighton had already made so great a name for himself that he was able to win the Presidency against the competition of Millais.

> The choice lay . . . between a native and a foreign product, for brilliant and superb as the 'article' chosen was, it cannot be denied that it was nevertheless one that had been 'made in Germany'.[18]

This was another symptom of the change that was taking place. The mid-Victorian painters of grand ideal pictures: Leighton, Poynter, Alma Tadema, Watts, had all received a foreign education. The great practitioners of this kind of painting were to be found on the continent, above all, perhaps, amongst the French academicians.

Leighton was the perfect painter of that age: incredibly skilful, exactly hitting off the kind of thing that his public wanted; handsome, dignified, impeccable in his morals, magnanimous, kindly, and yet never guilty of extravagance or enthusiasm. His biographer, Sir Wyke Bayliss, describes him thus:

> He was a great painter, he was a sculptor, he was a scholar, he was a man of affairs, a linguist, a courtier, a fine speaker—but before all things he was President of the Royal Academy.[19]

Henry James describes him even more perfectly in his character of Lord Mellifont.[20] Lord Mellifont it will be remembered was one of the guests at a house party in the Alps; Browning was another. Both are eminently sociable. The narrator presently discovers that Browning can only achieve this eminence by projecting a kind of pseudo-Browning into the drawing-room while the real poet is busily at work upstairs behind locked doors. But Lord Mellifont, who shines far more brilliantly than the poet, vanishes into thin air when he has no audience. The effort required for such an intense social performance as his, leaves him no energy for any other kind of existence.

Whether James, who was a fairly discerning art critic, meant this as a commentary on Leighton's paintings I do not know; but undoubtedly this fable expresses the opinion of many younger critics of the time—that is to say during the President's lifetime—who began to find his work empty and for all its social grace, entirely lacking in real passion and real meaning: confected with enormous competence but in some way dead.

Perhaps these critics were too severe and perhaps I am too severe. One may fancy that somewhere behind that faultlessly noble mask there was an unruly, an irreverent Leighton, and perhaps the faintest hint of a hoof, or the almost imperceptibly rapid whisk of a flying tail-tip, may sometimes be revealed in the work of his earlier years: those earlier years in Rome in the 1850s when

[18] Leslie, *op cit.*, p. 137; Leighton had been a pupil of the German artist Steinle.
[19] Sir Wyke Bayliss, *Five Great painters of the Victorian Age*, 1902, p. 33.
[20] Henry James, *The Private Life*; see also *The Painter's Eye*, ed. John L. Sweers, 1956, p. 247.

Thackeray prophesied that one day Leighton would run Millais close for the Presidency of the Academy.[21]

If one compares Leighton's careful, very tight, very competent drawings of hands made in Rome in 1857 and which show traces of his early training in Germany, with his studies for *A Hit* which date from about 1893 (Plates 43 and 44), we may see how Italianate British Art had become. We may also, I think, guess at what had happened to Leighton. The former does have the quality of something that has been observed in life and which is being recorded for its own sake, the later is an attempt to show that an artist of the mid-nineteenth century can pass himself off as a sixteenth-century Italian, and behind the 'brilliance' there is a loose and almost meaningless incoherence of form.

With Leighton in Rome was Edward Poynter. Poynter, even more than Leighton, was a product of a foreign education. He was born in Paris in 1836 and thither he returned in 1855 after working in Rome, to study *chez* Gleyre. Here he met Whistler and Du Maurier, and like Du Maurier, when he returned to England he tried to earn money as an illustrator, but his ambitions were similar to those of Leighton. He produced *Faithful Unto Death* in 1865 and his first great success, *The Catapult*, in 1868 (Plate 48). His best known work *The Visit to Aesculapius* (Plate 46) is in The Tate Gallery; it was painted in 1880. He was a President of the Academy in 1896 and continued in that office until his death. He became, not unnaturally, the *bête noire* of the young.

> I wonder [wrote Walter Sickert] if Mr. Fry and Mr. Bell have really ever had a drawing by Sir Edward Poynter in their hands since they left Cambridge. They will not suspect me of academic prejudice. Would they be surprised to hear that the painters of the future are much more likely to go for guidance to the excellent Ingres tradition that lingers in Sir Edward's painting, [than to Cézanne] and that I consider his drawings to belong to the rapidly diminishing category of real drawings.[22]

Mr. Bell admitted that he never had looked at Poynter's drawings seriously and I doubt whether Mr. Fry was more careful. I have attempted to repair the omissions of my elders and betters and although I doubt whether they would have found the St. Stephen cartoons (Plate 42) superior to Cézanne, I think that they would have allowed them to be competent, workmanlike, and, in their way, honest. They have none of the slick affectation of scholarship that we find in the later productions of Lord Leighton. They look the kind of thing that a master might well exhibit as a model to his students. This perhaps is the trouble with them; they are too consciously playing the academic game, too consciously right—even in their corrections and *lacunae*, and the same is true perhaps of all Poynter's work; he looks at nature with the certainty of finding, not something new, but something predictably artistic. And yet I cannot help being in his favour; his lectures deserve to be read, his work at the Slade was admirable, he laid the basis for the remarkable achievements of a later generation. I think he was the victim of his period; but then the same might be said of all these artists.

I feel much less kindly disposed to Alma Tadema, although he was undoubtedly a much more original painter. There was a thorough, an heroic

21 Mrs Andrew Lang, *Sir Frederick Leighton, his Life and Work*, 1884, p. 6.
22 Walter Sickert, *Cézanne Mesopotamia*, a review of *Art* by Clive Bell in *The New Age* 5 March 1914; reprinted in *A Free House*, ed. Osbert Sitwell, 1947, pp. 118–19.

element in his character. In his work, as in that of Holman Hunt, we find an attempt to bring modern techniques to ancient themes (it is yet another variant of Pugin's programme). But where Holman Hunt sought to be archaeologically faithful to the New Testament, and set out to find the clothes, the tools and the furniture of the first century in Palestine, Alma Tadema, seeking the impedimenta of ancient Rome, had to content himself with what he could find in books and museums. Nevertheless, with this material, he attempted to recreate classical antiquity upon the banks of the Regent's Park Canal. Here he built himself a house: 'which he had fitted up to make it appear as much like a Roman villa as was consistent with the peculiarities of the English climate, and the comforts of an English home.'[23]

But it was not easy altogether to exclude one's own century. Poor Alma Tadema's marble halls were shattered when a barge containing explosives burst at his doors.

Perhaps his art might have benefited from some equivalent irruption of unstable compounds but in his paintings it is the weather and the comforts of an English home that make themselves felt; his views of life in ancient Rome, for all their careful archaeological exactitude, are unmistakably and tediously Victorian. The mild anecdote, the tiny comedies and tragedies of everyday life are, one feels, enacted by ladies and gentlemen who could be trusted to behave as St. John's Wood expected ladies and gentlemen to behave in the 1870s, and who are disguised for purely artistic and for purely temporary reasons in the garments of antiquity.

Alma Tadema is, in a sense, a realist; ruthless enough and realistic enough, at all events, to show us that the patricians of ancient Rome could be thoroughly boring and their girl friends decidedly plain. He was in fact the exact opposite of Poynter, who knew that they were all ideally beautiful and most carefully composed. Both of them suffer from the fact that they were unable to use their considerable dexterity in the handling of paint because, when it came to the point, they had very little to say. (Plate 39)

The case of G. F. Watts is different; he had plenty to say, in fact almost too much; but he never found out how to say it. Of all the sad stories of young genius going astray—and Victorian painting is full of them—none is sadder than the tale of Watts. In his youth he entered the Westminster Cartoon competition with a very spirited picture of Alfred inciting the Saxons to repel the Danes, but his great masterpiece of this period—'masterpiece' is I think a legitimate word— is a landscape of Fiesole (Plate 49) which now hangs in the Watts Museum at Compton and would in itself justify a visit to that remarkable establishment.

But Watts was not content to delight the eye; he wanted to address himself to the passions and to the emotions. It has been truly said of him that he was 'a poet groping after beauty',[24] and that, in a sense, is his trouble. With astonishing powers and a very just eye for colour he had a powerful enthusiasm for—he did not exactly know what. He would give the 'utmost for the highest'. But what was 'the highest'? He hardly knew.

Ruskin, in one of his moments of dazzling clairvoyance, told Watts to look for beauty in the gutter.[25] But Watts would not listen; moreover, the gutter was not

[23] *Art Journal*, 1865, p. 12.
[24] Walter Bayes, *The Landscapes of G. F. Watts*, 1907, p. ix.
[25] Ronald Chapman, *The Laurel and the Thorn*, 1945, p. 160.

easily visible from Little Holland House where Mrs. Prinsep and Mrs. Cameron made life so agreeable and where the highest, in the form of Tennyson, was a constant visitor. Watts's painting is, in a sense, Tennysonian; he is deeply conscious of the social and theological perplexities of the age. He strives to give expression to its doubts and its aspirations, not by anecdote, but by great histories—for he is wholly Italian in education and feelings—quoting Titian and Michelangelo, producing vast machines like *Evolution* (Plate 51), *Love and Death, Hope, Industry and Greed*, or grotesque banalities such as *The First Oyster* (Plate 47). At the very end he stood perhaps on the edge of a discovery, in *The Sower of the Systems* (Plate 52). He matches the vagueness of his imaginings with a vagueness of form in which the figurative element seems almost to disappear—his work becomes almost abstract; but he would have done much better to have listened to Ruskin.

Watts's failure, the most tragic failure of them all, typifies the whole situation. The more eagerly he pursues beauty the more completely it seems to elude him. Of all the foreign-trained artists who sought to work in a Renaissance idiom there is only one whose reputation has stood firm. This was Alfred Stevens, a sculptor rather than a painter, and even his fame has fluctuated since he was discovered, and perhaps over praised, at the beginning of this century.

This then was the evolution of the 1850s, 1860s and 1870s. It is a sharp reversal of the trend towards a northern and a Christian type of art; a return to Italy and a return to the Renaissance. As such it was a reaction against most of the things that Ruskin stood for in 1851. But if it is hard to generalize about a period, it is also hard to generalize about Ruskin.

By 1875, Ruskin was turning back again to 'purist art'. He does not find very much to praise in his *Academy Notes* for that year and when he blames there is a new note, a note of hysteria, in his voice—the splendid, but at the same time painful hysteria of *Fors Clavigera*.

In his criticisms of the painting of that year's Academy he considers a large composition by Watts. 'Very beautiful it might have been—and is, in no mean measure; but as the years pass by, the artist concedes to himself, more and more, the privilege which none but the feeble should seek, of substituting the sublimity of mystery for that of absolute majesty of form.' Of Alma Tadema he writes:

> the modern Republican sees in the Rome he studies so profoundly, only a central establishment for the manufacture and sale of imitation-Greek articles of virtu. [As for Poynter] Mr. Poynter's object . . . is to show us, like Michelangelo, [of whom Ruskin now disapproved] the adaptability of limbs to awkward positions. But he can only, by this anatomical science, interest his surgical spectators; while 'The Golden Age' in this pinchbeck one, interests nobody. Not even the painter. . . .[26]

He did find some things to like including kittens, dogs and schoolgirls. But when he comes to Millais he bewails the plight of English painting. What has become of the England of his youth, the England of Wilkie and Constable, the England of Turner? Then he bids the public go to look at Giovanni Bellini, Mantegna and Titian.

There was once a day when the painter of this (*soi-disant*) landscape (Plate 53)

[26] Ruskin, *Collected Works*, Vol. XIV, pp. 266, 272, 273.

promised to do work as good—[then let them return to this . . .] four-petalled rose, the sprinkle of hips looking like ill drawn heather, the sun-dial looking like an ill-drawn fountain, the dirty birch tree, and the rest whatever it is meant for—of the inarticulate brown scrabble. . . .

He concludes, in a passage too long for quotation, that Millais has been corrupted by society, his talent destroyed and perverted in 'the withering pleasance of a fallen race, who have sold their hearths for money, and their glory for a morsel of bread.'[27]

Ruskin's view is subjective, the picture presented by the Academy Exhibition is incomplete, there were much more interesting things going on at this time outside the Academy, but there must be many critics today who would agree with his assessment of the later Millais; and his social analysis, wildly and extravagantly expressed though it was, sometimes comes very near to the truth.

[27] Ruskin, *Collected Works*, Vol. XIV. pp. 300–3.

5
Low Art

I have had a good deal of difficulty in arriving at a satisfactory title for this chapter, and perhaps my final solution is not altogether a happy one. But I think that the term 'High Art', a term of which the Victorians were rather fond, does convey a notion which, though imprecise, is not obscure. It suggests, does it not, the big easel picture, the important subject, the sublime theme, the great mural in a public edifice, the heroic group in marble or bronze. By 'Low Art' I mean, therefore, all the lesser territories of design, those which were universally recognized as being entirely humble, the door knobs, the antimacassars, the applied arts generally, and also those forms of pictorial art which, though they might be highly considered, and come from distinguished hands, were nevertheless not the kind of thing that you would find on the walls of the Academy: the work of the illustrators, the cartoonists, and the photographers, and it is these which concern me here.

Some years ago I attempted to define what I called (perhaps vaingloriously) 'Bell's law of aesthetic gravity'. This may be stated in one sentence: the higher you fly the harder you fall. If you will consider Plate 52 in conjunction with Plate 46 and Colour Plate III I think you will see what I mean. Poynter setting himself to provide an illustration to a magazine article arrives at a design which is not without force, drama and invention; Poynter evoking the glory that was Greece and the grandeur that was Rome is a pretentious old bore.[1]

The business of finding an appropriate clientele and then of laying oneself out to please it, of catching the acceptable shade of public sentiment, to which I referred in my first chapter, becomes extremely perilous when an artist attempts the sublime.

Consider Leighton's *Hesperides* (Colour Plate III). The painter conforms to the kind of programme that governed the work of his great predecessors; he fills his tondo with carefully harmonized forms but he has in addition to produce a vision of antiquity which will delight the respectable British public of the year 1892. He therefore makes it clear that the daughters of Hesperus are absolutely *comme il faut*, their garden is not, one feels, without a greenhouse and other civilized amenities and they are not too distantly related to the equally idealized and equally genteel ladies in Plate 54. It is true that Leighton's nymphs, or at all events she who is so interestingly involved with a serpent, show us more of their arms and bosoms than would be seemly in polite company; but art is licensed. This is indeed one of the things which forces the modern spectator to view Leighton's work with suspicion. For us the great Victorian *machine* seems feeble because its motives are so very social and, therefore, so very impure. No Atlas, but rather some beauty-loving businessman in search of a hellenized, unbuttoned, uncorseted Atlantis, will cull these orange pippins. We are disturbed, in short, by an insincerity of emotion equivalent to the ostensible grandeur of the theme.

But if we return to the fashion plate the very slightness of the theme, the fact that it is overtly and frankly social, allows us to overlook a certain amount of conscious absurdity. There is here no insincerity for there are no lofty pretensions.

Nevertheless, although a high and serious intention leads nineteenth-century

[1] A similar comparison could be made between the humbler and the more pretentious works of Millais in his later period. Luke Fildes, Wilson Steer and many other nineteenth-century painters show the same pattern of achievement.

painters to disaster, it leads them also to success, and the productions of the fashion plate artist—I use the term generically to indicate all those who score by aiming low—are successful in a somewhat negative way; they avert great disasters by avoiding perilous engagements.

Far more interesting are those artists who do arrive at a certain profundity of feeling by entering what we may call the marginal areas of art and who, protected as it were by an ostensibly modest purpose, conceal their high intention beneath a low disguise.

The joke has always been one of the most effective instruments for the expression of serious ideas. In the nineteenth century important, even terrifying things, sometimes found utterance in the form of jokes made, characteristically enough, in the nursery. Edward Lear, whose charming landscapes show but little of that gift for the fantastic which may be found in his nonsense drawings, is an obvious example. His paintings have been regarded enthusiastically for many years and should certainly be noted even by one who, like the present writer, has felt his enthusiasm wane. But in tracing the main currents of Victorian Low Art it is more profitable to look, not at the work of one eccentric genius, but at artists who represent a large field of activity. Those whom I have in mind are the photographers and the illustrators.

Photography was invented at the beginning of our period. From the first it was regarded with mixed feeling by 'High' artists; it was a medium which might be their servant and their ally; on the other hand it could be their rival. From the point of view of those who feared its power it had one saving grace, it was cheap. It could, and no doubt did, replace many of the humbler portrait painters supplying the middle and lower middle classes with quickly made, inexpensive likenesses; it circumvented the amateur topographical painter. But the big commissioned portrait and the big ideal scene continued—despite some efforts to which I will advert—to be 'done in oils'.

Almost any early photograph has a charm which is denied to the great majority of contemporary oil paintings. It has a quality of fact, of sincerity, which makes it appear that we are looking at the past without being distracted by the interposition of a style.

This is not always the case, but it is true enough. If we consider the portrait of Mr. and Miss Chalmers made by the Scottish portrait painter and photographer, Octavius Hill, in 1845 (Plate 55) we shall at once see how carefully 'artistic' a work it is. Hill has posed his group with taste—the taste of the eighteen-forties; he has made his young sitters quite as charming as they had any right to be; the entire scene comes, as it were, from a steel engraving in the *Art Journal*. And yet there is, in the features of the sitters, the fall of the drapery, the cast shadow of the guitar, the uncertain passage between the sheet of music and the girl's hand, enough of accident, irregularity and awkwardness to give a deliberately sweet subject the dignity and authority of truth. And this impression of truth redeems those qualities of sentimentality and affectation which would almost certainly have found their way into the very paint if this portrait had been made on canvas.

It may seem that I am denying Octavius Hill any virtue save that of having used the lens rather than the brush. I am not. Hill was a sensitive artist who escaped the besetting faults of his time by the wise use of a new medium and if we look at some other photographers we shall see that no lenses could save them. Indeed, if we examine the work of Mrs. Cameron, we shall find that

V WALTER CRANE:
illustration to Toy Book
The Forty Thieves

Ali Baba's son, who one day invited him to his father's house. On hearing that the new guest would eat no salt with his meat, Morgiana's suspicions were aroused, and she recognised him as the captain of the robbers. After dinner she undertook to perform a dance before the company, and at the end of it pointed a dagger at the captain, and then plunged it into his heart. Ali Baba was very much shocked, until Morgiana explained the reasons for her conduct; he then gave her to his son in marriage, and they lived in great prosperity and happiness ever after.

although she was an even more successful portraitist than Octavius Hill, she was also capable of imitating the worst excesses of contemporary painting.

Mrs. Cameron was certainly the most remarkable of the deliberately artistic photographers of the mid-century. Fate directed her to the very heart of artistic society in London during the years which followed the ending of the Pre-Raphaelite Brotherhood, for Mrs. Cameron fluctuated between Freshwater, where Tennyson was her neighbour, and Little Holland House where her sister Mrs. Thoby Prinsep entertained Holman Hunt and Burne Jones and where the resident genius was G. F. Watts. Enthusiastic, domineering, charming and rather silly, she threw herself into the pursuit of art with enormous energy.

She was naturally Italianate and her few essays in the manner of the genre were wholly disastrous. How surely one knows in *Pray God Bring Father Safely Home* (Plate 57), that father's only home is in the photographer's studio and that it is furnished with props brought out for the occasion. Her attempts to produce a photographic equivalent of Watts's ideal subjects (Watts being by far the strongest influence in her work) were, for the most part, deplorable. But Watts also exerted a benign influence. Only once, so far as I know, did she attempt a truly Pre-Raphaelite effect (Plate 56). Here she used the rather odd, awkward effect of space, the obstructed view and the nicety of detail that one might expect in a student of Holman Hunt or the early Millais. Such work, however, called for a sharper lens than hers and her genius (I use the word advisedly) was for the broad masses, the deep shadows of Watts. When she could follow this bent, and avoid falling into sentimental absurdity, when she could find a congenial sitter and an appropriate light, she could make the kind of portraits that Watts ought to have made.

In the portraits that I reproduce (Plates 59 and 60) she uses chiaroscuro with astonishing ability and great psychological insight. Compared with these Watts's portrait of Lady Lytton (Plate 58), which is by no means a contemptible performance, seems pale and unconvincing.

In Mrs. Cameron's work the aesthetic feelings of the age, the love of beauty and spirituality, are held in check by the discipline of facts and find a perfectly adequate means of expression. In her we have the one great Victorian portraitist; looking at her productions one can believe in the eminence of their great men, the beauty of their women.[2]

This could quite easily become a chapter on nineteenth-century photography. This is not my purpose but one other master must be mentioned. Dr. Peter Henry Emerson, who published his 'Naturalistic' photography in 1889, stands in clear cut opposition to Mrs. Cameron. Where she was influenced by Watts and the later Pre-Raphaelites, he, it would appear, was looking in the same direction as the New English Art Club; in his work we can see reminiscences of Leader, Clausen, La Thangue and the English followers of Jean François Millet and again it seems to me that the photographer has produced something which can confidently be set against the work of the painters. (Plate 61)

[2] Her sitters were not always so enthusiastic. 'I want to do a large portrait of Tennyson, and he objects! Says I make bags under his eyes—and Carlyle refuses to give me a sitting, he says its a kind of *Inferno*! The greatest men of the age (with strong emphasis), Sir John Herschel, Henry Taylor, Watts, say I have *immortalised* them—and these others object! What is one to do—hm?' Mrs. Cameron reported by William Allingham, *Diary*, ed. H. Allingham and D. Radford, 1907, p. 153.

VI WILLIAM ORPEN:
The Mirror. Tate Gallery

The photographer became the poor man's portrait painter and takes his place in the general diffusion of art which was characteristic of the century. Another, and somewhat more important, agent was the illustrated periodical. Given a large enough circulation it was a commercial proposition to prepare wood blocks—using a team of skilled craftsmen—for use in periodicals. With the repeal of the Stamp Act, the invention of steam printing and rail transport, these journals began in the 1840s to play a more and more important part in the life of the nation.

It was in the 'forties that *Punch, The Art Journal*, Henry Cole's *Journal of Design, The Illustrated London News*, and most of the illustrated weeklies, monthlies and quarterlies began to employ artists and engravers to illustrate fiction, record facts and disseminate elevating moral sentiments to the middle classes. The great wood-engravers, Swan and the Dalziel Brothers, entered into an era of prosperity which lasts for a generation and then vanishes before the advance of zinc lithography and other new processes. During this period, say 1840 to 1890, the wood-engravers were responsible for diffusing careful copies of work by old masters, quite as faithful to the originals as many of the coloured photographs in which we put our trust today, and for bringing into the homes of thousands of readers the work of Tenniel, Leech, Du Maurier, Keene, Guys, Poynter, Leighton, Millais—a broad spectrum of talent, part of which soon deserted what Ruskin called the 'black art', and part of which remained in this humbler occupation.

It was humble and it was anonymous. The general public did not know who created the art at its breakfast table and it did not know because it did not take such work very seriously. From the 1870s onwards Du Maurier generally signed his work, but nobody knew Du Maurier's name until he wrote a best-selling novel in the 'nineties. Keene's obituarist remarked that only a handful of people would know who had been responsible for the many thousands of drawings which, for nearly half a century, had carried the initials *C.K.* in *Punch*. The original work of these artists was, for many years, destroyed. It is not until the 1880s that the engravers begin to photograph drawings onto the wood block. Originally the drawing was made on the wood itself, the draughtsman was at the mercy of the engraver, who in effect destroyed his work while translating it. Rossetti's bitter complaints of ill treatment still remain on record. We knew also that the executants had their say and that the draughtsmen who know how not to set the engraver too many problems were more likely to gain employment.

I think we may divide this part of our history into three main periods; the age of Leech; the age of Du Maurier and the age of Aubrey Beardsley.

Leech, so it seems to me, represents his age very well; the aspect of the 1840s and 1850s which he presents to us is one of which I have said too little. For him, as for so many people, it was not a worried and medieval-minded age but an age of fat gooseberry-headed farmers, thin knobbly-kneed jockeys and plump young beauties in crinolines (Plate 62). The age, in fact, of Surtees, an age in which bawdy and cynicism is still to be found—at all events in the literature of the gun-room—and in which you have, not so much humour, as fun. There is also the grotesque—the sharp, rather terrifying grotesque of Cruickshank, the altogether gentler grotesque of Thackeray.

The second generation, which Cruickshank noticed and denounced as 'Pre-Raphaelite' in the 1860s, produced what may fairly be described as the Golden

Age of English Illustration. It is not my purpose to examine it in any detail and I can hardly support my claim for its excellence otherwise than by saying that if the reader will look carefully at the work of Lawless and Pinwell, of Boyd Houghton and at the illustrative work of Millais, Leighton, Poynter and Whistler, all of whom were working during the 1860s for papers such as *Once a Week* and *Good Words,* he will, I think, find a breadth of design, a nicety of drawing, a purity of sentiment which is wholly admirable.[3]

I certainly cannot do justice to this extremely interesting resurgence of illustrative talent, but confine myself to a brief examination of its development and of one or two individuals.

Once again the influence of Germany is most important. Hard-edge Pre-Raphaelism is a not very clearly distinguishable influence—except of course in the graphic work of Holman Hunt. Of those artists who were not members of the Brotherhood, Doyle is perhaps the most strongly influenced by it. Richter certainly attracted the attention of some illustrators in the 1840s, but to the later generation it is neither the Nazarenes nor any other intermediaries that matter, but Dürer himself, working in a cognate and easily available medium, who is of the first importance.

As with painters, so also with the illustrators, the German influence dies and is replaced by a freer, broader style. In the case of Frederick Sandys (Plate 68), whose earlier drawings are almost purely Germanic in feeling, the Teutonic influence is replaced—or rather amalgamated—with that of Rossetti; indeed he takes much of Rossetti's dramatic or melodramatic purpose, his strange, cramped forms and airlessly over-crowded compositions.

But there were other forces at work; we may see their action in the development of the young Du Maurier's style.

Du Maurier came to England in 1860, bringing with him two admirations: Whistler and Poynter. He was then, by temperament and training as also by birth, a francophile and yet he too could not escape the prevailing influence. Germanic art came to him, it would seem, through Frederick Sandys. In what a thorough-going spirit he received it may be judged from the illustration for *Good Words* (Plate 64) which he produced a year after his arrival in London.

Du Maurier's reconversion to a French style was effected by his friend Frederick Walker. Walker obviously impressed him deeply both as a painter and as a man. His painting which owes a little to Jean François Millet, has a sad, genuine and very personal quality. His illustrations—and in these he is perhaps nearer to Millais—are rather less expressive. Nevertheless, he understands volumes, he observes with fidelity and he is enormously workmanlike.

Du Maurier, with very great abilities, was able to arrive at something like a synthesis of Sandys and Walker. Witness that very remarkable early work published in *Once a Week* entitled 'On Her Deathbed' (Plate 63), a drawing which shows dramatic invention of a high order. At the same time the influence of Whistler persists (Whistler himself was also attempting to work in the same medium), and produces greater breadth and freshness, and a more unexpected quality of observation. From Whistler in particular the young Du Maurier must have learnt something about the spacing and the placing of figures, about the judicious use of intervals and about pictorial tact (Plate 65).

[3] See Gleeson White, *English Illustration: The 'Sixties,* 1897.

Du Maurier had, almost from the first, the ambition to find a permanent job on the staff of *Punch*. He must have realized how well suited that field of activity would be to his talents. He soon managed to get a certain number of drawings accepted and when Leech died he attained his ambition. For the next thirty years he produced two or three weekly offerings and by the time of his death he had given the comic side of the paper (if comic be the word, which may well be doubted) as definite a character as Tenniel (the inventor of the pictorial first leader) gave to its political side. For although he had a rival in Charles Keene, Keene for reasons which I will presently discuss, was rather less able to give the paper that particular tone which it acquired during the 'seventies, 'eighties and early 'nineties. *Punch* was obviously the voice, or more properly, the mirror of the great Victorian middle class and Du Maurier found himself perfectly at home in its heartland. His jokes, which are hardly jokes at all but more in the nature of quiet observations on the fashions, the sports, the manners and the sensations of the day, are always safe. Children make terrible remarks, duchesses are rude to the *nouveau riche,* bores are boring, servants don't know their place, cads are caddish, hostesses hunt for lions.

In the earlier drawings these delightfully anodyne comments are expressed with a beautiful distinction of line, a justness of placing, a feeling for the harmonious interval which make them extremely satisfying and successful.

Du Maurier was an infinitely polite artist. He pokes fun at the snobbishness of his class and he is witty at the expense of the aesthetes, the Maudles and the Cimabue-Browns, the collectors of blue and white, the partisans of Whistler (here indeed he comes near to savagery). But his dukes and his duchesses and his Ponsonby de Tompkins were very gently chastised, and beneath his ironies there is almost unbounded homage.

He creates a world of distinguished men and beautiful women, of security and easy refinement, which may fill the modern spectator with a certain nostalgia until he recollects that probably it could not have existed, or if it did exist, must really have been rather tedious. Presently Du Maurier's visual curiosity fades, his dream of fair women becomes monotonous, and one feels that his types are drawn again and again, not because he found them fascinating to look at, but because he knew that his public expected them to put in an appearance. After a time his compositions became dull and stereotyped, the freshness of his earlier invention fails him and at last he loses even that delicacy of line which for many years was his chief asset (Plate 66).

Du Maurier ends by becoming dull, but there was something in him of genius, a creature of wild imaginings and splendidly various talents lay within him, a creature which never quite managed nor wholly failed to emerge.

I have said that Du Maurier rather than Keene gave *Punch* its tone and what I meant was that, whereas Du Maurier held up a mirror to England and assured her that she was after all the fairest of them all, Keene said something rather different. It was said of Keene 'that he could not draw a Lady' and although his admirers resented and denied the charge, I think that it was true, or largely true; he was too candid, too simple an observer to give elegance where he did not see it. But above all he was interested in something else. Alone amongst the draughts-men whom I have been discussing, he was passionately excited by facts and described them with an enthusiastic affection which made questions of personal beauty or social distinction, or even of style, irrelevant. It is this that puts him in

the company of the Realists and the Impressionists.

If we look to his beginnings we shall find once again the ubiquitous influence of the Germans. An early illustration to Charles Reade's *The Cloister and the Hearth*, which appeared in *Once a Week* in 1861, is as wooden, as stiffly medieval as any caricature of Pre-Raphaelite painting and owes more than a little to the early Tenniel (Plate 69). Then, quite rapidly it would seem, he found his style and for thirty years and more while he was a regular *Punch* artist it hardly varies (Plates 67, 70, 71).

Keene was supplied with most of his jokes by his friend Crawhall and a few of the jokes were good, but usually they are based, like the jokes of Leech, on fat men falling down, on drunkards, highlanders, maiden ladies, and other objects which were considered to be funny in themselves. He has neither malice, nor fantasy, nor deep psychological penetration. He hardly enters the world of ideas at all—like Corot he stops short at the threshold, and for the same reason; he is enchanted by the visible world, by the frayed cuff of an old overcoat, the spread of ivy over a brick wall, the shape of a top hat or an elm tree. He had the rare artistic gift of humility; it enabled him to pause and look at the crease in the tunic of a volunteer's uniform with rapt attention, and to state it with authority and the finest economy. There is never a fussy or a meaningless line in his drawings: he can examine the facade of a suburban road with a quiet and sensitive thoroughness which makes one feel that for him it had become the most significant thing imaginable. His achievement was prodigious: he was the only Englishman of his generation whom we can place in the same category as the great French realists.

A lonely and obscure eccentric, he lived in conditions of some considerable squalor, surrounded by bagpipes, zithers, serpents and mandolines; a tame raven hopped on his terrace, he dined off marmalade and sausages seasoned with brown sugar; he smoked innumerable clay pipes filled with the strongest, the most pungent tobacco, from these he extracted the dottles and, when he judged one of his drawings good enough, he would treat himself to a pipeful of this hideously poisonous refuse.

In the eyes of his fellow artists he was, one gathers, something of a joke; a good enough fellow, but not, of course, an artist of any importance. His role was humble and comic; he never aspired to the heights, he knew nothing of sublimity and never achieved beauty.

To artists of a different tendency he appeared in a different light. Degas and Pissarro, when they became aware of him, took him very seriously indeed and presently a few of the youngest generation of English painters—Sickert, Wilson Steer and Tonks, did likewise. His fame spread far enough for him to receive a prize at the exhibition of the *Artistes Graveurs* in Paris in 1889. He was unimpressed and, germanophile that he was, certainly valued a few kind words from Menzel at a far higher rate.

On se sentait vraiment en presence de quelqu'un qui ignorait sa valeur, wrote a French critic who interviewed him.[4] It was true enough. Keene felt a humble and sincere admiration for the great and famous Academicians. He had too much humility to compare their work with his own; theirs, after all, was High Art.

[4] Derek Hudson, *Charles Keene*, 1948, p. 33. See also Du Maurier, *op cit.*, p. 121.

6
From Rossetti to *Art Nouveau*

It is with a deliberate intention that I have turned from the story of the Pre-Raphaelites to consider the High Art and the Low Art of the nineteenth century. The Pre-Raphaelites formed only one element in English painting at that time; it was, however, a most important element and it is time to return to them and to consider the second phase of the movement.

What I have called the 'hard-edge' school of Pre-Raphaelism had become well established and was exerting a powerful influence upon British painting by 1860. But, long before that, the Brotherhood itself was extinguished. Holman Hunt made his pilgrimages to the Dead Sea, Woolner went to Australia, Millais to the Royal Academy. F. G. Stephens and W. M. Rossetti drifted into literature, Collinson into obscurity. The task of creating a new movement fell into the powerful hands of Dante Gabriel Rossetti.

In 1857 Rossetti undertook the decoration of the Oxford Union. He was assisted, not by the Brethren, but by a group of undergraduates and notably by William Morris and Burne Jones.

It was a high spirited and entirely unmethodical affair; as Ruskin said, they were all 'the least bit crazy'.[1] The work was done without science and without skill: the artists painted, not on to plaster but upon whitewashed brick. Their decorations faded and crumbled faster even and more disastrously than the Westminster frescoes. Today, practically nothing remains save for William Morris's admirable ceiling, which is simple, elegant and very well calculated to complete the pattern of the roof beams.

It must have been great fun in 1857. Rossetti was 29 years old and this Oxford enterprise was, so to speak, the last fling of his youth. But for young Morris and for young Jones it was something altogether momentous. This, and they may perhaps have guessed at it, was the Orient from which they were to travel upon a path indicated by Rossetti, here they settled their directions as artists and in so doing determined the future course of painting in England.

Rossetti, it should be added, was not their only leader, for they, much more than the original Brethren, were guided by his patron. Nevertheless, it is a fairly safe generalization that painters are more influenced by other painters than by any writer howsoever great and certainly, in this case, Rossetti's paintings are of more importance to the later Pre-Raphaelites than anything that Ruskin ever said.

If we compare Rossetti's *Marriage of St. George* of 1857 (Plate 72) with Millais's *Ophelia* of 1852 (Plate 29), we can see at once the extent and the character of this new departure. Millais's painting is wholly realistic; he works in terms of depth, of ideated space. It is, eminently, an easel picture which leads us into an alternative but entirely convincing world. It is full of detail, as a realist picture of this kind must be, but it is not overcrowded.

The Marriage of St. George looks as though it had been cut from a manuscript; it makes no pretence at realism, it is filled to bursting point, the figures packed into their frame, objects wilfully distorted in order to develop the surface-pattern; and the pattern is all-important. It shows also—and in this it retains a quality which is characteristic of hard-edge Pre-Raphaelism, a certain awkwardness of pose (note the saint's right arm), and this is allied to another Pre-Raphae-

[1] Ruskin to W. M. Rossetti, 29 December 1857, Ruskin, *Collected Works*, Vol. XXXVI, p. 273.

lite quality, which I find it hard to explain in words; one might call it 'a tendency to look through holes', through the window into the detailed background, through the rents in a man's hat into his face (as in Ford Madox Brown's *Work*) or through the holes in a fence (as in Calderon's *Broken Vows*) (Plate 27, Colour Plate IV). It is a very odd conception of painting in which detail seems to be made deliberately alien to the main design of the picture.

The point however, on which I want to insist, is that, despite these 'hard-edge' details, the design is all important and that Rossetti's work is, essentially, decorative and liturgical.

I use the work 'liturgical' with considerable misgivings; 'devotional' might have been better but Rossetti is not exactly devout. He believes in nothing and yet he is altogether enchanted by the act of worship. Holman Hunt constantly seeks for Christian realism, Millais occasionally for Christian anecdote; Rossetti looks for a shrine on which he can lavish all his art and all his ingenuity, the deity of which, Mary, Beatrice, Guinevere, Astarte Syriaca, is so protean as to be non-existent. He is not religious but he is profoundly mythophiliac. His cult makes no demands either on faith or on morality, it implies no articles of belief and no rules of conduct. It is the religion of a man who wants something passionately and can only express his wants by way of incantation. What Rossetti wanted, to put it crudely, was girls. But that is to put it much too crudely, for in Rossetti the hearty commonsensical carnality which leads him to find such names as Guggums and Jumbo for his various 'stunners', is balanced by an opposite tendency to relegate them to the 'Gold Bar of Heaven'—in some of his drawings they seem almost sexless, almost ghostlike, it is the face, not the body, that captures our attention. It is perhaps significant that one of the very first of these Rossettian girls 'clad to the hands and feet with a green and grey raiment, fashioned to that time' (that is to say the thirteenth century) turns out to be, not a creature of flesh and blood, but the painter's own psyche.

I will not attempt to pursue that phantom to whatever place may have given it birth; but I would like to suggest that it was one of the most influential ghosts of the century.

The second generation of Pre-Raphaelites is haunted by a female figure—by a feminine principle one may almost say—which dominates Rossetti's work and the work of his disciple Burne Jones, and through them their followers: Frederick Sandys, Simeon Solomon, Harold Meteyard, Walter Crane, Frederic Shields and Aubrey Beardsley. (Plates 68, 99, 75, 82, Colour Plate V)

In the creation of this atheological religion Burne Jones was quite as important as Rossetti. Like Rossetti he takes whatever stories lie ready to hand, Christian, Pagan, and above all, the Arthurian legend, a story which captivates the mid-century precisely because it is so grotesquely improbable as to disarm criticism. Within such a context he is obstructed neither by history nor by probability and can, therefore, fill it with his own imaginings.

And what did Burne Jones imagine? He imagined a world without tears or laughter, a world in which no violent emotions exist, in which everyone is quietly and decently sad. The girls are all beautiful and terribly anaemic. They will never blush and never put on weight and their swains are not likely to help them to do so. They are all so irreproachably lady-like. It is a feminine world, a world of beauty and high ideals. I find it both repulsive and admirable.

Admirable, because this vision of things as they ought to be is humane, tender

and delicate. It is more intelligent than the world of Etty, more coherent than that of Rossetti's *Blessed Damozel*. It represents a seemly social ideal. It was thus that Kensington and Birmingham existed in their dreams; it was to this that the cultivated classes of Manchester aspired—a lovely pensive existence amidst Italianate scenery peopled by graceful persons whose soberly coloured robes echo faintly the realities of Marshall and Snelgrove, intense, serious and in every sense of the word, gentle.

Why then do I find it repulsive? I find it repulsive because it is so shockingly indecent. Take the *Pygmalion* series in Birmingham (Plates 77–80). It is a kind of hymn to sexuality in art. The sculptor creates an image of marble, he adores it and the goddess turns it into a real live woman—made of soap. Pygmalion is also made of soap and one recoils at the idea of their sad, cold, slimy, saponaceous embraces. I am not complaining of the cold; a cold linear painter, an Ingres, a David or a Poussin, might have attempted the same theme and have realized it in much the same way but his coldness would have been pure, pure because it was positive. Burne Jones's purity is negative, he is so horribly anxious *not* to be impure, he is determined that everything shall be kept on the elevated plane of High Art and it is precisely this anxiety which produces an overwhelmingly prurient effect.

Here is one of the diseases of the century, particularly of the mid-century, one of the things which makes its high art inclined to collapse; but in the case of Burne Jones it is particularly tragic for he was a man of immense potentialities. He was a much stronger, a much more fluent designer, than his master. In his hands the crowded angularities of Pre-Raphaelism may lose vigour, but they gain lucidity and rhythm. He is strong enough to create, by a marriage of Quattrocentist and Mannerist elements, the ideal female figure to which Rossetti contributes only a certain ecstatic expression.

He must have owed a great deal to his collaboration with Morris, for Morris led him away from his dreadful visions of beauty to the discipline of the applied arts and it was through Morris that he came to produce his masterpiece—the glorious windows of Birmingham Cathedral. Unfortunately no illustration in a book could be more than a travesty of that superb glass.

These essays are concerned with the figurative arts and it is not my business to examine the achievements of Morris, Marshall and Faulkner; but the revolution in design which that firm engendered was to have a very decided influence on the art of painting, for it produced that reunion of the arts, that nineteenth-century style which we call—oversimplifying it I fancy—*Art Nouveau*.

To gain a general notion of how, during the second half of the century, the age developed a style of its own, it may be helpful to look at the drawings reproduced overleaf. Figure 1 shows an adaptation of leaf forms to ornamental purposes made in 1876 by Richard Redgrave who was then Principal of the South Kensington Schools. You will see that it has no very strong stylistic flavour, it could belong to almost any period, that is to say the symmetrical shapes which Redgrave extracts from a thistle are of very wide application and suited therefore to the imitation of a variety of styles. You will observe also that Redgrave reduces his plant to a pattern built in the main upon curves which can almost be described with a pair of compasses. Now look at a similar exercise by Walter Crane (Figure 2). Here the stylization is violent and is clearly related to a

FIGURE I *The Use of Plant Forms in Ornament*, from *A Manual of Design*
by Richard Redgrave, 1876

recognizable period. Also, Crane positively cultivates asymmetry and irregularity.

This preoccupation with curves which break away from all closed and regular forms was something that the later nineteenth century took almost for granted. The term 'curves of beauty' was part of the current jargon of art.[2] The preference for pointed arches rather than for the squares and circles of Bramante and of Palladio might in itself suggest a doctrine of curves to the reader of *The Stones of Venice*; but in the fourth volume of *Modern Painters* Ruskin deals with the question thoroughly and systematically. Here he points out that the finite curve, the curve which is a portion of a circle and returns inwards upon itself, is very much less interesting and beautiful than the immortal curve—that is to say the curve which contains an infinitely extensible relationship, the parabolic curve, the catenary, the spiral which Ruskin finds continually in nature and particularly in vegetable forms[3] (Figure 3).

The curves that Ruskin bids us admire are natural curves and it is therefore rather too easy to find them in contemporary painting. It is when they have to be accommodated in a design—as, for instance, in natural forms in ironwork between

[2] He suggested curves of beauty,
Curves pervading all his figure,
Which the eye might follow onward,
Till they centered in the breast-pin,
Centered in the golden breast-pin.
He had learnt it all from Ruskin
(Author of the 'Stones of Venice',
'Seven Lamps of Architecture',
'Modern Painters' and some others).
Lewis Carroll, 'Hiawatha's Photographing' in *Phantasmagoria*, 1869, p. 72.

[3] Ruskin, *Collected Works*, Vol. VI, 320–34.

STUDY·OF·HORNED POPPY

FIGURE 2 *The Use of Plant Forms in Ornament*, from *The Art of Walter Crane*, by P. G. Konody, 1902

the spandrells of Woodward's Natural History Museum in Oxford—that they seem to prefigure *Art Nouveau*. Nevertheless, Burne Jones's drawings for the *Battle of Flodden*, his parabolic forms in *The Resurrection* and Rossetti's *Proserpine* seem to me worthy of inclusion in the prehistory of *Art Nouveau*[4] (Plates 74, 76, Colour Plate VII).

Looking at Ruskin's drawing of debris curvature the reader will at once have remembered the profile of Mount Fujiyama. From this he should draw no conclusions whatsoever; but it will at least serve to remind him of another great formative influence in the changing aesthetic pattern of the 'sixties and 'seventies.

In Paris, the influence of Japan had been felt in the late 'fifties. Whistler brought it with him when he arrived in London in 1863; already, in 1861 Henry Cole had invited a Japanese section to the Great Exhibition of that year. In 1865, a naval officer arrived in this country with a bundle of Japanese prints, some of which he gave to a very young artist who seemed to be vastly interested in them. The young man was Walter Crane.[5] By 1871 the *Art Journal* discovers the Far East and Japan appears as regularly in its pages as did Germany thirty years before.

The Japanese print, with its breathtaking pictorial audacities, captivated

[4] Mr. Schmutzler, in his learned work on *Art Nouveau*, sees the young Rossetti as one of the originators of the style and believes that he influenced Millais in this direction. I find some difficulty in accepting his views. See Schmutzler, *Art Nouveau*, 1964, pp. 62, 63.
[5] Konody, *The Art of Walter Crane*, 1902, p. 24.

FIGURE 3 Illustrations from Volume IV, chapter XVII of *Modern Painters* by Ruskin

Walter Crane. It exerted a very healthy influence upon a style which, too often, tended to a rather coarse imitation of Morris and Burne Jones. Crane is yet another of those artists who say most when they attempt to say least, and it is in his *Toy Books*, rather than in his big easel paintings, that he shows himself as a highly interesting, indeed a central figure, in the making of *Art Nouveau*. (Plate 95, Colour Plate V)

But the influence of Japan, which affected France as a revelation in colour and design, must surely have had another, and an additional effect, upon a country which, like ours, was so very much concerned with the literary content of art.

In the eighteenth century we had borrowed oriental *motifs*, but always for architectural or ornamental purposes; in history painting there were but two themes: the pagan and the Christian.

In 1857 it was still possible for Ruskin to declare that there was no serious art beyond the confines of Europe.[6]

But, obviously, confronted by the Japanese, British painters must have been obliged to think again. Here was a manifestly civilized, infinitely polite and gifted people, producing an art which had to be taken very seriously indeed, an art which represented transactions the nature of which could only be guessed at, the story of which was buried in the conventions of an alien culture, an art which therefore had to be accepted on purely aesthetic terms, an art which, for its discoverers, was art for art's sake.

When Whistler brought the Tables of Law—as Max Beerbohm puts it—from the summit of Fujiyama, the world was ready for his teachings. I shall discuss him and them in a later essay. Here I would like to mention his friend Albert Moore.

During his lifetime the fame of Albert Moore was somewhat overshadowed by that of his brother, Henry Moore, a very dashing but not very interesting marine painter. Today his name, for a long period almost forgotten, is again attracting attention.

Of the illustrations that I provide, Plate 83 is the more characteristic of his work. It shows that abiding interest in patterning and texture which his generation derived from Rossetti; it shows also the lack of moral earnestness, of recognizable content, which, to his contemporaries, was so startling a feature of his work. The other example (Plate 85) may help the reader to understand why he was regarded by critics of the 'eighties and 'nineties as an artist who had married the art of Greece to that of Japan.[7] It may also remind us that Moore developed within the influence of the later Pre-Raphaelites and that we have here yet another example of Burne Jones's eternal feminine. Nevertheless, we are, obviously, very far from that master's complicated state of erotic suffering. As a young American critic, Mr. Allen Staley, has put it:

> In the Victorian context, the Grecian ladies play about the same role as, in contemporary terms, the square of Josef Albers.

And again, quoting Swinburne:

> His painting is to the artists what the verse of Theophile Gautier is to poets; the faultless and secure expression of an exclusive worship of things formally beautiful. That contents them, they leave to others the labours and joys of thought or passion.[8]

In effect the aesthetic element in Rossetti's religion of beauty had grown with cuckoo strength until it had thrown everything else out of the nest.

And yet, another development of late Pre-Raphaelite doctrine was possible. Aubrey Beardsley, the last and the most wayward of Burne Jones's disciples, travels far from his master and yet never quite leaves him. In a sense he appears to be the natural outcome of later Pre-Raphaelism; in him the *Art Nouveau* curve

[6] Ruskin, *Collected Works*, Vol. XVIII, p. 76.
[7] Pythian, *Fifty Years of Modern Painting*, 1908, pp. 291–3; see also *Art Journal*, 1881, p. 163.
[8] Allen Staley, *Painters of the Beautiful*, New York, 1964, Introduction.

finds its ultimate extension, the mannerist figure its greatest altitude, the latent sexuality its final audacious expression, the voluptious religiosity its proper end. (Plates 45, 82)

Beardsley belongs to a continental movement and if I mention Charles Conder it is not because I claim him as a Pre-Raphaelite, but because he too, with his odd clumsily pretty evocations of Watteau, works in that international style to which the school of Rossetti had made its contribution. (Plate 26)

How large, how important the English element in that style may have been I do not know. In 1892 the *Art Journal* carried a report from Paris which suggests that, not only Burne Jones, but the hard-edge school, had become an object of interest.

> Now to be modern means to be cosmopolitan. Even the self-centred French-man has at length gathered this fact and . . . siezes on the themes of our English Pre-Raphaelites and presents his version of them dished up with French piquancy. Americans . . . seeing that Parisians have, in some manner or other, come to be aware of the existence of our primitives, offer them Yankeeised reproductions of Holman Hunt, Hughes and Madox Brown.[9]

A French critic of the late nineteenth century remarked that in any inter-national exhibition there are, in effect, two sections: that devoted to France and her imitators and that which represents British Art.[9] The fact that England had taken her own path was in itself interesting. The path that she had taken was likely to be congenial to those who were turning from realism to a mystical and symbolist art and who had already welcomed, in Gustave Moreau, a French equivalent of Burne Jones. At the same time Ruskinian ideas, bringing with them some hope of averting the social war which now threatened the continent, began to be known and appreciated abroad. It is perhaps a measure of Ruskin's growing fame that Signac and Cross should have appealed to his authority in advancing their views on colour.

At the end of the century the Arts and Crafts Movement spread rapidly through Germany and the Low Countries; Walter Crane was fêted, first in Budapest, then in Milan. Meanwhile the young Picasso in Barcelona was looking with passionate attention, not for news from Paris, but for the latest issue of *The Studio*.[10]

In short, it would appear that a peculiar contribution to painting which derives from Rossetti, which was enormously modified, first by Burne Jones and then by the Japanese, is one of the elements, drastically translated no doubt, which formed the art of the twentieth century.

But if we were, at this period, making an appreciable contribution to French painting, the French, at the same time were having a profound effect upon us.

[9] *Art Journal*, 1892, p. 328.
[10] The influence of Rossetti, Burne Jones and the followers of Burne Jones in Catalonia at the end of the last century is very fully discussed by Sir Anthony Blunt and Dr. Phoebe Pool in *Picasso, the Formative Years*, 1962.

The year 1870 may be used as a convenient punctuation mark in the history of British painting, as of so much else. It was in 1870 that Ruskin began his lectures at Oxford and that Poynter began to teach at the newly-founded Slade School in London, bringing with him a Frenchman, Alphonse Legros, to act as master of painting. In 1877 Sir Coutts Lindsay opened the Grosvenor Gallery, hanging Whistler's *Falling Rocket* upon his walls and provoking Ruskin to his celebrated libel. Nine years later the New English Art Club held its first exhibition at Colnaghi's. The 1870s sees the final and complete extinction of the Germanic influence in this country, and a growing interest in French painting which continues unabated for the next eighty years.

But when we think of the ascendancy of France which, together with that of Japan, certainly characterizes British painting during the last three decades of the century, we must remember that in those days it was a matter of some difficulty to cross the English Channel. It was a vast and stormy ocean, on the other side of which there were heaven knew what fortifications, labyrinths, landmines and moral petards bursting backwards to hoist the incautious foreigner who might lay siege to the studios of Paris. France was a very foreign country and one which required careful exploration.

It is necessary also to remember that French painting in the 1870s was not at all like the kind of French painting that we see in a London exhibition of nineteenth-century art. For us, the great French achievement of those years is concerned with the rendering of lights and hues, the observation of a hitherto unrecorded range of complementaries within the shadows cast by sunlit objects, the prismatic disintegration of local colour, the optical reunion of colours analysed down to their simplest, their most dazzling components. For us the French painting of the 'seventies is the purple shadow of a blue haystack beneath an orange sky or a bright ultramarine patterning of leaf shadows on a white muslin skirt.

It comes then as a shock to hear Ruskin allude to the muddy darkness of the modern French School, a school in which he could see only one supreme master, Edouard Frère.[1] But it is even more shocking that the young revolutionaries of the 'seventies and 'eighties were themselves under the impression that the chief lesson that we had to learn from France was a lesson in tonality, in *les valeurs*, in drawing.

Once again we see how easy it is to be misled by the judgments of history: we imagine that the visitor to Paris could hardly have avoided seeing the works of Monet, Renoir, Sisley, Pissarro and Manet, whereas the unavoidable painters would in fact have been Meissonier, Bonvin, Bésnard, Cormon and Bonnât. The Impressionists were there, but they were not easy to find. Monet does gradually emerge in the 1890s as a recognizable influence on British painting; but the rest are not clearly perceived until very late in the century. (One may perhaps make an exception here of Degas.)

It was not simply that they were hard to find, but that the English were not looking for them. Of the young English painters born about the middle of the century and coming to maturity in the 'seventies, very few, perhaps only Clausen and La Thangue, were seriously interested in Impressionism. Colour

[1] Ruskin, *Collected Works*, Vol. XIII, p. 371; Vol. XIV, pp. 141–3.

was something which had obsessed the older generation and had led to results—the excruciating arsenical greens, magentas, and coal-tar violets of Holman Hunt—of which a young man could hardly be expected to approve. What the young man wanted was realism, the kind of realism that would suit English tastes, something humanitarian and ennobling, and this he found in Jean François Millet, in Corot, and to some extent, in the School of Barbizon. He found it also in Fantin Latour and in Bastien Lepage; both of whom were sufficiently well known in England.

That generation which gathered together in protest against the Royal Academy and made the New English Art Club was not very deeply affected by Whistler. Whistler becomes the hero of modern painting in England towards the end of the century. In fact there is a certain hesitant vein of social realism, visible in the work of Frank Bramley, Stanhope Forbes and Luke Fildes (Plates 90, 92, 93, Colour Plate VIII), echoing perhaps the increasing social conscience of the time which may be discerned in the work of the last quarter of the century, and there is a hint of social protest even in Clausen (Plate 89). But one is near to the neutral objectivity of Impressionism and hence to purity of sentiment in the work of this artist and of La Thangue. Of the two La Thangue is the most Impressionist. Clausen is interested in silhouette: he is a linear artist, a tonal artist, altogether an English painter of his period and therefore a long way from Impressionism. But even La Thangue is far from his French contemporaries; colour is not his forte, what he has learnt from France is a certain audacity in the composition of pictures (Plate 91).

We have thus at the end of the century a kind of colourless Impressionism in England. At the same time there is a more frankly tonal landscape, deriving from Corot, Le Page and Jean François Millet and almost unconnected with the Impressionists, which is produced by four other painters, all of them born around the middle of the century—Alfred East, Wilson Steer, Fred Brown and B. W. Leader (Plates 86, 87, 88, 96).

Leader I mention mainly because he was so very highly regarded by cultivated public opinion at the turn of the century; he is certainly a very skilful performer but I find it a little hard to account for his prodigious following. East's adaptation of Corot seems more understandably popular; he has that taste for tall, soaring verticals, which is one of the signatures of the period and his view of nature is pleasant, urbane, dignified, with a quiet suggestion of *Art Nouveau* about it. Fred Brown, a very influential teacher at the Slade, which now becomes the chief nursery for young British artists, can on occasion produce work which is little better than a pastiche of Corot; but there is something lively and robust about him and he is an artist who would repay further study. All these painters were, it must be said, of unequal talent and none was more drastic in the variations of his achievement than Wilson Steer, at his worst a painter capable of shattering silliness. Steer at his best really did understand colour, really did achieve a kind of synthesis between the impressionism of Whistler and the impressionism of Monet. He was a man, I imagine, of almost ludicrous simplicity of mind who could rise to the heights when he could find a subject to match his own simplicity, but who also attempted eighteenth-century conceits or parodies of Constable or heaven knows what misguided poetics for which he had no aptitude whatsoever.

Whistler was 54 when the New English Art Club was founded and had been

settled in Chelsea since 1863. He worked as an illustrator, he exhibited and some-
times sold his works at the Academy where he was not unkindly, or at all
events not savagely, noticed. He achieved celebrity by his wit; but until the
crucial period of the 'seventies he was not regarded as an enemy of society and
was on fairly civilized terms with the world at large. It was in 1872 that he
quarrelled with the Academy over the hanging of the portrait of his mother;
henceforth he sent no pictures to Burlington House. Meanwhile he was forming
his style. His former colleagues, the pupils of Courbet and Manet, had not fully
developed *pleinairism* before 1870, but Whistler saw where they were going and
deliberately set out upon a divergent path.

> . . . I came at an unfortunate moment, [he wrote to Fantin Latour in the
> 'sixties]. Courbet and his influence were odious. . . . That damned realism
> made such an appeal to my vanity as a painter, and, flouting all tradition [I]
> shouted with the assurance of ignorance 'Vive La Nature! . . . Oh! why
> wasn't I a pupil of Ingres? I don't say that in rapture before his pictures, I
> don't much care for them. . . . But, I repeat it, why wasn't I his pupil? What
> a master he would have been. How safely he would have led us. Drawing by
> Jove! Colour, colour is vice. Certainly it can be and has the right to be one of
> the finest virtues. Grasped with a strong hand, controlled by her master,
> Drawing, Colour is a splendid bridge with a husband worthy of her—her
> lover but her master too—the most magnificent mistress in the world, and the
> result is to be seen in all the lovely things produced from their union. But
> coupled with indecision, with a weak, timid, vicious drawing, easily satisfied,
> colour becomes a jade making game of her mate. . . . And look at the result,
> a chaos of intoxication, of trickery, regret, unfinished things. Well, enough
> of this. It explains the immense amount of work I am now doing. I have been
> teaching myself this for a year and more, . . . I am sure I shall make up the
> wasted time. But—but—what labour and pain.[2]

Thus in the 'sixties Whistler turns his back on the free pursuit of colour, and
it is hardly an exaggeration to say that in so doing he carried English painting
away with him into the pursuit of line and tonality, into a completely one-sided
and idiosyncratic interpretation of Impressionism that was to characterize
British Art for half a century.

But if Whistler rejected realism and colour he did not seek or did not find an
Ingres to direct his pencil in the pursuit of the ideal. The greatest living exponent
of academic drawing was Degas but Degas remained, or rather became, a very
thorough-going realist and his influence on Whistler was not very great.
Instead Whistler addressed himself to Velasquez and the Japanese. From both
he extracted a kind of elegance, a 'daintiness', to use his own favourite word,
which, when used with exquisite tact and considerable power, could produce
some very notable results (Plate 81), but could also lead to an almost precious
nicety of handling, a social grace which pleases but does not move us profoundly
and which, in the hands of his followers, could easily degenerate into a very
trivial kind of stylishness.

Whistler's followers were the young men who reached maturity in the 1880s
and 1890s. As his reputation grew there can be little doubt that a personality as

2 *Art Journal*, 1906, p. 9.

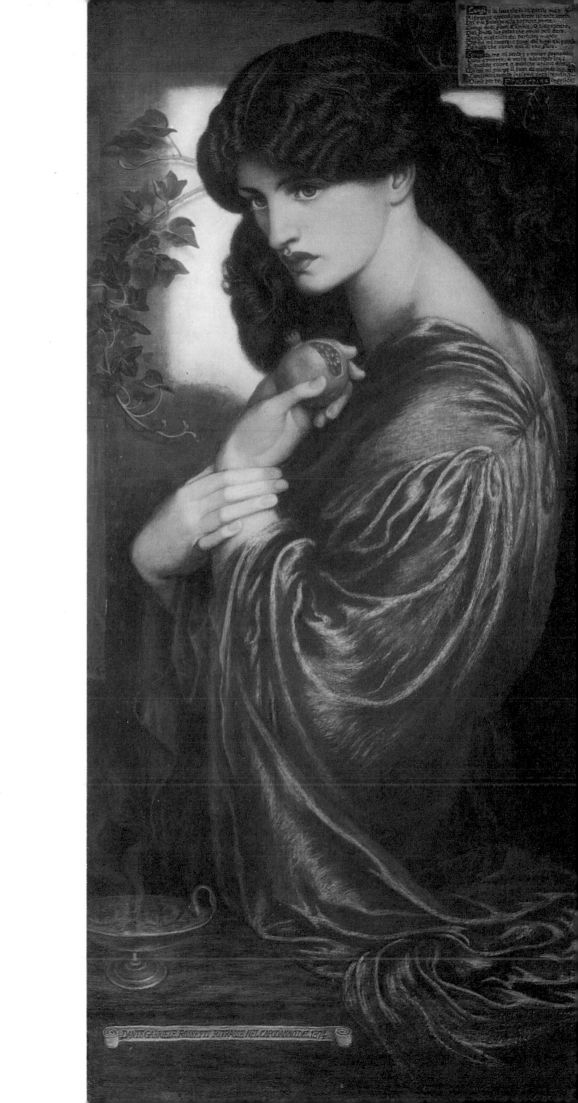

formidable, a talent as remarkable as his, would have attracted disciples. But to that generation Whistler was I think more than a great man, he was a hero and indeed something of a martyr. The collision with Ruskin was a disaster for both parties, for Whistler's temper and fortunes, and for Ruskin's reputation. Whistler, financially ruined by the encounter and permanently embittered, left nevertheless a legend of mental agility in the witness box; his was the verbal triumph of the wit and the aesthete over the philistine, an exhibition of forensic brilliance which, I suppose, was what led poor Wilde to his fate seventeen years later. Ruskin himself was not present at the trial, he was at the beginning of his madness, and so the unfortunate Burne Jones, a timid, unwilling conscript, was thrown into the battle shoulder to shoulder with Frith. An awkward squad if ever there was one. Burne Jones had very little stomach for the fight and I doubt whether he very much cared for his ally or that his ally very much cared for him. At all events Burne Jones's weakness, the fact that Frith was by now identified with all that was most bleakly reactionary and bourgeois in the Academy, Ruskin's own absence—which meant that a serious case against Whistler was never put—the brutal philistinism of the Attorney General and the Judge, all left the impression that Whistler was fighting not simply for himself but for Art and that Ruskin stood unequivocally on the wrong side.

The trial marks the beginning of that long decline in Ruskin's reputation of which we are only now beginning to see an end. I have already attempted, in considering the art of Rossetti and Albert Moore, to describe the manner in which an art of praise, in which the object of worship was mythical, came into existence and, after the discovery of Japan, became an art which praised nothing save art. Whistler's quarrel with Ruskin will serve to remind us of another determining influence of the late nineteenth century in England. People were becoming bored by and irritated with Ruskin.

He had enemies. He had made plenty of statements which left him open to attack; above all, the Victorians were tired of his tone of voice, they were tired of being preached at, scolded at, thundered at. Manifestly the future lay with some other kind of criticism or perhaps with no criticism at all, with an art which called for no comment, which—oh blessed relief—carried no message, which was a self-sufficient, as self-explanatory as the music of Scarlatti.

We have seen the logical conclusion of that train of thought in the painting of our century: the perfectly tasteful regulation of forms and colour unhampered by meaning or message. The followers of Whistler: Lavery, Orpen, William Nicholson, Augustus John, McEvoy, were not so thorough-going. They found the necessary elements for their 'harmonies in grey and gold', their 'arrangements in black and white', in natural forms; but in their choice and in their translation of subjects, they display the same nicety as their successors in the 1950s. There was a considerable body of talent available for their aesthetic researches and the research itself was a project of some magnificence.

Everything depended on getting the relationships right. The drawing must be a faultless essay in harmonious intervals, an impeccable pattern which will be perfectly completed, completed with the snugly-fitted perfection of a jigsaw by the addition, not so much of colour, as of exquisitely graduated tones. A work like *The Mirror* (Colour Plate VI) by Orpen has this quality, the painter has learnt the lessons of Whistler, of Vermeer and Velasquez; nature, it would appear, has played straight into his hands, his design has been given him and he has used it

VIIIa STANHOPE FORBES :
The Health of the Bride.
Tate Gallery

VIIIb ARNESBY BROWN :
Silver Morning. Tate
Gallery

with consummate skill. And yet, this exquisite withdrawal from life, this refusal to be bothered with anything save the patient and sensitive correlation of harmonized forms, does not after all escape from its social context.

Consider Lavery's *Grey Drawing Room* (Plate 84). I choose the picture because, although it dates from the very end of our period, it seems to sum up all that the followers of Whistler could learn from their master; the tall elegance of the curtains and the mirror and the standing lady, balanced by the seated man, the pattern of pictures and fireplace, the fine tonal 'rightness' of it all shows the school at its best. But this is certainly not a picture that need be considered simply on its purely formal merits.

Today we can look at it as a document of social history, a whole society is here, a society which has leisure and taste and imagination and dividends, it is 'awfully nice', as nice as the painting. Even the artists and the writers are 'nice'. See how Orpen has immortalized them. How serenely Eva Gonzales looks down upon George Moore, Wilson Steer, Tonks, MacColl, Hugh Lane and Sickert. How noble they look (Plate 98).

This is the life of cultivated gentility; another kind of society, more opulent, less introspective and less restrained, lies very close to it and its painters again take something from Whistler, but more from his compatriot, John Singer Sargent. Intermediate between them we find painters such as J. J. Shannon. Sargent, an international figure, was certainly well instructed in the techniques of Impressionism. For him they become the great means to 'effect' and in him they are combined with the methods of the later English portrait painters of the great school, Hoppner, Raeburn, Romney, the school in fact of Slosh. There is more to Sargent than that; but the Wertheimer portrait of 1901 (Plate 100), fascinating though it is as a document of British Society at the beginning of the century, is little more than a piece of dignified Edwardian Baroque furniture. J. J. Shannon and William Nicholson at their best (Plates 94, 101) are much more interesting painters with more style and more integrity than Sargent.

The influence of the successful portrait painters, and in particular of Sargent, was very great. It accounts in part for the collapse which followed.

For once again this history becomes a history of degeneration. Brangwyn, Lavery and Orpen, McEvoy, Shannon and Augustus John—perhaps the most brilliant of them all—were still exhibiting when I first began to look at pictures with an attempt at comprehension, and what they were exhibiting in the 1920s was abysmal. It is in a way shocking to discover how good they once were. In each case the history is the same. They were without the power or the will to sail against the wind of fashion, indeed the doctrine of art for art's sake left them no other motive. They had nothing to lose but their taste.

The great flood-tide of late Victorian and Edwardian optimism, the age of little wars and great dominions, of the steadily increasing supply of pearl necklaces and the steadily increasing supply of bosoms to support them, drifted them into fashionable portraiture, allowed them to float prosperously and without exertion and when, suddenly, that pomp of waters ebbed, they who had ridden so high were left grounded, their spars askew, their hulls naked and ridiculous upon the mud-bank of history.

Such metaphors and such generalizations may be dangerous. Generalization is inevitable and metaphor will, I hope, be excused; but I must point out that I have treated the School of Whistler very much as an isolated thing, isolated

say from Conder and Aubrey Beardsley and such attempts to categorize cannot but be somewhat unreal. Also I have omitted two important names: Sickert, to whom my last chapter is mainly devoted, and William Nicholson.

William Nicholson in his early paintings shows nearly all the characteristics of the Whistlerian School: the love of elegance, the distinguished pose, the vertical form. He was not only a painter, and his work in conjunction with James Pryde in making posters and illustrations shows a natural development of the flat two-dimensional rendering of forms into a medium for which it was particularly appropriate. And yet, to my mind, Nicholson's early work in black and white is by no means his best; in fact often it seems to me intensely boring. He was a painter rather than a designer and in his case, happily, there was that inner spark of constancy which endures to the end, so that despite some regrettable portraits and some meretricious still-lives he went on painting good pictures—some very good—until his death.

8
Sickert
and the Post-
Impressionists

In 1910 the first Post-Impressionist exhibition was held in the Grafton Galleries. The British public discovered with horror and astonishment what had been happening in Paris; in April of the same year the Royal Academy held its one hundred and forty-second exhibition.

The Academy itself had not played an adventurous role in the history of Victorian painting. It had been slow to welcome either the Pre-Raphaelites or the New English Art Club; Rossetti, Burne Jones, Holman Hunt, Watts, Albert Moore, Ford Madox Brown and Whistler were not included amongst its forty immortals. Nevertheless there were many outsiders and some rebels who were anxious to find a place in its summer exhibitions.

> By an overwhelming majority the artists testify to the preference they give the Exhibition at the Academy over any other in the kingdom. Individual disappointments, and even cases of injustice, are occasionally met with, but in spite of this the judgment of the Academy Council, composed as it is entirely of experienced fellow-workers, is regarded by the great bulk of artists in general as the best and fairest that can be found. . . .[1]

Thus wrote Leslie, not without a certain measure of truth. He proceeds to point out that Government institutions, and specifically the Royal College of Art, had full confidence in the Corporation and confided to its members the awarding of all prizes. Indeed it might be said that in 1910, and for long after, the Academy had its place almost as of right, although it was not responsible to Parliament, in all national decisions where the Fine Arts were concerned.

The Academy could moreover claim that, although it did not encourage aesthetic rebellions, it came to terms with them. Millais had in the end come to the Presidency and the rebels of the 'eighties and 'nineties were drifting gracefully into the fold: Sargent in 1897, Clausen in 1898, Orpen in 1910. Shannon was to follow in 1911. By this time indeed, the feud with the New English Art Club, which had started with revolutionary manifestos directed against the Academy, had lapsed and it had become a kind of Lower House where radical sentiments could be softly uttered in polite terms.

At this point, if I were delivering a lantern lecture with two screens behind me I would project on one of them *Pearls for Kisses* by Fred Appleyard, which was exhibited at the Academy in May, 1910 (Plate 110), and on the other a Cézanne, one of the Cézannes which were shown to the British public in December of that year. I would then ask you how Mr. Appleyard's public was likely to react to Post-Impressionism.

The question is of course rhetorical. It need hardly be said that the art-loving public decided, with an almost unanimous voice, that the Cézanne was obscene.

The cry of fury and disgust which arose at the sight of the Post-Impressionist pictures in the Grafton Gallery has been described. There is no necessity here to quote the fierce denunciations of Sir William Richmond, Mr. Morley and Mr. Robert Ross, the philippics of Ricketts and Philip Burne Jones, nor to discuss the furious gibes and savage innuendos that fell upon the puzzled, amused and yet slightly indignant head of the organizer of the exhibition—Roger Fry.

What needs to be assessed, if we are to understand the character of British art at the beginning of the century, are the emotional sources of the opposition to

[1] G. D. Leslie, *The Inner Life of the Royal Academy*, 1914, p. 72.

Post-Impressionism which was most acutely felt and violently expressed by artists themselves.

A large measure of historical sympathy is called for if we are to understand why the Post-Impressionist exhibition created such distress. We need to understand the feelings of people who were genuinely outraged by what they saw, people many of whom lived long enough to change their opinions. To this end I would, in the first place, like to discuss the character of the Royal Academy annual Exhibition.

The Exhibition which graced the London season for the year 1910 was not felt to be particularly brilliant. Both *The Times* and *The Studio* described it as being, on the whole, disappointing. And yet, the critics of both these journals were able to point to some good work.

The Times singles out for praise Brangwyn's heroic decorations for Pittsburgh, Edwin Abbey's histories, Mr. Arnesby Brown's cows (Colour Plate VIII), Mr. Shannon's *Duchess of Buccleuch* and a portrait by Mr. Briton Riviere, a painter best known for his morally invigorating pictures of polar bears (Plate 107).

Looking back over old numbers of *Royal Academy Pictures* it is hard to see any radical change in the prevailing style during the first decade of the century. In 1910 Mr. T. C. Gotch is rather less determinedly Pre-Raphaelite than he had been in 1896, Miss Laura Knight shows a lively Impressionist sketch entitled *Flying a Kite* (Plate 106), Mr. Sims has something of the same kind but in neither case is this the kind of Impressionism that could, so to speak, 'hurt'. The President, Sir Edward Poynter, and his successor, Sir (then Mr.) Frank Dicksee remain faithful to themselves. If the reader will refer to Plates 102–111 and Colour Plate VIII, he will gain not too unfair an image of official painting during the Edwardian epoch and may fairly conclude that it continues the Victorian Age.

A truly representative selection would of course have to be very large. It would include a great many misty streams at dawn and sunlit orchards by the River Wye, a wilderness of rolling seas, a bevy of muslin debutantes, a pride of mayors, and no end of urchins, hounds and horses. Nor should I forget Henry Tuke's hardy adolescents by the Cornish coast (Plate 108), with always a mast, a spar, a passing seagull, some blessed bollard or a supremely fortunate garland of rigging to hide their impudence. Then there was Ernest Crofts, manfully treading in the footsteps of Lady Butler and producing, with a wealth of accurate military detail, *The Capture of a French Battery by the 52nd Regiment at Waterloo* (Plate 103). But the list grows too long, besides my intention is merely to show how much the Edwardian appetites could stomach. For this purpose the works that reproduce are sufficient.

It was, in its way, a superbly uninhibited age. Confined within the liberties of the picture frame, it could reveal its yearnings and its complacencies, its violent and its tender emotions, its pride and its gentility. It had no need of the defensive joke, the allusive and arcane obscurities behind which we half conceal our pictorial literature. Who, today, would so frankly depict a nice young lady being thrust under duress into the bed of a stranger, for that in effect is what is going on in Plate 104. Did anyone titter when the painter's wife (who worked under the name of Henrietta Rae) presented to the public her very different conception of the proper relationship between the sexes (Plate 105)? I doubt it. For pictures of this kind were, so to speak, beautiful dreams remote from the realities of life. And in the year 1910 dreams were not scrutinized as they are now.

To be violently shaken out of a daydream is unpleasant. This sense of shock was, I believe, one important element in the fury of that year. But the protests came, not only from Academicians, but also from the New English Art Club, and even from the most revolutionary and most gifted of English painters, Walter Sickert. To understand the anger and thereby to understand the art of the period, it is necessary to examine several shades of opinion.

The violence of the Poynters and Dicksees, of the artistic establishment in London, is understandable enough. They were addressed in an entirely foreign pictorial language and they had to contemplate an aesthetic to which they were wholly unaccustomed. To them it seemed that certain skills acquired since the fifteenth century were being set aside, that certain standards of 'finish' expected in an easel painting were disregarded and that, in failing to meet these requirements, the Post-Impressionists showed either incompetence or effrontery. But the violence of the art-loving public suggests a deeper cause of offence. It was in fact precisely those who had most admired the unsophisticated charms of the epoch before Raphael who were now loudest in their disgust.[2] Their feelings might be compared to those of someone who has for long admired the Christian sculpture of the twelfth century and is confronted by the equally skilful, but darkly alien and profoundly disquieting work of savages. It was not 'incompetence' that troubled these artists and cognoscenti but 'ugliness'.

I have said that the Victorians loved beauty; the Edwardians loved it, if it were possible, even more. But the beauty to which they were devoted—and honestly devoted—was a social thing. It had very little to do with reality as, say, the young Pre-Raphaelites understood the word. It was concerned, rather, with the poetry of evasion. The artists wanted, and their public wanted, either to avoid, or to dignify, to render socially acceptable, to ease the guts out of all that was coarse, violent, impure and uncompromising. Hence the anodyne subject: nature, the cottager, the comic or tender incident; hence also the nobly flattering portrait, the calculated gallantry and panache of the high imperial theme; and hence also the drama of lust and violence, for in paint it is made poetically acceptable and over all is flung the safe warm cloak of art.

But suppose that art is something different, suppose one must look at works of art which are not concerned with social refinement, at works which are informed by all the crude violence of emotion that you might find in the crudest productions of our forefathers, but unattenuated, unpatinated by the pleasing hand of time. Then, even though the artist might embody his ungoverned feelings in pots and pans, apples and pipe-smoking card players, the polite spectator must feel a profound disquiet. Such art is, in every sense of the word, rude.

The grand tendency of Victorian art is in the direction of polite feeling. The age was, after all, made by a class which had but recently achieved power and which was in consequence desperately conscious of the need to prove its gentility; an aristocracy would have been neither so gentle or so genteel. To such a class the expression of any sincere emotion is, necessarily, dangerously close to a breach of manners. The truths of Post-Impressionism suddenly, loudly, and abruptly shouted, were abominably uncivil.

The rage and laughter of London in the last months of 1910 is, in this light,

[2] Roger Fry, 'Retrospect' in *Vision and Design*, 1920, p. 192.

understandable. Moreover, the town had been taken unawares. In Paris, where the blows fell with less interruption, the emotion was never so great and perhaps Fry might have been held in less execration if he had proceeded with more tact.

That which was felt by what we may call the die-hards of the art world must have been felt equally by the older members of the New English Art Club. In fact one may surmise that their sentiments were more bitter because, in a positive sense, they had more to offer.

And now, having looked with some attention at the Old Guard at Burlington House I feel that I must in simple justice emphasize the fact that the New English, although it failed to do what one might have hoped it would do for British Art, did not fail altogether.

The general run of the Academy painters, the Dendy Sadlers and Byam Shaws, the Solomons and Sants and Dicksees, were incompetent at any level and the critic might fairly say to them, as Lord Chesterfield said to Garter King at Arms: 'You foolish man, you do not even know your own foolish business.'

The New English painters did at least know their business, and it was not always so foolish. They maintained a decent professional standard, they had a certain tact and a certain skill, they brought to our studios a breath of Parisian fresh air at a time when British art had become unbearably stuffy. The methods they had learnt in French studios, the effective placing of masses upon the canvas, the commanding pose, the adroit tonal planning, the suave manipulation of the brush, did at least represent a serious professional effort. They were very competent craftsmen and were justifiably proud of their craftsmanship. For that very reason they found a kind of painting which made craftsmanship seem irrelevant, completely intolerable. For the Slade School and for its remarkable teacher, Henry Tonks, Cézanne became and always remained the Enemy.

But it was not only for the Academicians and for the New English artists that Post-Impressionism was a catastrophe. It fell with greatest force upon a little group of painters who stood at the extremity of the artistic spectrum, that coterie which, since his return to England in 1904, had gathered around Walter Sickert at No. 19 Fitzroy Street and which was to become, in 1911, the Camden Town Group. In the case of these young men the term 'catastrophe' may be used in its less usual sense, for Post-Impressionism offered them the possibility of a complete change of direction, a drastic and perhaps glorious transformation of themselves. But they had been trained in the New English school, they had made of its teachings something good and solid and their leader, Walter Sickert, was violently opposed to Cézanne on grounds that were by no means contemptible. For them therefore the decision was, not only crucial, but very hard to make, in that they had to choose between two kinds of aesthetic truth, two equivalent systems of aesthetic virtue.

Sickert was born in 1860, he was just of the right age to be entirely captivated as a young man by Whistler and he appears, in the 'eighties, as the disciple of The Master. As such he at once displayed notable brilliance in paint, in print and in conversation. But, beyond Whistler, lay something else, the half-known world of Impressionism.

In Paris he discovered Degas and at once realized that here was a master of a rather different magnitude. For the rest of his life Sickert was a follower of Degas, paying very little attention to the Impressionists, a draughtsman profoundly concerned with the presentation of observable truth and, more parti-

cularly, with the human comedy. As such, he remained within the British tradition as it existed in his time. He was only a step away from the painters of the New English Art Club, but the interval was of decisive importance.

'A glance round the walls of any New English Art Club exhibition [he wrote] does certainly not give us the impression of a page torn from the book of life.' That was the essential thing—'life'. It was that which Degas had seen, steadily and whole, that which the Impressionists, with their fields and haystacks, had lost sight of—the human comedy that makes art great.

Now Life is a commodity which every painter is ready to define in accordance with the bent of his own genius. Degas found in on the racecourse, in the brothel, in the *coulisses* of the Opéra. Save for a short period when he painted Venetian architecture (with much profit to his sense of design), Sickert pursued 'life' with unabated appetite in the smoke-filled galleries of the music hall, in the streets of Dieppe and in cheap bed-sitters in Camden Town. Life was not really life until you approached its harder realities; you will find it, not in the drawing-room but in the kitchen. Refinement, prosperity, the august site, the 'nicely got up young person', are not properly alive; nor should you look for it in the dramatic squalor of unqualified misery, the picturesque is as far from life as the refined.

But of all lifeless places none is so dead as the life room of the art school. There sits the expected model in the inevitable pose. There students subtly convert her into a plaster cast, *le nu académique*, stiff, cold, deformed by the ideal corsets of antiquity. She is a prop; she gathers dust.

But fire the model, follow her through the drab streets of Camden Town, up the grubby stairs of the house that she shares with heaven knows what dubious friends, into her bed-sitter, where pale attenuated sunlight filters through grubby lace curtains upon an unmade bed, and then, as she yawns, weary, plain, *desoeuvrée*, yet relaxed, then—*there* is 'life'.

Life is fleeting. It will not pose, nor is it right that it should, for pose means unreality. You must then draw it feverishly, not making a 'work of art' but rather capturing at high speed the essentials of the situation.

And the essentials of the situation are given by tone, by accent, by the minimum of precisely necessary lines, and when the swift drawing becomes a painting this remains true; the picture of life is essentially a tonal picture. Sickert enriches his colour in the years between 1904 and 1910, but the lovely harmonization of warm and cold that we find in the pictures of this period are always subordinate to the tonal plan.

The painting of life is the painting of a 'story'.

'I have always been a literary painter, like all decent painters,' wrote Sickert to Virginia Woolf, 'do be the first to say so.'[3]

But it is a reticent literature. Sickert is committed to a kind of realism which insists upon banality, upon the normal, the mediocre. Drama, anecdote, pathos, he excludes, as his master Degas had excluded them, they can at best (or at worst) be inferred; in real life you will not see figures which explain themselves in the manner of a Hogarth or a Daumier. It was perhaps appropriate that the authoress of *An Unwritten Novel* should have made him the subject of an essay[4]

3 Virginia Woolf to Quentin Bell, 8 March 1934.
4 Virginia Woolf, *Walter Sickert, a Conversation*, 1934.

for just as Virginia Woolf builds a biography upon the unknown character of her silent companion in a railway train, only to shatter it against the hard vessel of reality, leaving us in the end with a deeper apprehension of the richness and variety of existence, so Walter Sickert offers us, so to speak, the woman in the train and with her a multitude of possible situations.

Sickert indeed is perfectly ready to tease the spectator with false clues. Frank Rutter tells us that the study originally entitled *The Camden Town Murder* was later exhibited as *Father Comes Home* and finally sold as *The Germans in Belgium*.[5]

Sickert's literature is then a literature of mood, a literature of suggestion and above all, a literature which achieves its end by charging the commonplace with a current of the highest tension. Look at Plate 112 and then, indiscreetly, through the still uncurtained windows of some modest home where the lamps are lit for tea of an autumn evening. There you may be sure to find any quantity of unpainted Sickerts. People neither remarkably beautiful nor remarkably ugly are going about their wholly unremarkable business. There is no drama, no gesticulation, no message. The flowers are slowly dying, the cigarette will soon be finished, the glass is nearly empty. By what magic the space between the woman's backside and the picture on the wall, the relationship of gently aspiring curves, their ascent terminated by the oval frame, the play of lamplight, the pattern on the wall-paper, is made as grand as Veronese I do not know. But the thing has been done. From elements of the utmost banality Sickert has extracted a masterpiece. He himself wrote of Spencer Gore that he could wring attar of roses from a stone.[6] It was true of Gore, but it was even more true of Sickert himself.

If I have not wholly failed to convey my meaning in the foregoing pages it will be clear that Sickert had found a way of painting that was, at all events, wholly suited to his own genius. Degas had told him of his regret that the younger generation should have experimented with colour rather than with drawing. By 1910 Sickert could fairly say that he had been more fortunate; the more gifted of the younger men could hardly fail to see that he stood head and shoulders above his English contemporaries, and it is possible, until the time of the Post-Impressionist exhibition, to speak with exactitude of a School of Sickert.

I hope that it may also be clear why, when Post-Impressionism came to England, Sickert, despite his considerable respect for Van Gogh and for Gauguin, found himself in complete opposition to Fry and violently opposed to Fry's estimate of Cézanne.

Of the younger men who had to choose between Sickert and Cézanne and who, inevitably as it now seems, chose the Post-Impressionists, I need say little. They do not belong to the history of Victorian painting. We are only now beginning to realize that artists such as Bevan, Ratcliffe and Drummond were very fine painters, even the really astonishing gifts of Harold Gilman and Spencer Gore have yet to be appreciated at their true worth; there was no lack of talent in the School; what they did lack was any knowledge of what was happening on the continent of Europe.

This last phrase is an exaggeration; but it is not a gross exaggeration. Bevan, to be sure, had been at Pont-Aven with Gauguin and brought from the con-

[5] Frank Rutter, *The Camden Town Group, a Review*, 1930, Introduction.
[6] Walter Sickert, 'A perfect Modern', in *A Free House*, 1947, p. 277.

tinent something of French Post-Impressionism, something too of the flaming colour and mysterious agitations of central Europe; but Spencer Gore, influenced not only by Sickert, but by the expatriate Lucien Pissarro, was producing pure Impressionist paintings of outstanding beauty, such as might have been made thirty years before in the Isle de France. Gilman, completely under the influence of Sickert and the New English, was entirely and thoroughly insular.

There was, however, a profound feeling of dissatisfaction with the New English Art Club. The young men tried to set up a new body, the Allied Artists, which held a few enormous exhibitions without a jury to exclude pictures and this resulted, in 1910, in bringing Charles Ginner to London, and with him the doctrines of Van Gogh. The young rebels also exhibited on Saturday afternoons in Sickert's studio and, after these not very profitable exhibitions, the group of rebels would meet in a restaurant in Golden Square to discuss the formation of some organization which would serve the *avant garde*.

The final determination to break with the New English at all costs was not made until after the Post-Impressionist Exhibition. At that moment all the unstable elements in the situation were set in furious commotion.

The Camden Town Group formed and almost at once broke into fragments. John came into the group and then flew back to the New English. The younger men launched violently into Post-Impressionism. All the quiet, dingy, tasteful refinements of the late Victorian palette were hastily scraped away. Brilliant chromes, cadmiums and alizarines took their place. Violent complementaries leapt between jagged thick lines of ultramarine drawing. Spencer Gore became a Post-Impressionist overnight. Gilman began to paint like an inspired lunatic. Quiet artists, men who seemed incapable of mischief, suddenly took fire from the general conflagration and burnt themselves out in a frantic blaze of excitement. New figures: Epstein, Wyndham Lewis and Duncan Grant, soared away upon unfamiliar trajectories.

Never, in living memory, had England seen anything like this. The Victorian Age was gone. It ended with a bang.

The Plates

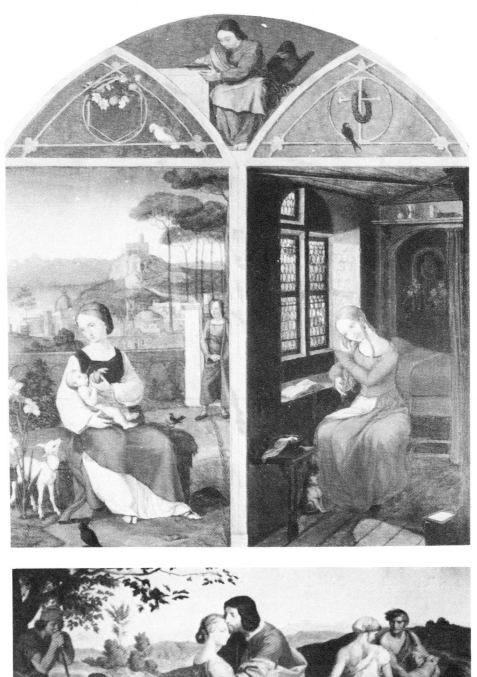

1 FRANZ PFORR: Sulamith und Maria. Collection Georg Schafer, Schweinfurt
2 JOSEF VON FÜHRICH: Jacob and Rachel. Osterreichische Galerie, Vienna

3 WILLIAM POWELL FRITH: At the Opera. Harris Museum & Art Gallery, Preston
4 JOSEF VON FÜHRICH: two engravings from the *Art Journal* (1851)

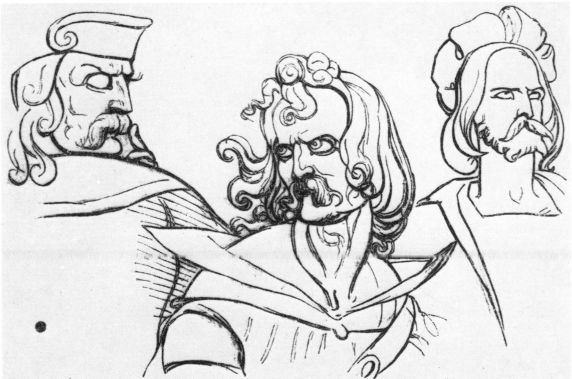

5 EDWIN LANDSEER: There's No Place Like Home. Victoria & Albert Museum
6 'The German School' (from *Punch*, Vol. X, 1846)

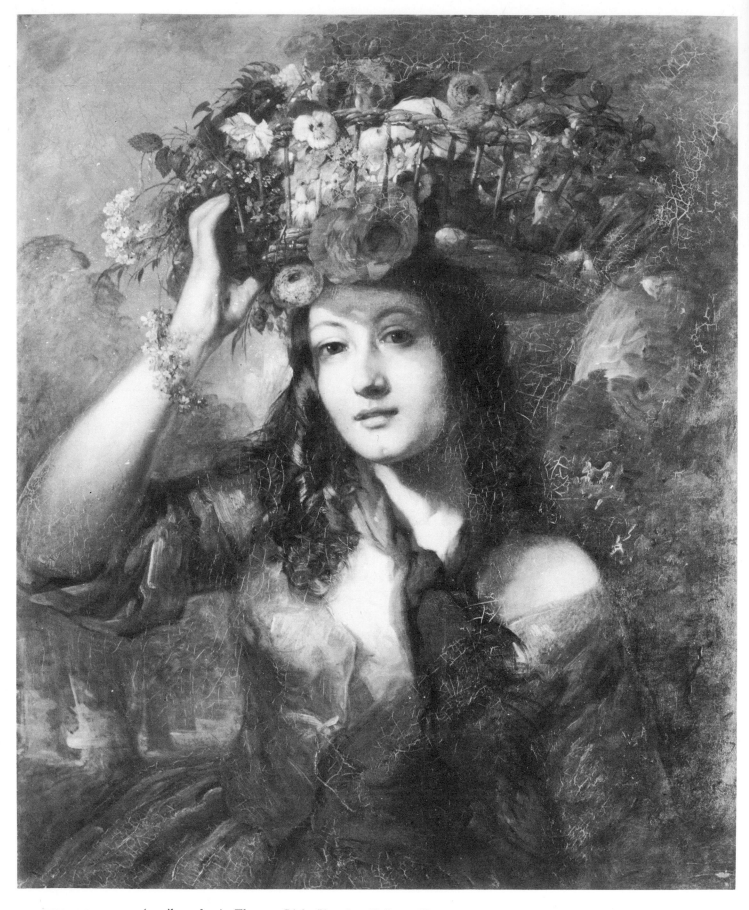

7 WILLIAM ETTY (attributed to): Flower Girl. City Art Gallery, York

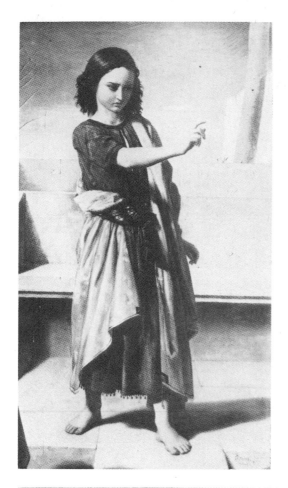

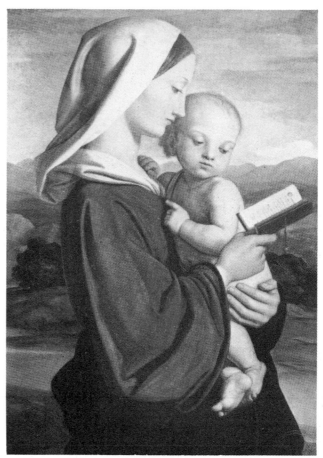

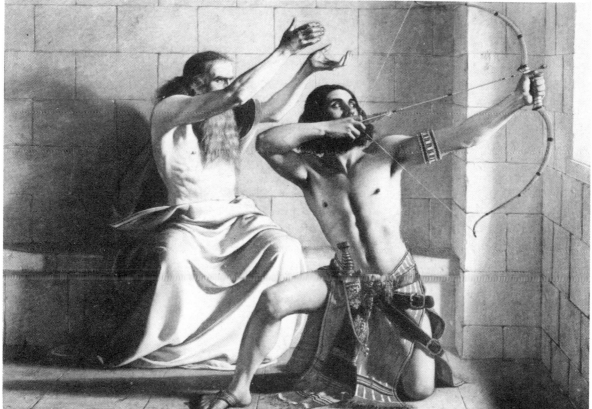

8 JOHN ROGERS HERBERT: The Judgment
 of Daniel. Harris Museum & Art Gallery,
 Preston

9 WILLIAM DYCE: Madonna and Child.
 Reproduced by gracious permission
 of Her Majesty the Queen

10 WILLIAM DYCE: Joash Shooting the Arrow
 of Deliverance. Kunsthalle, Hamburg

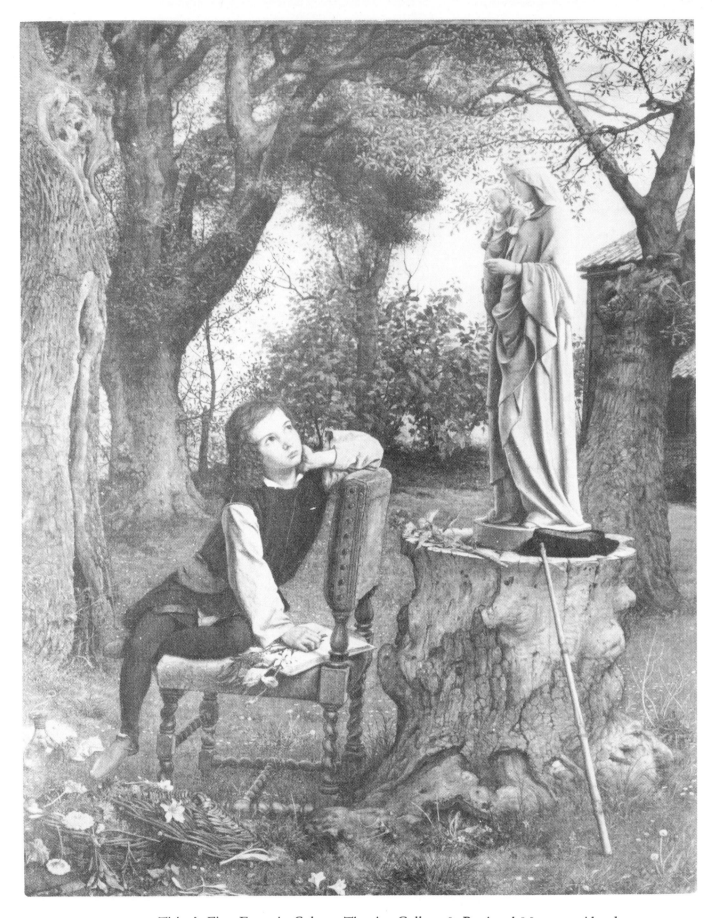

11 WILLIAM DYCE: Titian's First Essay in Colour. The Art Gallery & Regional Museum, Aberdeen

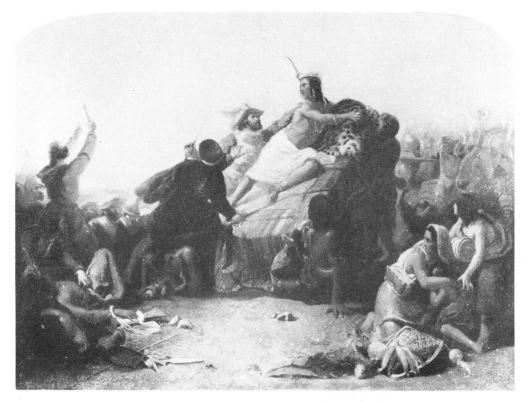

12 JOHN EVERETT MILLAIS: Pizarro Seizing the Inca of Peru. Victoria & Albert Museum

13 WILLIAM E. FROST: The Sea Cave. Russell Cotes Museum, Bournemouth

14 BENJAMIN ROBERT HAYDON: The Raising of Lazarus. Tate Gallery
15 BENJAMIN ROBERT HAYDON: Punch, or May Day. Tate Gallery

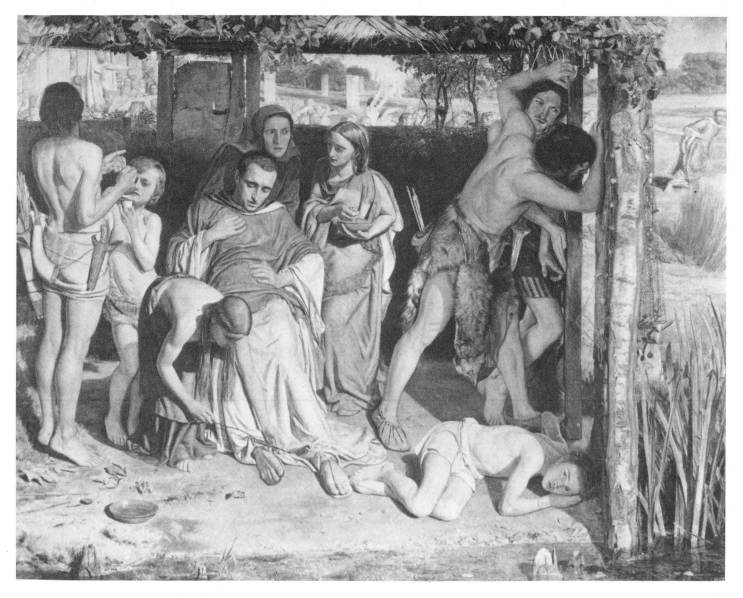

16 WILLIAM HOLMAN HUNT: Early Britons Sheltering a Missionary from the Druids. Ashmolean Museum, Oxford

17 Detail of the above taken in a raking light

18 DANTE GABRIEL ROSSETTI: Study for *Found*. Emily and Gordon Bottomley Bequest, City Art Gallery, Carlisle

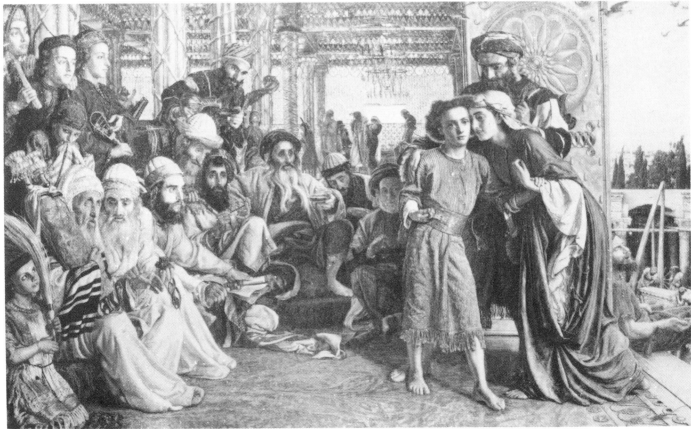

19 WILLIAM HOLMAN HUNT: The Triumph of the Innocents. Walker Art Gallery, Liverpool
20 WILLIAM HOLMAN HUNT: The Finding of Our Saviour in the Temple. City Museum & Art Gallery, Birmingham

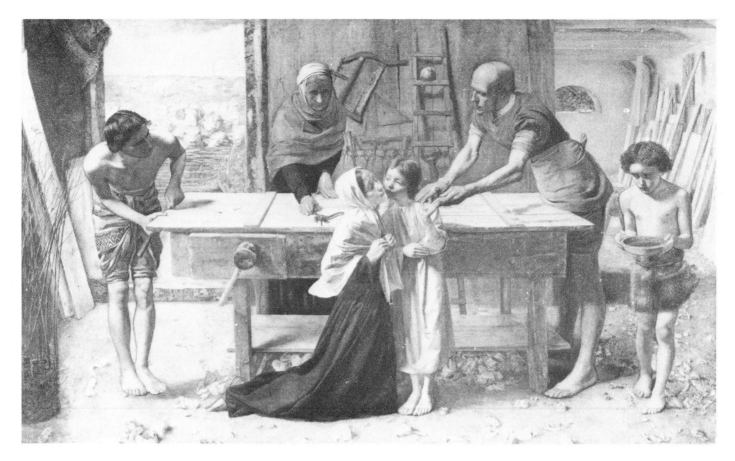

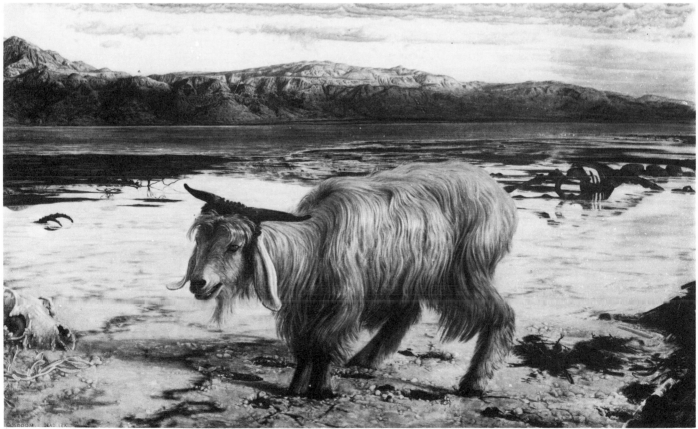

21 JOHN EVERETT MILLAIS: Christ in the House of His Parents (The Carpenter's Shop). Tate Gallery
22 WILLIAM HOLMAN HUNT: The Scapegoat. By permission of the Trustees of the Lady Lever Art Gallery, Port Sunlight

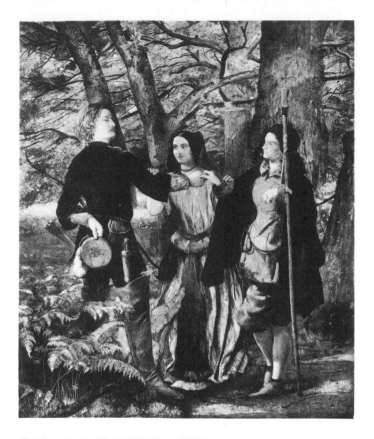

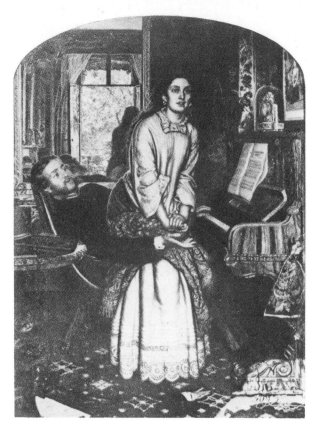

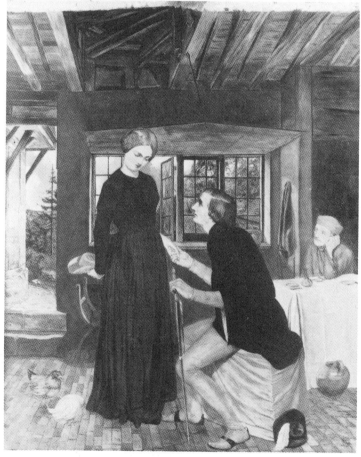

23 WALTER DEVERELL: As You Like It. City Museum
& Art Gallery, Birmingham

25 FREDERIC G. STEPHENS: The Proposal. Tate Gallery

24 HOLMAN HUNT: The Awakened Con
science. By permission of the Trustees
of Sir Colin and Lady Anderson

26 CHARLES CONDER: decorative panel 'In
the Glade'. (From *Art Journal*, 1906)

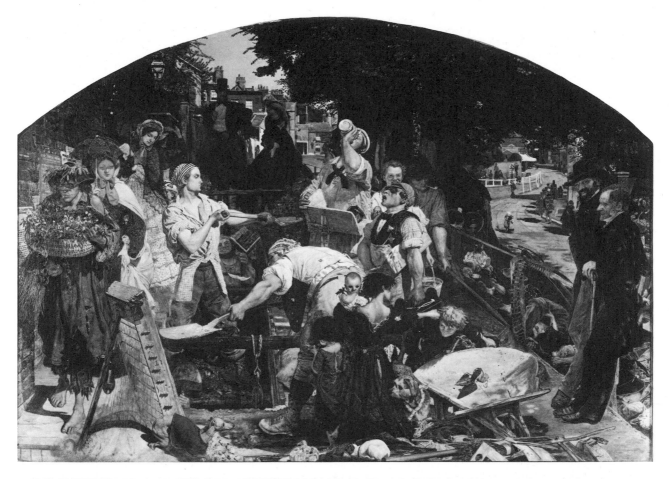

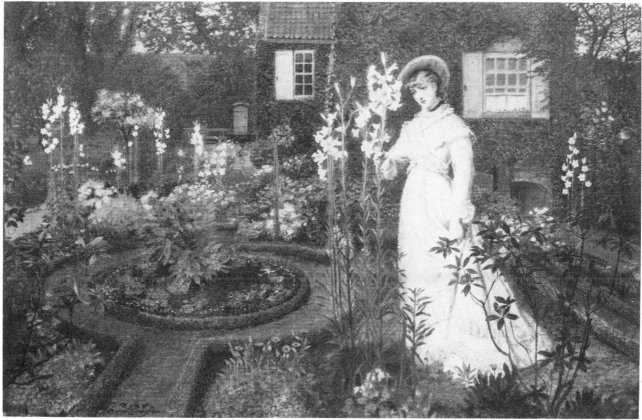

27 FORD MADOX BROWN: Work. City Art Gallery, Manchester
28 ATKINSON GRIMSHAW: The Rector's Garden. City Art Gallery, Leeds

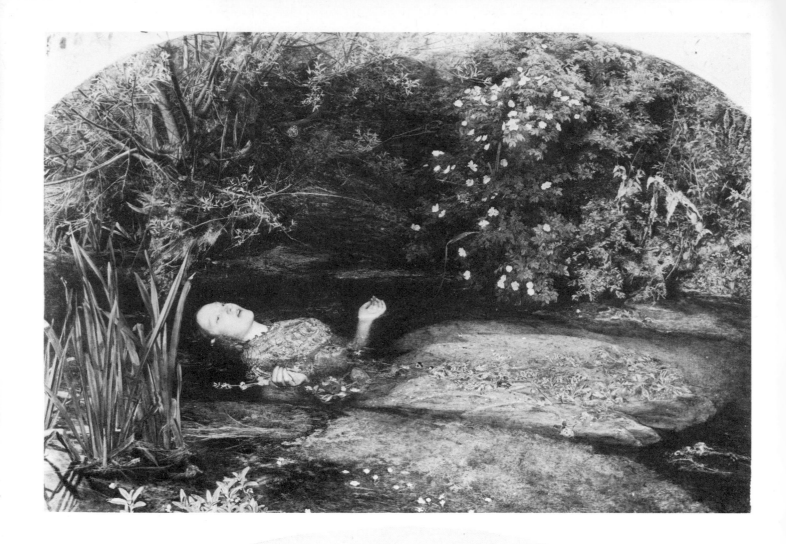

29 JOHN EVERETT MILLAIS: Ophelia. Tate Gallery
30 FORD MADOX BROWN: English Autumn Afternoon. City Museum & Art Gallery, Birmingham

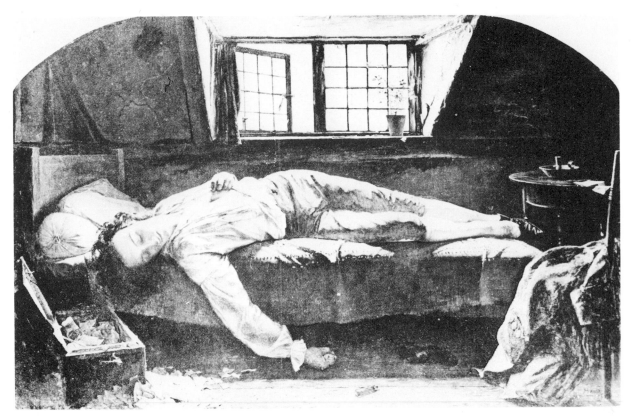

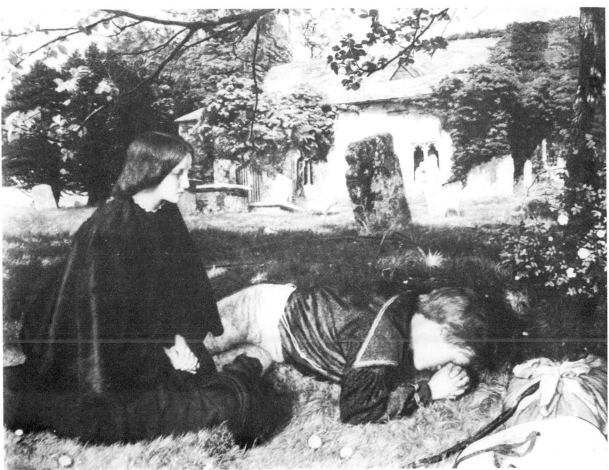

31 HENRY WALLIS: The Death of Chatterton. Tate Gallery
32 ARTHUR HUGHES: Home from the Sea. Ashmolean Museum, Oxford

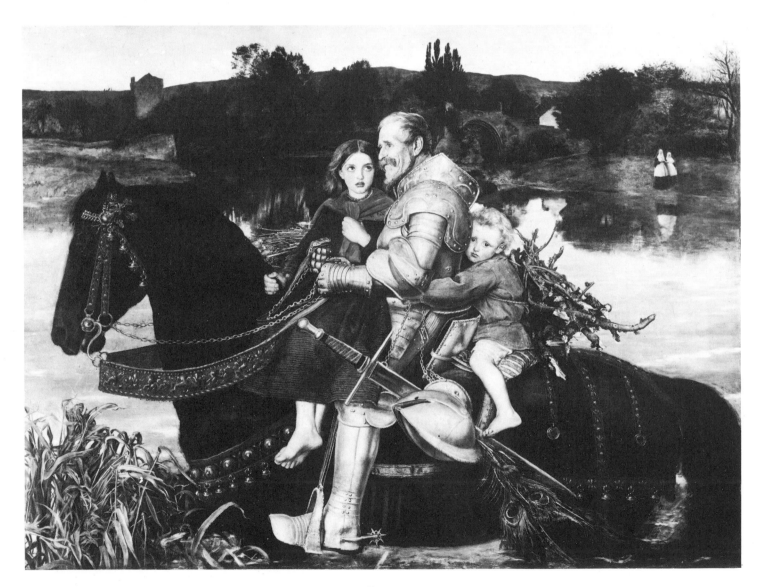

33 WILLIAM BELL SCOTT: Newcastle Quayside in 1861. Wallington Hall. By permission of the National Trust

34 FREDERICK SANDYS: A Nightmare. British Museum

35 JOHN EVERETT MILLAIS: Sir Isumbras at the Ford. By permission of the Trustees of the Lady Lever Art Gallery, Port Sunlight

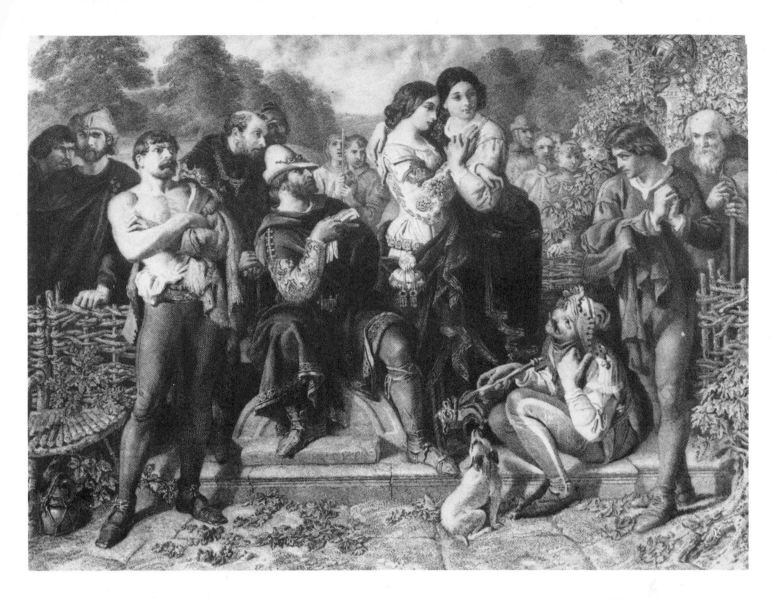

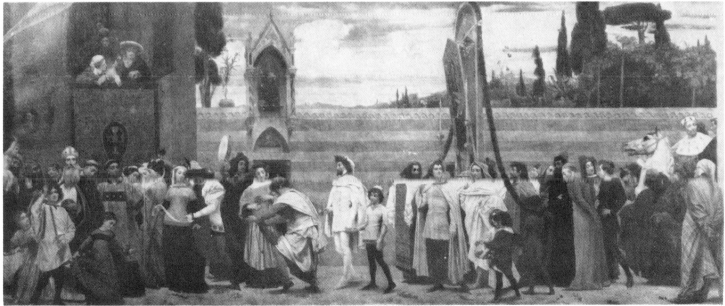

36 DANIEL MACLISE: The Wrestling Scene from 'As You Like It'

37 FREDERIC LEIGHTON: Cimabue's celebrated Madonna being carried
through the streets of Florence. Reproduced by gracious permission of Her
Majesty the Queen

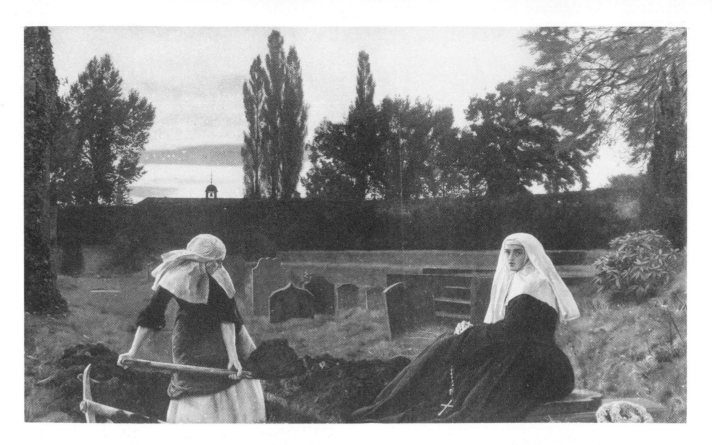

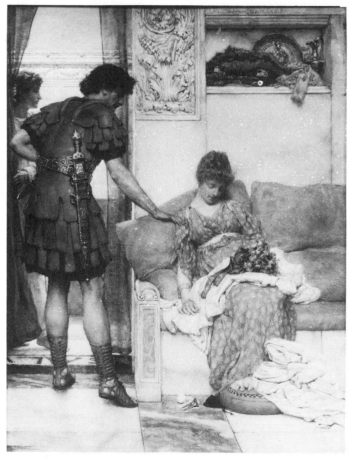

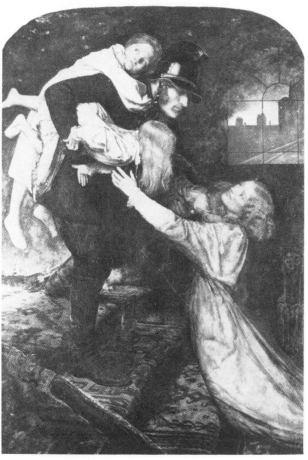

38 JOHN EVERETT MILLAIS: Vale of Rest.
Tate Gallery

39 LAWRENCE ALMA-TADEMA: A Silent Greeting.
Tate Gallery

40 JOHN EVERETT MILLAIS: The Rescue.
National Gallery of Victoria. By permission
of the Trustees of the Felton Bequest

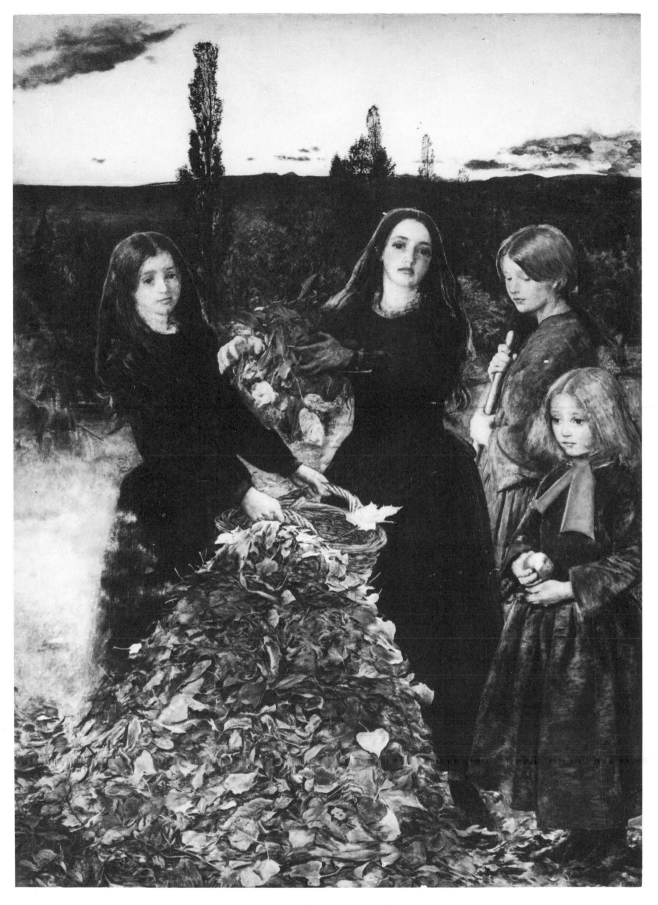

41 JOHN EVERETT MILLAIS: Autumn Leaves. City Art Gallery, Manchester

42 EDWARD J. POYNTER: Studies for the
St. Stephen Frescoes. British Museum

44 FREDERIC LEIGHTON: Drawing of Hands.
British Museum

43 FREDERIC LEIGHTON: Study for *A Hit*.
British Museum

45 AUBREY BEARDSLEY: Christmas Card.
British Museum

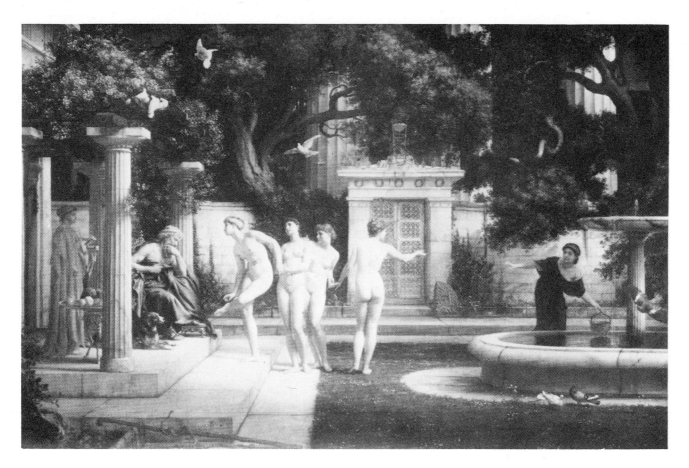

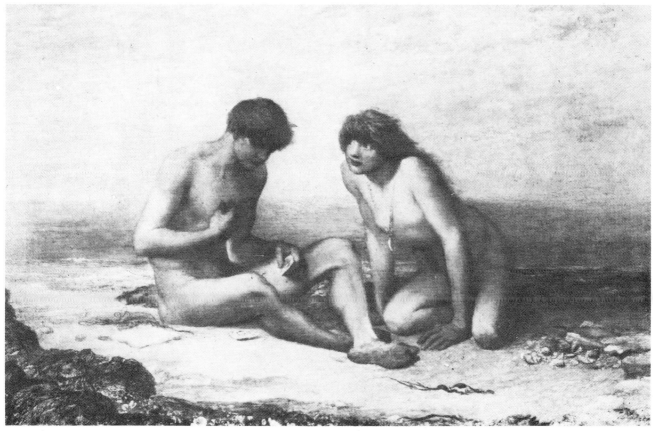

46 EDWARD J. POYNTER: A Visit to Æsculapius. Tate Gallery
47 GEORGE FREDERIC WATTS: The First Oyster. Watts Gallery, Compton

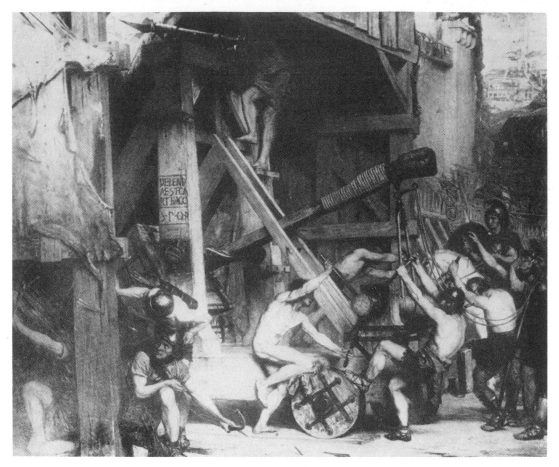

48 EDWARD J. POYNTER: The Catapult
49 GEORGE FREDERIC WATTS: Fiesole. Watts Gallery, Compton

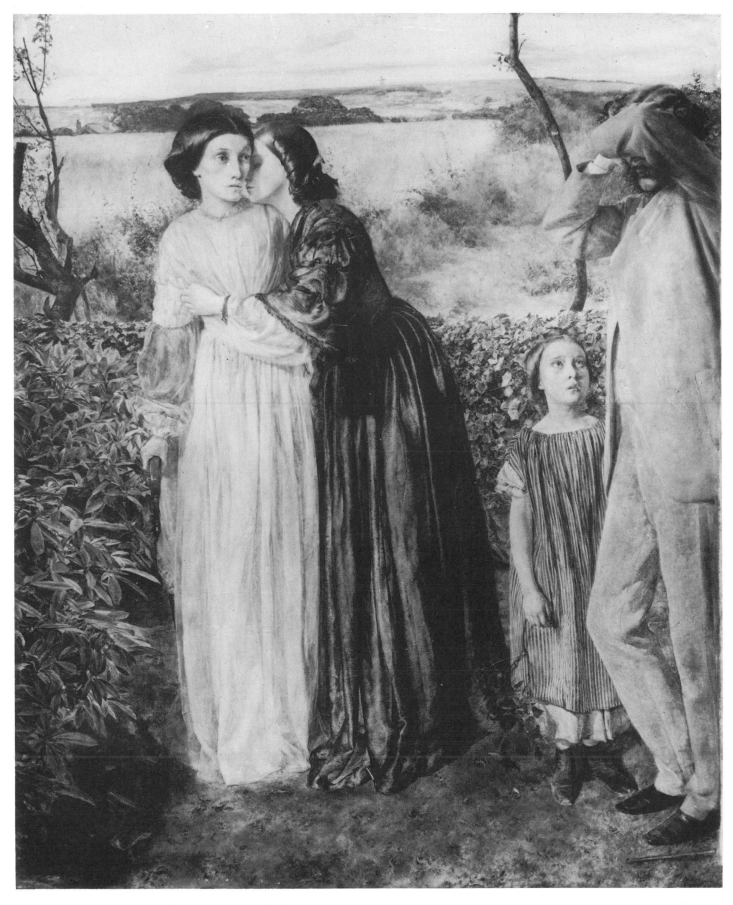

50 WILLIAM WINDUS: Too Late. Tate Gallery

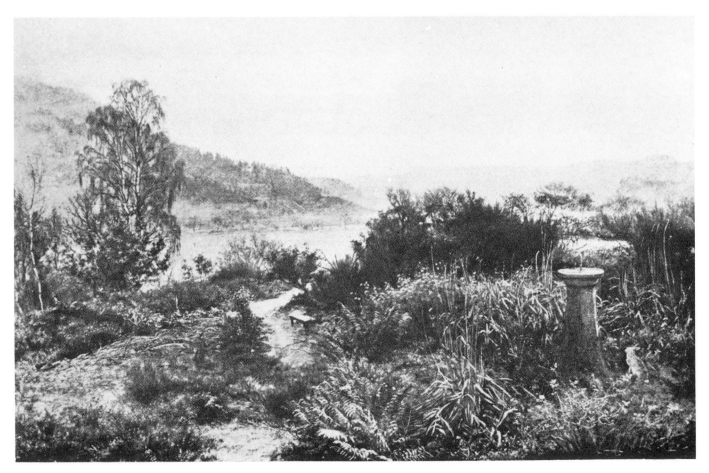

51 GEORGE FREDERIC WATTS: Evolution. Watts Gallery, Compton

52 GEORGE FREDERIC WATTS: The Sower of the Systems. Watts Gallery, Compton

53 JOHN EVERETT MILLAIS: The Deserted Garden. (Photo: Witt Library, Courtauld Institute)

54 The Newest French Fashions: designed for the *Ladies' Treasury*, 1875

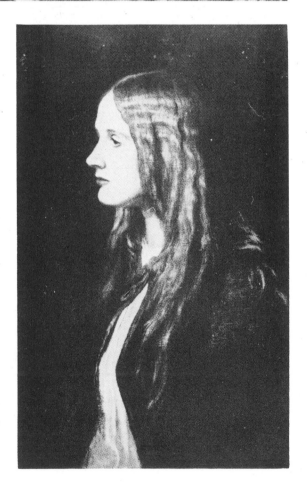

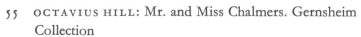

55 OCTAVIUS HILL: Mr. and Miss Chalmers. Gernsheim
Collection

57 JULIA MARGARET CAMERON: Pray God Bring
Father Safely Home. Royal Photographic Society
of Great Britain

56 JULIA MARGARET CAMERON: An un-
identified couple. Gernsheim Collection

58 GEORGE FREDERIC WATTS: Miss Edith
Villiers (Lady Lytton)

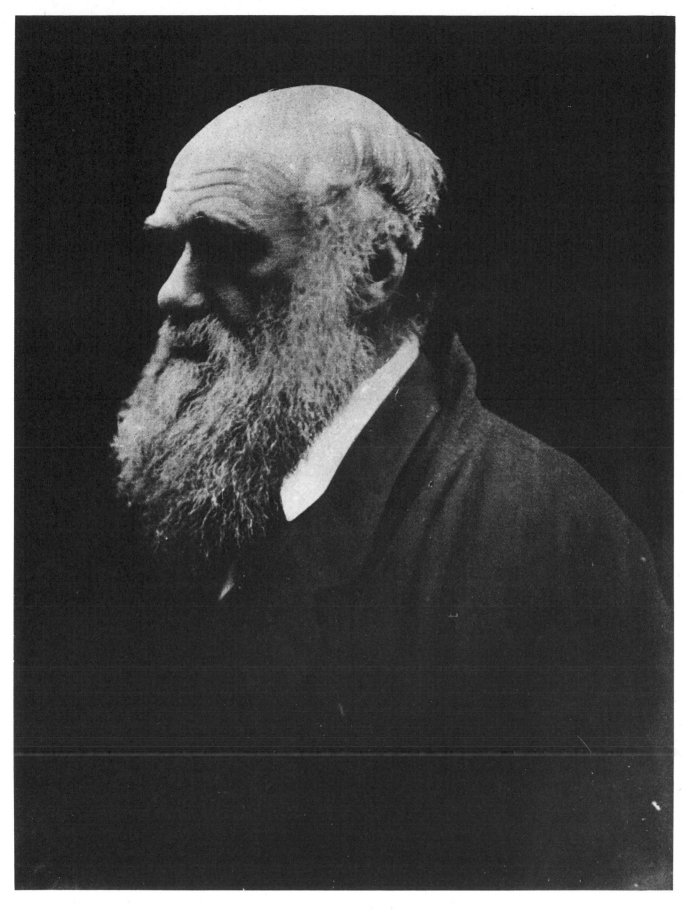

59　JULIA MARGARET CAMERON: Charles Darwin. Gernsheim Collection

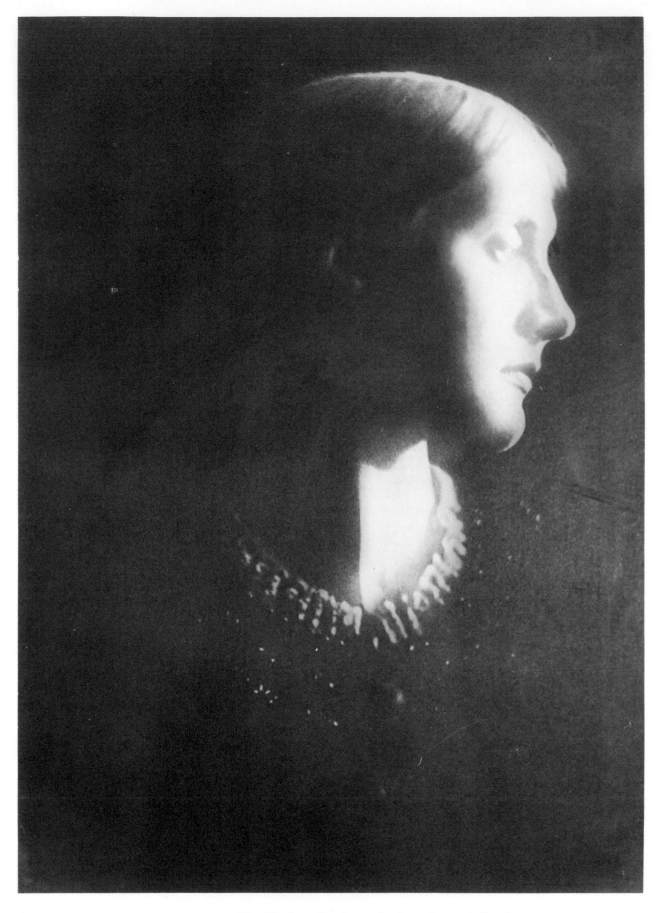

60 JULIA MARGARET CAMERON: Mrs Herbert Duckworth. Gernsheim Collection

61 PETER HENRY EMERSON: The Barley Harvest. Gernsheim Collection
62 JOHN LEECH: 'Now then, Sir, Jump up on the Roof, and look sharp, please, Sir;
Here's t'other Bus a-coming'. (From *Punch*, 1846)

63 GEORGE DU MAURIER: On Her Death-
 bed. (From *English Illustrations of 'the*
 Sixties')

64 GEORGE DU MAURIER: A Time to Dance. 65 GEORGE DU MAURIER: Gross Flattery.
 (From *English Illustrations of 'the Sixties'*) (From *Punch*, 1865)

THINGS ONE WOULD RATHER HAVE EXPRESSED OTHERWISE.

(*Lady Festus At Home—2 A.M.*)

Hostess. "ONLY JUST COME SIR GEORGE? HOW GOOD OF YOU TO COME SO LATE!"

66 GEORGE DU MAURIER: **Things One Would Rather Have Expressed Otherwise.** (From *Punch*, 1892)

67 CHARLES KEENE: A Study. (From *Art Journal*, 1901)

68 FREDERICK SANDYS: illustration of a poem by Christina Rossetti. (From Gleeson White's *English Illustrations of 'the Sixties', 1857–1870*. London 1894)

69 CHARLES KEENE: A Good Fight. (From *English Illustrations of 'the Sixties'*)

70 CHARLES KEENE: sketch for a *Punch* drawing. University of Leeds

71 CHARLES KEENE: Couple in a Four Poster. Ashmolean Museum, Oxford

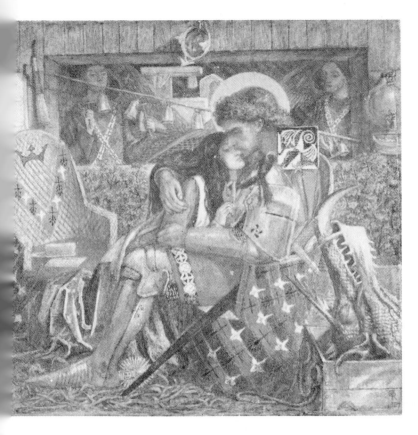

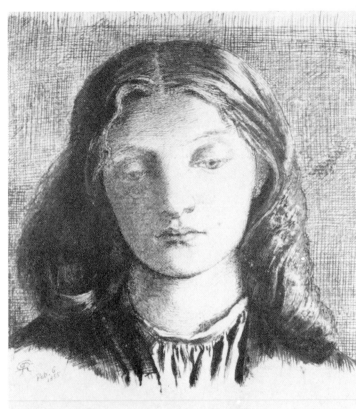

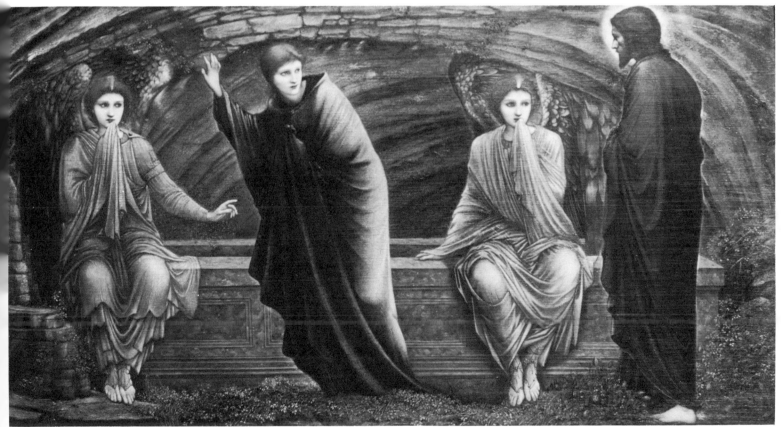

72 DANTE GABRIEL ROSSETTI: The Marriage of St. George
and Princess Sabra. Tate Gallery

73 DANTE GABRIEL ROSSETTI: Miss Siddal. Ashmolean
Museum, Oxford

74 EDWARD BURNE JONES: The Resurrection. Tate Gallery

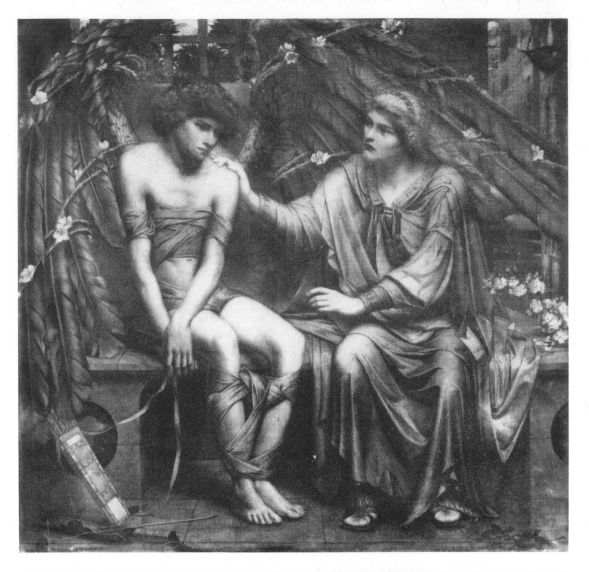

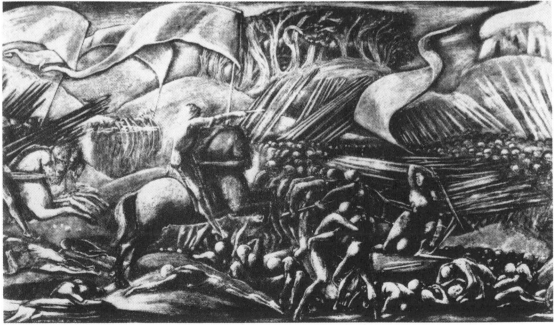

75 SIDNEY METEYARD: Love in Bondage. City Museum & Art Gallery, Birmingham

76 EDWARD BURNE JONES: design for a bronze relief 'The Battle of Flodden Field'.
(From *Easter Art Annual*, *Art Journal*, 1900)

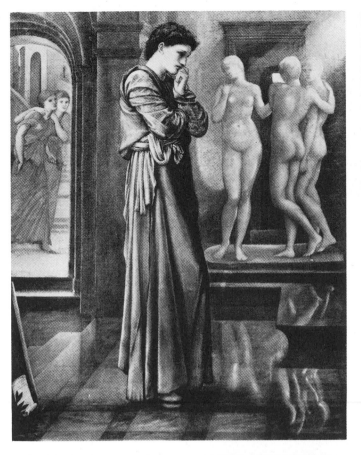

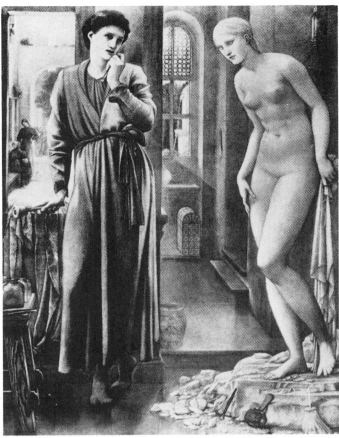

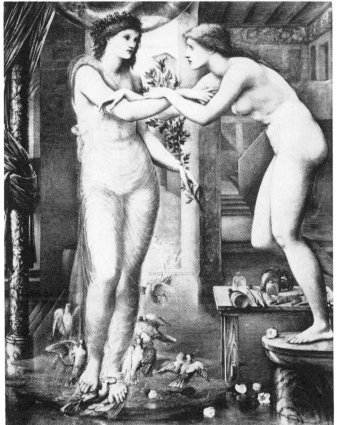

77 EDWARD BURNE JONES: Pygmalion 1. City Museum & Art Gallery, Birmingham

78 EDWARD BURNE JONES: Pygmalion 2. City Museum & Art Gallery, Birmingham

79 EDWARD BURNE JONES: Pygmalion 3. City Museum & Art Gallery, Birmingham

80 EDWARD BURNE JONES: Pygmalion 4. City Museum & Art Gallery, Birmingham

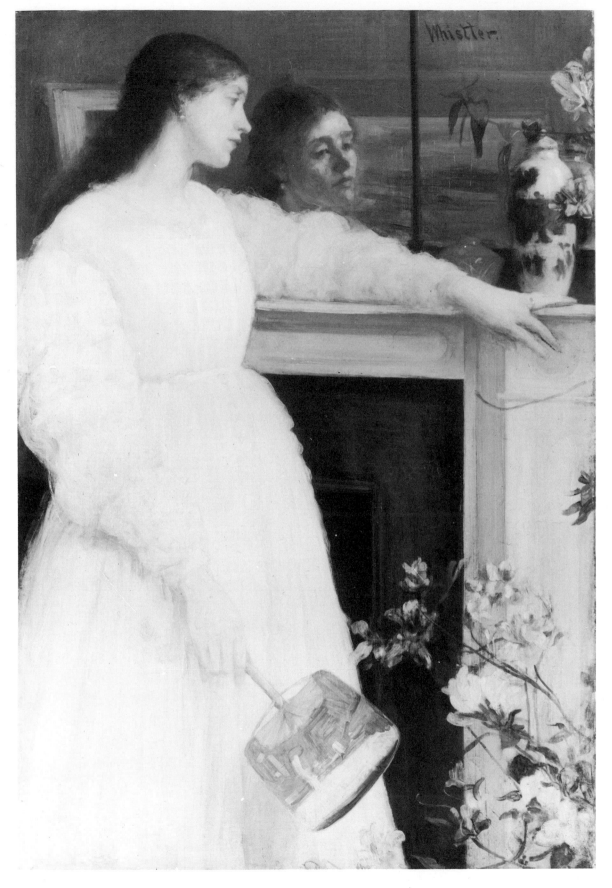

81 JAMES MCNEILL WHISTLER: The Little White Girl: Symphony in White No 2.
Tate Gallery

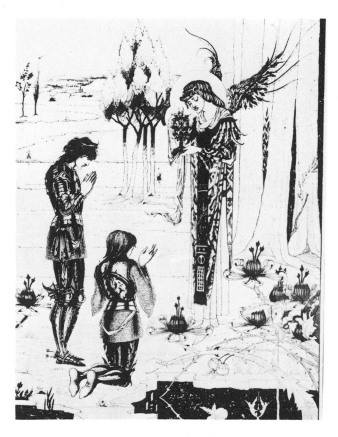

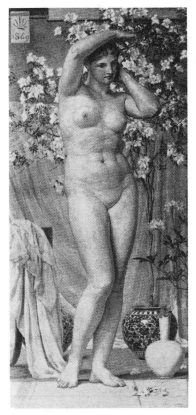

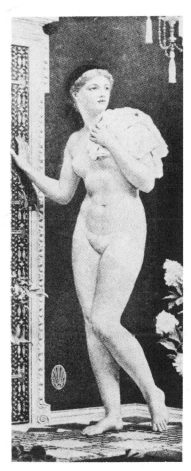

82 AUBREY BEARDSLEY: The Achieving of the
San Greal. British Museum

83 ALBERT MOORE: Venus.
City Art Gallery, York

84 JOHN LAVERY: The Grey Drawing Room.
(From *Royal Academy Illustrated*, 1909)

85 ALBERT MOORE: White
Hydrangeas. (From *Art
Journal*, 1903)

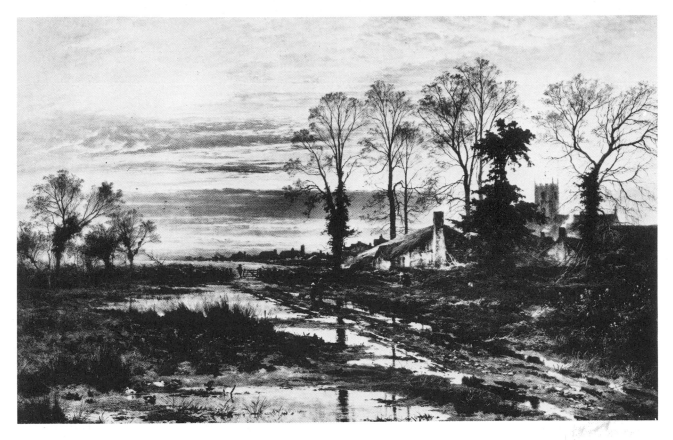

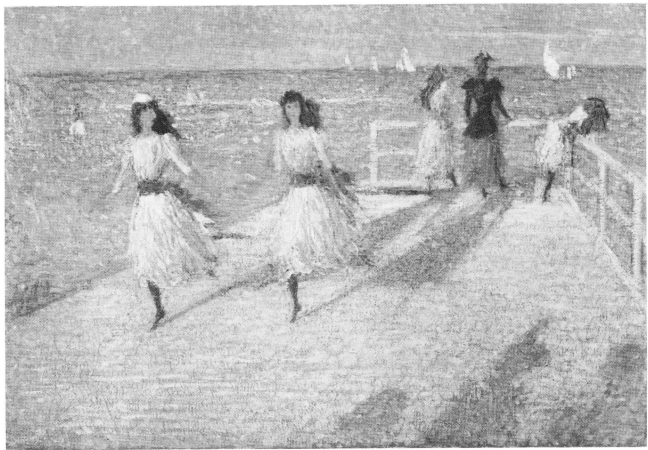

86 BENJAMIN LEADER: February Fill Dyke. City Museum & Art Gallery, Birmingham

87 PHILIP WILSON STEER: Girls Running, Walberswick Pier. Tate Gallery. By kind permission of W. Hornby Steer

88 FREDERICK BROWN: The Storm. Tate Gallery (Photo: Witt Library, Courtauld Institute)

89 GEORGE CLAUSEN: Building a Hay Rick. City Museum & Art Gallery, Birmingham

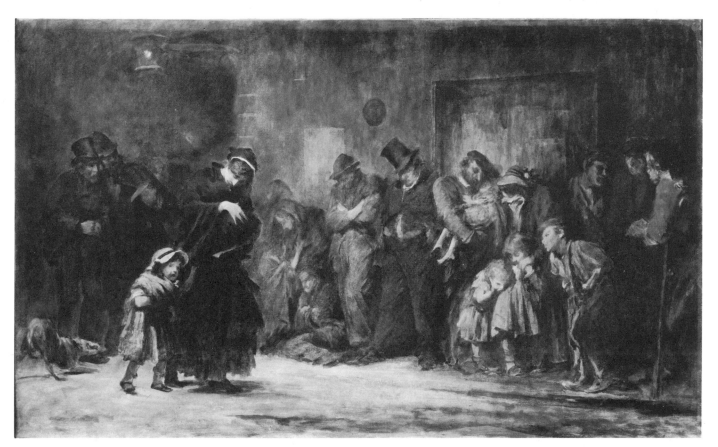

90 LUKE FILDES: sketch for 'An Al-Fresco Toilette'. (From *The Art Annual* (*Art Journal*), 1895)

91 HENRY LA THANGUE: The Water Splash. (From *Royal Academy Illustrated*, 1900)

92 LUKE FILDES: Applicants for Admission to a Casual Ward. Royal Holloway College (Photo: Witt Library, Courtauld Institute)

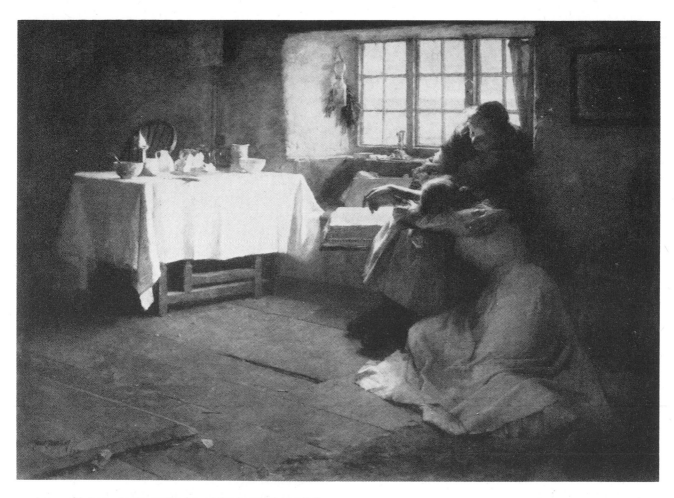

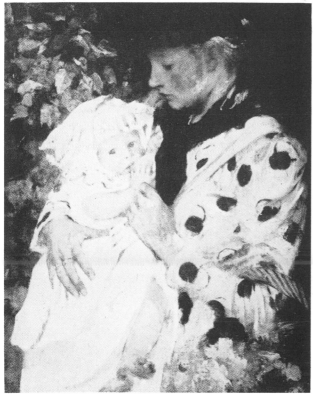

93 FRANK BRAMLEY: A Hopeless Dawn. Tate
Gallery

94 JAMES SHANNON: The Flower Girl. Tate
Gallery

95 WALTER CRANE: illustration to Toy Book
The Fairy Ship. British Museum

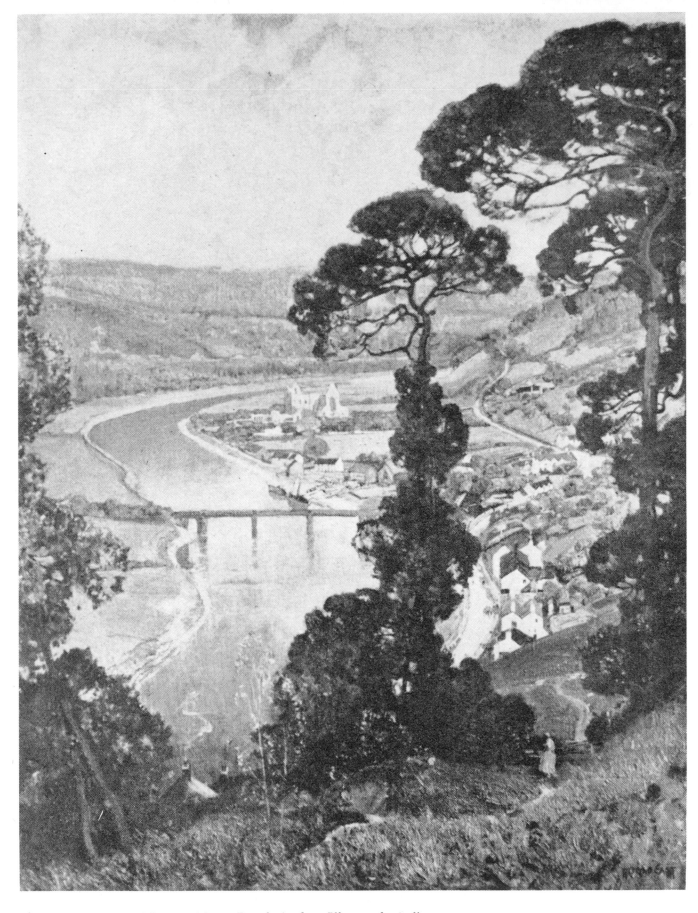

96 ALFRED EAST: Tintern. (From *Royal Academy Illustrated*, 1896)

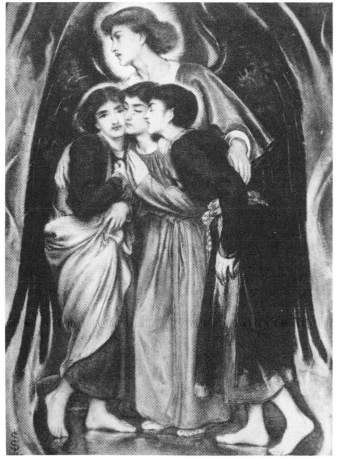

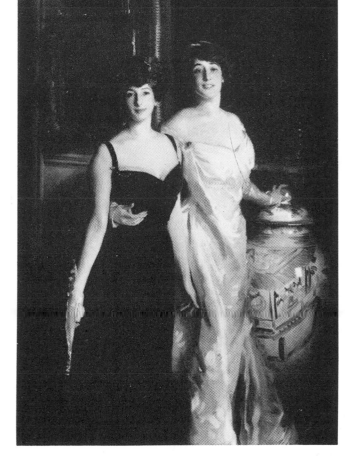

97 AUGUSTUS JOHN: An Equihen Fisher Girl.
National Gallery of Canada

98 WILLIAM ORPEN: Homage to Manet. City Art
Gallery, Manchester

99 SIMEON SOLOMON: watercolour. Collection
Eric Dobson, Esq.

100 JOHN SINGER SARGENT: Ena and Betty,
Daughters of Asher and Mrs. Wertheimer.
Tate Gallery

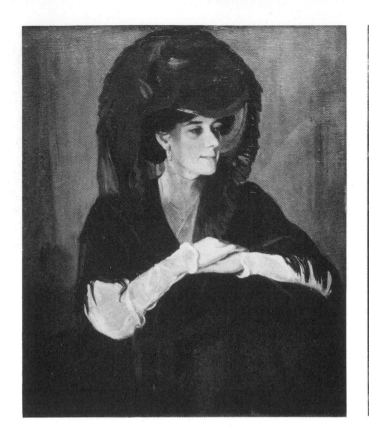

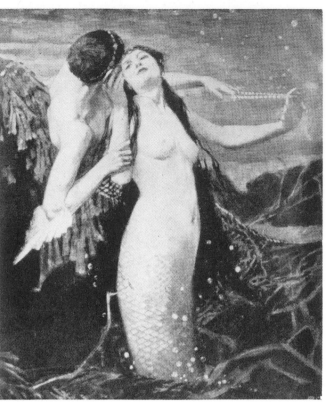

101 WILLIAM NICHOLSON: The Brown Veil. City
Museum & Art Gallery, Birmingham

102 FREDERICK APPLEYARD: Pearls for Kisses.
(From *Royal Academy Illustrated*, 1910)

103 ERNEST CROFTS: Capture of a French Battery at
Waterloo. (From *Royal Academy Illustrated*, 1896)

104 ERNEST NORMAND: In Bondage. (From *Royal Academy Illustrated*, 1895)

105 HENRIETTA RAE (MRS. ERNEST NORMAND): Apollo and Daphne. (From *Royal Academy Illustrated*, 1895)

106 LAURA KNIGHT: Flying a Kite. National Gallery of South Africa
107 BRITON RIVIERE: Beyond Man's Footsteps. Tate Gallery

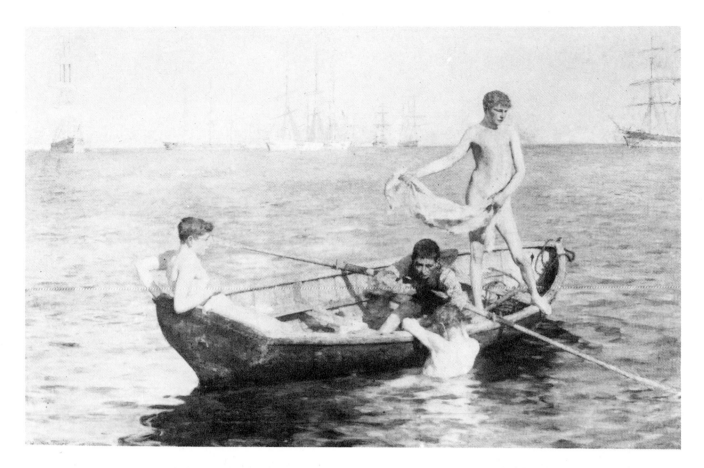

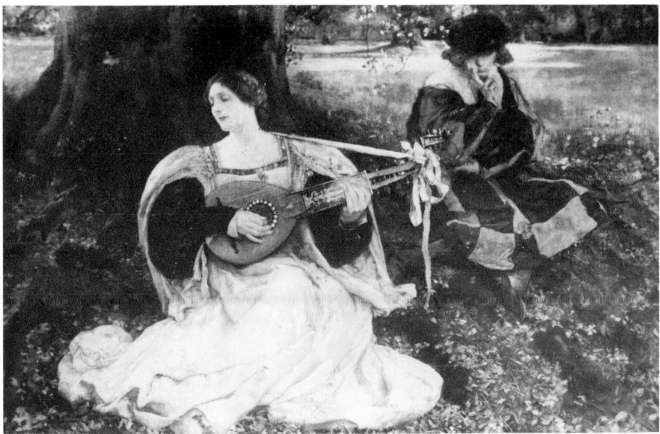

108 HENRY TUKE: August Blue. Tate Gallery
109 EDWIN A. ABBEY: Fair is My Love. Harris Museum & Art Gallery, Preston

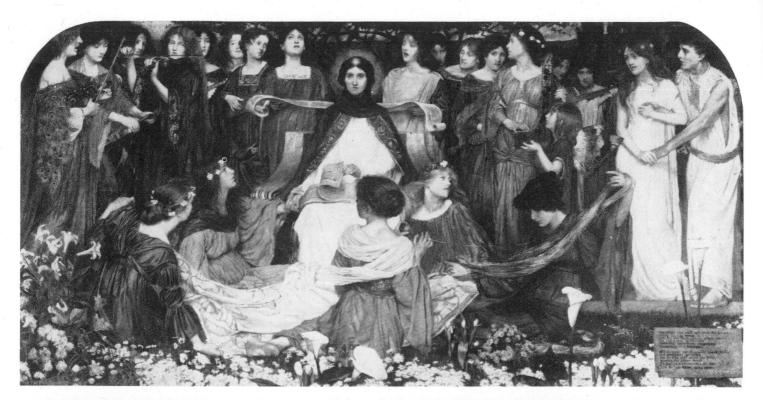

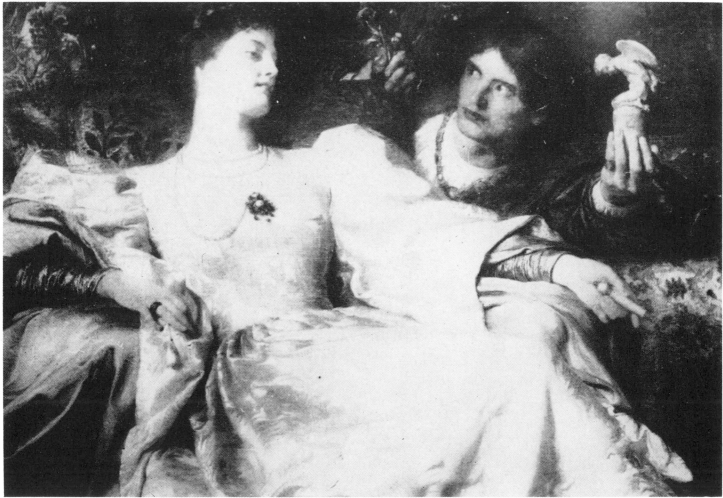

110 JOHN BYAM SHAW: The Blessed Damozel. Guildhall Art Gallery
111 FRANK DICKSEE: An Offering. (From *Christmas Art Annual*, 1901)

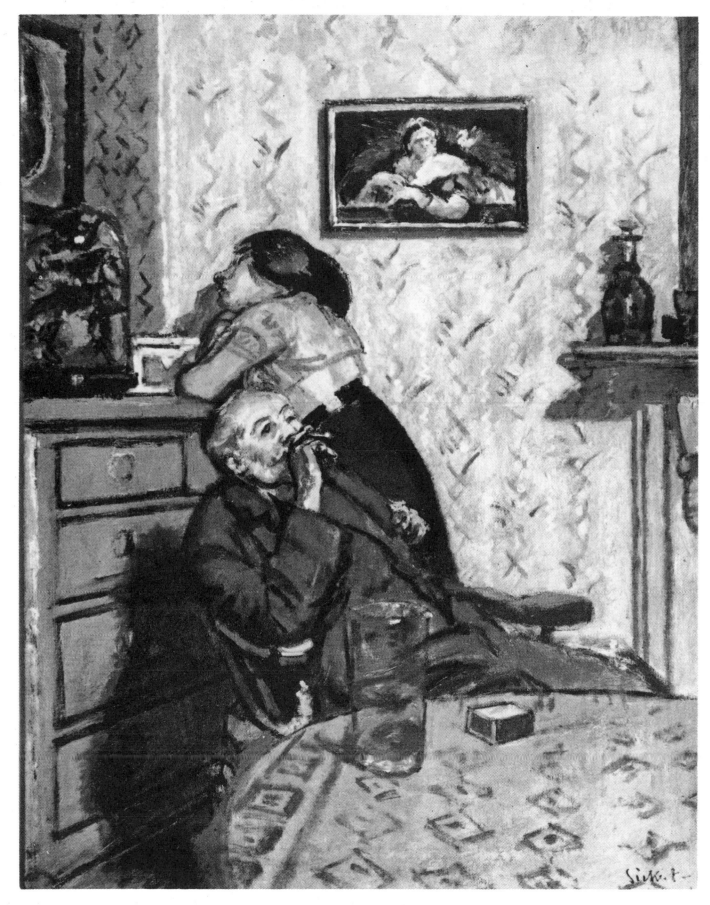

112 WALTER SICKERT: Ennuie. Ashmolean Museum, Oxford

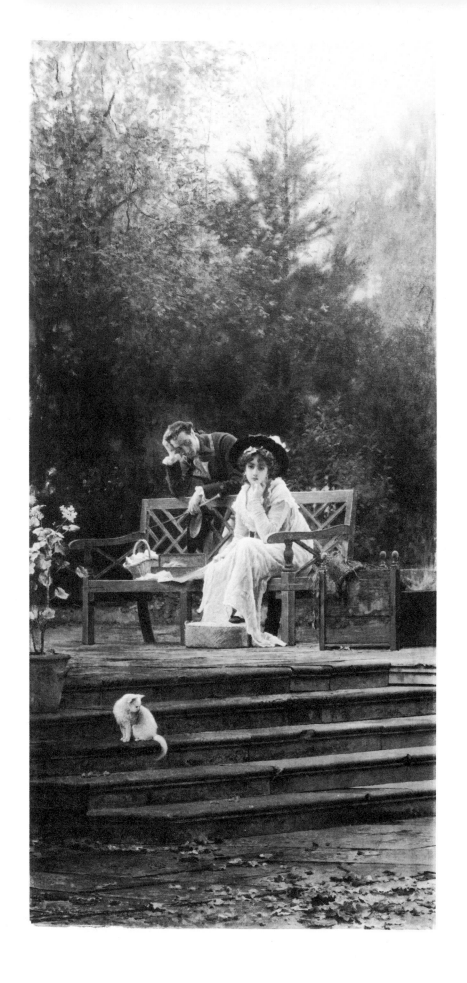

114 SPENCER GORE: The Icknield Way

113 MARCUS STONE: Il y en a toujours un autre. Tate Gallery

A note on sources

While this book was in preparation Mr. William E. Fredeman published *Pre-Raphaelitism, a Bibliocritical Study* (Harvard, 1965). I no doubt have the unenviable distinction of being the last person to write a book on Victorian art without his assistance. Beyond his field, which covers both the earlier and the later Pre-Raphaelites, there are few guides to the study of this period. It seems worthwhile, therefore, to offer a list such as that which follows and which, although it provides the student with comparatively few names, may be useful.

Where no other information is supplied it may be assumed that works were published in London.

Bibliography

Periodicals

The Athenaeum employed Frederick George Stephens as its art critic from 1861–1901; he was succeeded by Roger Fry.

The Art Journal (until 1849 the *Art Union Journal*) runs from 1836 to 1912.

Punch begins publication in 1841 and is an invaluable source of material for the period.

The Germ expired after only four issues in 1850.

The Saturday Review was from its beginning (1855) extremely favourable to the Pre-Raphaelites and contains some notable criticism by Coventry Patmore. (*See* Merle S. Bevington, *The Saturday Review*, Columbia 1941.)

The Studio runs from 1893 until the end of the period.

Of current periodicals the most useful is *Victorian Studies*, published by Indiana University.

Book List

Academy Notes, 1876–1906, ed. Henry Blackburn.

ANDREWS, KEITH, *The Nazarenes*, Oxford 1964.

ALLINGHAM, WILLIAM, *William Allingham, A Diary*, ed. Helen Allingham and D. Radford, 1907.

Art Nouveau in Britain, Catalogue of an Arts Council Exhibition, with an introduction by Nikolaus Pevsner, 1965.

ATKINSON, J. BEAVINGTON, *Overbeck*, 1872.

BARRINGTON, Mrs. RUSSELL, *The Life, Letters and Work of Frederic Leighton*, 2 vols., 1906.

BATE, PERCY H., *The English Pre-Raphaelite Painters; Their Associates and Successors*, 1899.

BALDRY, A. L., *Albert Moore: His Life and Works*, 1894.

—— *Sir John Everett Millais: His Art and Influence*, 1899.

BAYES, WALTER, *The Landscapes of G. F. Watts*, 1907.

BAYLISS, Sir WYKE, *Five Great Painters of the Victorian Era: Leighton, Millais, Burne-Jones, Watts, Holman Hunt*, 1902.

BELL, Mrs. ARTHUR (N. D'ANVERS), *Representative Painters of the XIXth Century*, 1899.

BELL, MALCOLM, *Edward Burne-Jones: A Record and Review*, 1892.

BELL, QUENTIN, *The Schools of Design*, 1963.

—— 'The Camden Town Group' in *Motif*, Nos. 10 and 11, 162, 1963.

—— see also [DRUMMOND, MALCOLM].

BENNETT, MARY, see [BROWN, FORD MADOX].

BENSON, E. F., *As We Were: A Victorian Peep-Show*, 1930.

BERTRAM, ANTHONY, *A Century of British Painting, 1851–1951*, 1951.

[BEVAN, ROBERT], *Robert Bevan, 1865–1925*. Catalogue of an Arts Council Exhibition, with an introduction by J. Wood Palmer, 1965.

—— *Robert Bevan, A Centenary Exhibition of Paintings, Drawings, and Lithographs*, Ashmolean Museum Catalogue, with an introduction by Ian Robertson, Oxford 1965.

BEVAN, R. A., *Robert Bevan, 1865–1925. A Memoir by his Son*, 1965.

—— 'The Pen Drawings of Harold Gilman' in *Alphabet and Image*, No. 3, 1946.

BICKLEY, FRANCIS, *The Pre-Raphaelite Comedy*, 1932.

BLACKBURN, HENRY, see *Academy Notes*.

BOASE, T. S. R., *English Art, 1800–1870* (Oxford History of English Art), Oxford 1959.

—— 'The Decorations of the New Palace of Westminster, 1846–1863' in *Journal of the Warburg and Courtauld Institutes*, Vol. XVII, 1954.

[BROWN, FORD MADOX], *Ford Madox Brown, 1821–1893*, Catalogue of an Exhibition organized by the Walker Art Gallery, Liverpool, with an introduction by Mary Bennett, Liverpool 1965.

BROWSE, LILLIAN, *Sickert* (With an introduction by R. H. Wilenski), 1943.

—— *William Nicholson*, 1956.

—— *Sickert*, 1960.

—— see also SICKERT, WALTER RICHARD.

Bibliography

BUCK, RICHARD, see *Paintings and Drawings of the Pre-Raphaelites and their Circle*.

BURNE-JONES, GEORGIANA Lady, *Memorials of Edward Burne-Jones*, 2 vols., 1904.

[CAMDEN TOWN], *The Camden Town Group*, Catalogue of an Exhibition at the Leicester Galleries, with an introduction by Frank Rutter, 1930.

—— *The Camden Town Group*, Catalogue of an Arts Council Exhibition, with an introduction by Eric Westbrook, 1951.

—— *The Camden Town Group*, Catalogue of an Arts Council Exhibition, 1953.

—— *Drawings of the Camden Town Group*, Catalogue of an Arts Council Exhibition, with an introduction by J. Wood Palmer, 1961.

CARTER, CHARLES, see *Dyce Centenary Exhibition*.

CHAPMAN, RONALD, *The Laurel and the Thorn: A Study of G. F. Watts*, 1945.

CLARK, Sir KENNETH, see *Ruskin and his Circle*.

DAFFORNE, JAMES, *Pictures by William Mulready, R.A.*, 1872.

—— *Pictures by Daniel Maclise, R.A.*, 1873.

DESTRÉE, OLIVIER GEORGES, *Les Pré-Raphaélites: notes sur l'art décoratif et la peinture en Angleterre*, Brussels 1894.

[DRUMMOND, MALCOLM], *Malcolm Drummond, 1880–1945*, Catalogue of an Arts Council Exhibition, with an introduction by Quentin Bell, 1963.

DU MAURIER, GEORGE, *The Young Du Maurier; a Selection of Letters, 1860–1867*, ed. Daphne Du Maurier, 1951.

[DYCE, WILLIAM], *Dyce Centenary Exhibition*, Catalogue of an exhibition at Messrs. Agnew, with an introduction by Charles Carter, 1964.

EMMONS, ROBERT, *The Life and Opinions of Walter Richard Sickert*, 1941.

FARR, DENIS, *William Etty*, 1958.

FERGUSSON, LOUIS F., *Harold Gilman: An Appreciation* (with Wyndham Lewis), 1919.

FORD, FORD MADOX, see HUEFFER, FORD MADOX.

FREDEMAN, WILLIAM E., 'Pre-Raphaelites in Caricature' in *Burlington Magazine*, Vol. CII, December, 1960.

—— *Pre-Raphaelitism. A Bibliocritical Study*, Harvard, 1965.

FRITH, WILLIAM POWELL, *My Autobiography and Reminiscences*, 1887–8.

—— *An Exhibition of Paintings by William Powell Frith, R.A., 1819–1909*. Catalogue of a Whitechapel Art Gallery and Harrogate Arts Society Exhibition, with an introduction by Jonathan Mayne, 1951.

FRY, ROGER, 'Retrospect' in *Vision and Design*, 1920.

FURST, HERBERT, *The Decorative Paintings of Frank Brangwyn*, 1924.

GAUNT, WILLIAM, *The Pre-Raphaelite Tragedy*, 1942.

—— *The Aesthetic Adventure*, 1945.

—— *The March of the Moderns*, 1949.

—— *Victorian Olympus*, 1952.

GEORGE, ERIC, *The Life and Death of Benjamin Robert Haydon*, 1948.

GERE, JOHN, see IRONSIDE, ROBIN.

GERNSHEIM, HELMUT, *Julia Margaret Cameron*, 1948.

—— *A Concise History of Photography*, 1965.

[GILMAN, HAROLD], *Harold Gilman*, Catalogue of an Arts Council Exhibition, with an introduction by J. Wood Palmer, 1954.

GINNER, CHARLES, 'The Camden Town Group' in *The Studio*, November, 1945.

—— *Charles Ginner, 1878–1952*, Catalogue of an Arts Council Exhibition, with an introduction by Hubert Wellington, 1953.

[GORE, SPENCER FREDERICK], *Spencer Frederick Gore, 1878–1914*, Catalogue of an Arts Council Exhibition, with an introduction by J. Wood Palmer, 1955.

—— *Spencer Gore: Frederick Gore*, Catalogue of an Exhibition at the Redfern Gallery, with an introduction by J. Wood Palmer, 1962.

GRAY, H. O., *The Life of William Quiller Orchardson*, 1930.

GRIGSON, GEOFFREY, see *Ten Decades of British Taste*.

HAYDON, BENJAMIN ROBERT, *Correspondence and Table Talk, with a Memoir by his Son, Frederick Wordsworth Haydon*, 2 vols., 1876.

Bibliography

HAYDON, BENJAMIN ROBERT, *Diary*, ed. Willard B. Pope, 5 vols., Harvard 1960–3.

HENLEY, W. E., *A Century of Artists*, Glasgow 1889.

HILLIER, BEVIS, 'The St. John's Wood Clique' in *Apollo*, June, 1964.

HONE, JOSEPH, *The Life of Henry Tonks*, 1939.

HUDSON, DEREK, *Charles Keene*, 1947.

HUEFFER, FORD MADOX, *Ford Madox Brown: A Record of His Life and Work*, 1896.

—— *Rossetti: A Critical Essay on his Art*, 1896.

—— *The Pre-Raphaelite Brotherhood: A Critical Monograph*, 1907.

HUNT, WILLIAM HOLMAN, *Pre-Raphaelitism and the Pre-Raphaelite Brotherhood*, 2 vols., 1905–6.

IRONSIDE, ROBIN, *Wilson Steer*, 1953.

—— and GERE, JOHN, *Pre-Raphaelite Painters*, 1948.

JAMES, RICHARD, see *Royal Academy Diploma Pictures*.

JAMES, HENRY, *The Painter's Eye*, ed. John L. Sweers, 1956.

JOHN, AUGUSTUS, *Chiaroscuro*, 1952.

KNIGHT, Dame LAURA, *Oil Paint and Grease Paint*, 1936.

KONODY, P. G., *The Art of Walter Crane*, 1902.

—— *William Orpen, Artist and Man*, 1932.

LAIDLAY, W. J., *The Origin and First Two Years of the New English Art Club*, 1907.

[LANDSEER, Sir EDWIN], *Paintings and Drawings by Sir Edwin Landseer*, Catalogue of a Royal Academy Exhibition, with an introduction by John Woodward, 1961.

LANG, Mrs. ANDREW, 'Sir Frederick Leighton: His Life and Work' in *Art Annual*, 1884.

LA SIDERANNE, ROBERT DE, *La Peinture anglaise contemporaine*, Paris 1895.

LAYARD, GEORGES SOMES, *Life and Letters of Charles Keene*, 1892.

LEIGHTON, FREDERIC (Lord Leighton), *Addresses . . . to Students*, 1896.

LESLIE, G. D., *The Inner Life of the Royal Academy*, 1914.

LEWIS, P. WYNDHAM, see FERGUSSON, LOUIS F.

MacCOLL, D. S., *Nineteenth Century Art*, Glasgow 1902.

—— *The Administration of the Chantrey Bequest*, 1904.

—— see also [STEER, PHILIP WILSON].

MacLAREN YOUNG, ANDREW, see [WHISTLER, JAMES MCNEIL].

MADSEN, TSCHUDI S., *The Sources of Art Nouveau*, Oslo 1956.

MARILLIER, H. C., *Dante Gabriel Rossetti: An Illustrated Memorial of His Art and Life*, 1899.

—— *The Liverpool School of Painters: An Account of the Liverpool Academy from 1810 to 1867, with Memoirs of the Principal Artists*, 1904.

MAYNE, JONATHAN, see FRITH, WILLIAM POWELL.

MELLON COLLECTION, see *Painting in England, 1700–1850*.

[MILLAIS, Sir JOHN EVERETT], *The Works of Sir John Everett Millais*, Catalogue of an Exhibition at the Grosvenor Galleries, with notes by F. G. Stephens, 1886.

MILLAIS, J. G., *The Life and Letters of Sir John Everett Millais*, 2 vols., 1899.

MONGAN, AGNES, see *Paintings and Drawings of the Pre-Raphaelites and their Circle*.

MONKHOUSE, COSMO, *British Contemporary Artists*, 1899.

MOORE, GEORGE, *Modern Painting*, 1893.

MOUNT, CHARLES MERRILL, *John Singer Sargent*, 1957.

Nineteenth Century Life, Catalogue of an Exhibition at Messes. Newmans, 1961.

O'DRISCOLL, WILLIAM JUSTIN, *A Memoir of Daniel Maclise, R.A.*, 1871.

OPPÉ, A. P., 'The Pre-Raphaelites' in *Early Victorian England, 1830–1865*, ed. G. M. Young, 2 vols., Oxford, 1934.

Painters of the Beautiful (Leighton, Whistler, Moore and Conder). Catalogue of an Exhibition at Messrs. Durlacher Bros., New York, with an introduction by Allen Staley, 1964.

Painting in England, 1700–1850, from the Collection of Mr and Mrs Paul Mellon, Catalogue of the Royal Academy Exhibition, 1964.

Paintings and Drawings by Victorian Artists in England, Catalogue of an Exhibition, with an introduction by Allen Staley, Ottawa 1965.

Bibliography

Paintings and Drawings of the Pre-Raphaelites and their Circle, Catalogue of an Exhibition at the Fogg Museum, Harvard, with an introduction by Agnes Mongan and a note on techniques by Richard Buck, Harvard, 1946.

PALMER, J. WOOD, see BEVAN; CAMDEN TOWN; GILMAN; GORE.

PENNELL, JOSEPH, *The Work of Charles Keene,* 1897.

PEVSNER, NIKOLAUS, *The Sources of Modern Art* (with Jean Cassou and others), 1962.
—— see also *Art Nouveau in Britain.*

PHYTHIAN, J. E., *G. F. Watts,* 1906.
—— *Fifty Years of Modern Painting, Corot to Sargent,* New York 1908.

PICKVANCE, RONALD, see SICKERT, WALTER RICHARD.

[A] *Picture Book of English Paintings, 1800–1870,* Manchester City Art Galleries' Publication, Manchester, 1951.

[A] *Picture Book of Pre-Raphaelite Paintings,* Manchester City Art Galleries' Publication, Manchester 1952.

[A] *Picture Book of British Paintings, 1900–1930,* Manchester City Art Galleries' Publication, Manchester, 1954.

POYNTER, Sir EDWARD J., *Lectures on Art,* 1897.

QUILTER, HARRY, *Preferences in Art, Life and Literature,* 1892.

REDGRAVE, RICHARD, *A Century of British Painters,* 1866.
—— *Richard Redgrave, A Memoir compiled from his Diary by F. M. Redgrave,* 1891.

REYNOLDS, A. M., *The Life and Work of Frank Holl,* 1912.

REYNOLDS, GRAHAM, *Painters of the Victorian Scene,* 1953.
—— see also *Victorian Paintings.*

RHYS, ERNEST, *Frederic, Lord Leighton,* 1895.

ROBERTSON, IAN see [BEVAN, ROBERT].

ROSSETTI, W. M., *Fine Art, Chiefly Contemporary,* 1867.
—— *Dante Gabriel Rossetti: His Family Letters, with a Memoir,* ed. W. M. Rossetti, 2 vols., 1895.
—— *Ruskin: Rossetti: Pre-Raphaelism. Papers 1854–1862,* ed. W. M. Rossetti, 1899.
—— *Rossetti Papers, 1862 to 1870,* ed. W. M. Rossetti, 1903.

ROTHENSTEIN, Sir JOHN, *Artists of the 1890s,* 1928.
—— *Nineteenth Century Painting,* 1932.
—— *Modern English Painters: Sickert to Smith,* 1952.
—— *Modern English Painters: Lewis to Moore,* 1956.

[ROYAL ACADEMY], *The First Hundred Years of the Royal Academy, 1769–1868,* Catalogue of the Royal Academy Exhibition, 1951.
—— *Royal Academy Diploma Pictures, 1768–1851,* Catalogue of an Arts Council Exhibition, with an introduction by Richard James, 1961.

RUSKIN, JOHN, *The Works of John Ruskin: Library Edition,* 39 vols., ed. E. T. Cook and Alexander Wedderburn, 1902–12. More especially: Vol. XII, *Letters on the Pre-Raphaelite Artists, 1851–1854: Pre-Raphaelism, 1851:* Vol. XIV, *Academy Notes, 1855–1859, 1875;* Vol. XXXIII, *The Art of England, 1884.*
—— *Ruskin and His Circle,* Catalogue of an Arts Council Exhibition, with an introduction by Sir Kenneth Clark, 1964.

RUTTER, FRANK, *Art in My Time,* 1940.
—— 'Harold Gilman, an Appreciation', in *Art and Letters,* 1919.
—— 'The Work of Harold Gilman and Spencer Gore' in *The Studio,* March, 1930.
—— see also [CAMDEN TOWN].

SCHMUTZLER, ROBERT, *Art Nouveau,* 1964.

SCOTT, WILLIAM BELL, *Autobiographical Notes . . . and Notices of His Artistic and Poetic Circle of Friends, 1830–1882,* ed. W. Minto, 2 vols., 1892.

SICKERT, WALTER RICHARD, *A Free House! or the Artist as Craftsman,* ed. and with a preface by Sir Osbert Sitwell, 1947.

SICKERT, WALTER RICHARD, *Bastien Lepage—Modern Realism in Painting,* 1892.
—— *Notes and Sketches by Walter Richard Sickert from the Walker Art Gallery, Liverpool,* Catalogue of an Arts Council Exhibition, with an introduction by Gabriel White, 1949.

Bibliography

SICKERT, WALTER RICHARD, *Sickert, 1860–1942,* Catalogue of an Arts Council Exhibition (Scottish Committee), with an introduction by Lillian Browse, Edinburgh 1953.

——*Sickert: Paintings and Drawings,* Catalogue of an Arts Council Exhibition, 1960.

—— *Sickert: an Exhibition of Paintings and Drawings,* Catalogue of an Arts Council Exhibition, with an introduction by Ronald Pickvance, 1964.

SITWELL, Sir OSBERT, see SICKERT, WALTER RICHARD.

SPIELMANN, MARION H., *Millais and His Works,* 1898.

STALEY, ALLEN, see *Paintings and Drawings by Victorian Artists in England.*

—— see also *Painters of the Beautiful.*

STANDING, PERCY CROSS, *Sir Lawrence Alma Tadema, O.M., R.A.,* 1905.

STANNUS, HUGH, *Alfred Stevens and His Work,* 1891.

[STEER, PHILIP WILSON], *A Memorial Exhibition of the Works of Philip Wilson Steer, 1860–1942,* Catalogue of an Exhibition at the National Gallery, with a foreword by D. S. MacColl, 1943.

STEPHENS, F. G., *Masterpieces of William Mulready: Memorials of William Mulready Collected by F. G. Stephens,* 1867.

—— see also [MILLAIS, Sir JOHN EVERETT].

STEPHENSON, W. R., *Sickert: the Man and his Art* (Privately printed), 1940.

TEMPLE, Sir A. G., *The Art of Painting in the Queen's Reign,* 1897.

Ten Decades of British Taste, Catalogue of an Arts Council Exhibition, with an introduction by Geoffrey Grigson, 1951.

THORNTON, ALFRED, *Fifty Years of the New English Art Club,* 1935.

Victorian Painting, Catalogue of an Exhibition at Nottingham University Gallery, with an introduction by John Woodward, Nottingham, 1959.

Victorian Paintings, Catalogue of an Arts Council Exhibition, with a preface by Graham Reynolds, 1962.

Victorian Paintings, A publication of the Victoria and Albert Museum, 1963.

WALKER, R. A., *The Best of Beardsley,* 1948.

WATTS, M. S., *George Frederic Watts;* Vols. 1 and 2: *The Annals of an Artist's Life;* Vol. 3: *His Writings,* 1912.

WEDMORE, FREDERICK, *Studies in English Art,* 1880.

—— *Whistler and Others,* 1906.

—— *Some of the Moderns,* 1909.

WELLINGTON, HUBERT, see GINNER, CHARLES.

WEST, W. K., *G. F. Watts,* 1904.

WESTBROOK, ERIC, see [CAMDEN TOWN].

WHISTLER, JAMES MCNEIL, Catalogue of an Exhibition held jointly by the Arts Council and Knoedler Galleries, New York, with an introduction by Andrew MacClaren Young, 1960.

WHITE, GABRIEL, 'Sickert's Drawings' in *Image,* No. 7, Spring, 1952. See also SICKERT, WALTER RICHARD.

WHITE, GLEESON, *English Illustration: 'The 'Sixties', 1855–1870,* 1897.

WILENSKI, R. H., see BROWSE, LILLIAN.

WOOD, ESTHER, *Dante Gabriel Rossetti and the Pre-Raphaelite Movement,* 1894.

WOODWARD, JOHN, 'Painting and Sculpture' in *The Early Victorian Period, 1830–1860* (Connoisseur Guides), 1958.

—— see also [LANDSEER, Sir EDWIN] and *Victorian Painting.*

WOOLF, VIRGINIA, *Walter Sickert: A Conversation,* 1934.

WOOLNER, AMY, *Thomas Woolner R.A., Sculptor and Poet: His Life in Letters,* 1917.

YOUNG, The Rev. EDWARD, *Pre-Raffaelitism,* 1857.

Index of names and titles